EARLY MASTERS
Ukiyo-e Prints and Paintings from 1680 to 1750

W9-DGC-153

EARLY MASTERS
Ukiyo-e Prints and Paintings from 1680 to 1750

Gunhild Avitabile EARLY MASTERS
Ukiyo-e Prints and Paintings from 1680 to 1750

Japan Society Gallery
New York

This catalogue is published in conjunction with the exhibition
EARLY MASTERS: JAPANESE WOODBLOCK PRINTS FROM
1680–1750, shown at Japan Society Gallery from October 3
to November 24, 1991.

The exhibition was organized by the Japan Society Gallery. It
was made possible through generous grants from The Japan
Foundation; the National Endowment for the Arts; the Lila
Acheson Wallace/Japan Society Fund, established at
Community Funds, Inc. by the co-founder of the Reader's
Digest; and the Friends of Japan Society Gallery. The Society
is also grateful for the in-kind support of the Dezernat Kultur
und Freizeit (the Department of Culture and Leisure) and the
Museum für Kunsthandwerk (Museum of Applied Arts),
Frankfurt am Main, Germany.

All texts are by Gunhild Avitabile with the exception of entries
by (in alphabetical order):
Johann Georg Geyger (J.G.G.)
Rose Hempel
Bettina Klein
Eiko Kondo (E.K.)
Ekkehard May
Martina Schönbein

Translation into English from the original edition in German
by Celia Brown.

Design by Johann Georg Geyger

Text paper is Gardapat 13
Set in Centenial by Benedict Press,
Münsterschwarzach, Germany.

Printed and bound by Benedict Press in a revised English
edition of 1,000. Original German edition published in 1988
by the Museum für Kunsthandwerk (Museum of Applied
Arts), Frankfurt am Main, Germany.

Library of Congress Catalog Card Number: 91-60526
ISBN: 0-913304-33-6
All right to this revised English edition reserved by Japan
Society, Inc., New York

Cover illustration: *A Courtesan of the Genroku Era in Facing
Mirrors* (detail), by Okumura, Masanobu, 1701, page 52.

All photographs are by N. Ramstedt, Frankfurt am Main
except for: pages 3, 17, 25, 35, 37, 41, 51, 67, 75, 121, 123,
125, by Edelmann, Frankfurt am Main; pages 11, 23, 43, 47,
57, 75, 77, 107 by Beck, Frankfurt am Main; page 87 by
Klinger, Heidelberg.

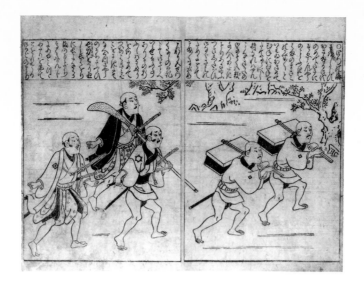

FOREWORD Julius Kurth in his 1922 book, *Primitives in Japanese Woodblock Prints,* asked for an exhibition of art works from the youthful stages of the popular *Ukiyo-e* tradition, so that the public could better understand the unique artistic value of these early works. He could not have then known how many years would pass before his wish would be fulfilled. Although early *Ukiyo-e* prints ("primitives") form part of several collections in both the East and West, there is very little written material pertaining specifically to this field. H. Gunsaulus wrote a catalogue in 1955 about the marvelous collection of early prints from the Clarence M. Buckingham Collection in the Art Institute of Chicago. Donald Jenkins prepared a catalogue in 1971 in conjunction with an exhibition showing a selection of these prints. In 1977, Howard Link presented theatrical prints of the Torii Masters from the James A. Michener Collection in the Honolulu Academy of Art. This exhibition was followed in 1980 by a catalogue raisonné of the primitives in this collection.

No exhibition devoted exclusively to primitive prints was held in the U.S. or Europe after that until 1988, when a German private collector gave permission for the first time to show his very special collection, dedicated solely to the primitives, in the Museum für Kunsthandwerk, Frankfurt am Main, Germany. This exhibition created a sensation in the world of the numerous admirers of *Ukiyo-e.*

Now, twenty years after the Chicago show, and fourteen after the one in Honolulu, New York City will be the only venue in this country for the current exhibition.

This collection was assembled by one of Germany's leading contemporary painters. Recently enriched by important new objects, the collection contains unique specimens from nearly all the early *Ukiyo-e* masters. Many of these prints are the only existing copies. Some of them can be identified as belonging to the most famous collections of the past. Certain prints were assumed to have been lost during the time around World War II.

The artists represented are the predecessors of Harunobu, Utamaro, Hiroshige and Hokusai. Their work is still related to technical and stylistic principles inherent in a print made from a design cut into a block of wood. These early prints don't imitate "real" painting, a quality which sometimes fascinates us in later prints. Instead, they represent the graphic medium in its most natural and striking way, revealing the power of black and white and a very limited but strong color scheme. The handcoloring of most early prints limits the possibilities of exposing them to light.

Hishikawa, Moronobu: Procession of a Daimyô, leaf from a book, around 1680.

The term "primitive," which is usually used to refer to these prints, is in fact related to the original meaning of the Latin *primitivus* (existing at the beginning, in the earliest age, original). However, these works seem also to share the spirit and style of prints made in the West during its renaissance of printmaking at the end of the 19th and beginning of the 20th centuries.

My thanks for being able to have this wonderful exhibition in the Japan Society Gallery go first to the collector who wants to remain anonymous, as is often the custom in Germany. He believes only his treasures should speak to us; he himself has no importance.

Dr. Arnulf Herbst, Director of the Museum für Kunsthandwerk in Frankfurt, and the city of Frankfurt am Main receive my warm gratitude for allowing me to use the German version of the catalogue I wrote for the Frankfurt exhibition in order to generate this English edition. The Frankfurt institution also allowed us to use the color separations to illustrate all prints of the German version. Nearly a third of the objects are new acquisitions.

Prof. Dr. Ekkehard May, University of Frankfurt am Main, collaborated with his assistants, Martina Schönbein, M.A., and Bernd Jesse, M.A., and the students in his seminary, especially Stella Bartels-Wu and J. Wu. Misako Wakabayashi-Oh and Karl Gottheimer, M.A., from the University of Heidelberg, translated many of the Japanese texts into German. The names of actors, roles, and theatre pieces were identified by Prof. Dr. Eiko Kondo of Bologna, Italy.

My special thanks go to the following theatre specialists in Japan: Prof. Toshihiko Uda, Toita Women's Junior College, Tôkyô; Prof. Bunzô Torigoe, Ryô Akama, and Hideo Furuido, all from Waseda University, Tôkyô; Kaoru Matsuyama, Dr. Tsubouchi Memorial Theatre Museum of Waseda University, and Yaeko Kimura, Tôkyô Central Library.

The great German *Ukiyo-e* scholars, Dr. Rose Hempel, former curator of the Museum für Kunst und Gewerbe, Hamburg, and the late Steffi Schmidt, former curator of the Ostasiatische Museum, Berlin, receive my special acknowledgement for their always valuable advice.

Prof. Johann Georg Geyger, Frankfurt am Main, created the wonderful design of this book. Dr. Celia Brown, Freiburg im Breisgau, provided the English translation and Mary Laing, New York, copy-edited the texts. Brother Sturmius Stöcklein, Benedict Press, Münsterschwarzach, handled the English version with the same ability as he did the German one.

The complicated task of preparing an exhibition and catalogue could not have been completed without the efforts of my effective team of collaborators: Erica Weeder, Mari Saegusa, Elizabeth Rogers, Dana Dince, Chinami Kondô, and Melanie Drogin, our summer intern. For the actual exhibition, Art Clark assisted me as design consultant, and Jeffrey Nemeth was in charge of the installation. Thanks to all of them.

The Japan Society would like to express its very special thanks to: the Lila Acheson Wallace/Japan Society Fund established at Community Funds, Inc. by the co-founder of the Reader's Digest; the Marlene and Morton Meyerson Charitable Trust; and the Friends of Japan Society Gallery. The Japan Foundation provided a major grant for preparation of this catalogue. The National Endowment for the Arts found the project worthy of receiving a significant grant. Without the financial help of these individuals and institutions, it would not have been possible to present this catalogue and the related exhibition to the public.

Dr. Gunhild Avitabile
Director, Japan Society Gallery

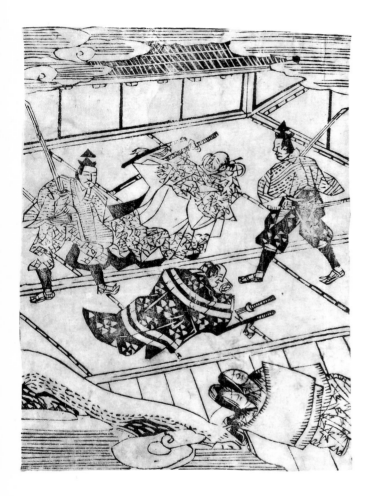

The folk art *Kana-zôshi* emulated the luxurious *Saga-bon* illustrated in Tosa style, the texts of which were printed by means of moveable letters. The *Kana-zôshi* were produced from 1620 by small publishing houses in Kyôto, following the emergence of a new middle class of merchants. The name came from the *Kana* syllabic script, which was widely understood and was engraved for these volumes in solid wood blocks. It can be assumed that the illustrations for the texts were not the work of particular artists, but of the writers who prepared the texts for printing. Although the illustrations with their cloud borders and their often festive style of composition frequently exhibit characteristics of the Tosa School, the carving of the pictures in wood makes them the early antecedents of the woodblock *Ukiyo-e* genre illustrations which were soon to appear. The new livelier style, which was developed by a series of artists who cannot always be clearly identified, soon led to the emergence of the first great *Ukiyo-e* masters, namely Hishikawa, Moronobu and Sugimura, Jihei.

Until recently, the pictorial quality of these relatively small woodblock prints was not highly regarded, but their naive charm is now better appreciated, and the clearly recognizable character of the carving of the woodblock. This positive evaluation also recognizes many correspondences with modern woodblock masters which are certainly not accidental; as, for example, in the case of Munakata, Shikô (1903–1975).

J.G.G.

Plate 1
The *Soga* Brothers killing *Kudô, Suketsune* (see pp. 78, 102).
A leaf from the *Soga-monogatari,* chaps. 8–10, 12 volumes,
21 x 14.5 cm, from the Kan'ei Era (1624–1643).
Sumi-e, 19 x 14 cm.

Yoshida, Kogorô, *Tanrokubon, Rare books of 17th century Japan,* Tôkyô-New York, (1984), pp. 70f.

INTRODUCTION

The victory of Tokugawa, Ieyasu (1542–1616) at the battle of Sekigahara in the year 1600 concluded 150 years of war among the military nobility, and secured absolute power over Japan for himself and his family. Fifteen members of his dynasty ruled as *shôgun,* imperial administrator, in the name of the powerless emperor, until the year 1868. When the last *shôgun* passed his office on to the young Emperor Meiji (reigned 1867–1912), the country, having enjoyed a period of peace which lasted for more than 250 years, was able to start out on its path towards the modern age without significant difficulties.

The preconditions were created by Ieyasu and his successors by way of a variety of measures in the 17th c. A precise land registry of the country was compiled. The feudal relationships were redefined. Ieyasu retained Central Japan and the richest provinces for his family and his faithful vassals. The *daimyô* (feudal lords) were required by law to reside for a certain time of the year in Edo and spend the other half on their fiefs. Their families remained in Edo (Tôkyô). Their lifestyle incurred high living expenses and thus they lacked money for military ventures. Christianity was forbidden and all foreigners were expelled (1640), except for the Dutch, Chinese and Koreans who were allowed to trade in Nagasaki (until 1868). A ban on foreign books and the possession of foreign literature was enforced with draconian punishments; only works in Chinese, and some in Dutch, were permitted, dealing with the arts, literature, medicine or related subjects.

In 1636 complete isolation from the outside world was imposed on the country. Public and private life were subject to strict sumptuary laws. The Chinese philosophy of Confucianism regulated human interrelationships and reciprocal responsibilities. Society was divided into four strictly defined classes. At the top were the military nobility (*buke*) who enjoyed the exclusive right to use weapons; below them were the court nobility (*kuge*) who were mostly resident in Kyôto and who were expected to devote themselves to the arts and sciences. The class of farmers had to supply the basic necessities of life. The lowest position was occupied in feudal society by the craftsmen and merchants, called the *chônin* (city folk), who were organized into powerful guilds. In spite of the scorn in which they were held by the ruling military class, they were to become the dominant social group in the Edo Period. The groups outside society were classified together as the *hinin* (non-humans): courtesans, actors, jugglers, conjurers, vagabonds, convicted criminals and outcast members of the legal social classes. Under certain conditions these last could be readmitted to their previous social class. The fruits of these measures benefitted the successors of Ieyasu in the 18th c., some of whom can be regarded as enlightened absolute dictators in the European sense. However, the period was also marked by repressive sumptuary laws and the surveillance of the population.

The rise of the *chônin* went hand in hand with the financial erosion of the military class and the flourishing of the large cities in the second half of the 17th c. Edo (Tôkyô) as the political centre of the country, allied itself with Kyôto, the old cultural centre, and Ôsaka, the prospering trading city in Kamigata. The permanent presence of the *daimyô* families soon became a source of attraction, especially for merchants, craftsmen and artists. Between the "three cities," traffic, trade and cultural exchange flowed unimpeded along established trade-routes; e.g., the Tôkaidô, which led from Edo to the Kamigata.

While the military caste increasingly lost its status, the *chônin* were becoming patrons of the arts on account of their wealth: in their magnificent houses they surrounded themselves with every conceivable luxury; they employed artists, literati and artisans, and kept beautiful, highly-cultivated courtesans. Nevertheless, they were subject to the constant control of the mistrustful *shôgunate.*

8

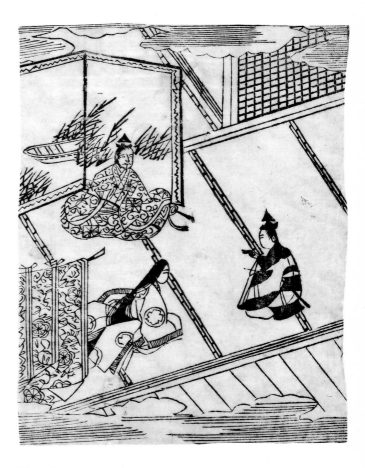

Plate 2
A distinguished gentleman receives a message from a subordinate. He is sitting in front of a folding screen which is decorated with a boat in reeds. A woman in the court dress of the Heian Period sits on the left-hand side. Unidentified leaf from the Kan'ei Era (1624–1643).
Sumi-e, 18.5 x 14 cm.

This new, middle-class culture found its own expression in what was described by the word "*ukiyo*." This originally Buddhist concept referred to the "transitory, floating world." Much time was devoted to the cult of beauty, to women, wine, the arts of poetry and of music, or simply to gazing at the moon. The world of *ukiyo* manifested itself at its most impressive in the pleasure quarters of the big cities; e.g., in Yoshiwara in the capital city Edo. There, even class differences disappeared.

Ukiyo, with its literature and art, became more widespread in the last quarter of the 17th c. through woodblock art, which from 1620 onwards attained increasing refinement and popularity. The first artists who can be identified by name, such as Hishikawa, Moronobu (died 1694) and his pupils, or Sugimura, Jihei (active 1681–1700), devoted themselves to this world of the beautiful and transitory. They also created illustrations for classical and contemporary poetry in ever new variations. Their preference was for the world of the brothel district with its courtesans and lovers. At this time they were already creating erotic woodblock prints (*shunga*). Their witty travesties revealed them to be highly educated connoisseurs. With their carefully conceived designs, they joined the company of famous contemporaries such as Ogata, Kôrin (1681–1700). They painted on silk and paper. But their best-known works are their black-and-white woodblock prints created from their designs and coloured by hand. Many details reveal that they were acquainted with other stylistic trends of the epoch, such as the courtly Tosa painting, the splendid Kanô painting, or the pictures in ink influenced by *zen* Buddhism. About 1700, the works of the Torii School heralded a new thematic area: the Kabuki theatre. This theatre for the middle classes, which is still performed to the present day, had its origins in the dance performances of a female *Shintô* shrine dancer, Okuni, in about 1600 in Kyôto. After the female Kabuki (*onna-kabuki*) and the youth Kabuki (*wakashû-kabuki*) were prohibited in 1629 and 1653 respectively as immoral, appearances were restricted to male actors. The role types were laid down; all female roles were played by men specializing in such roles (*onna-gata*), most of whom also lived as women in their private lives.

In the second half of the 17th c., theatre with fixed forms had already emerged. Plays divided into several acts were performed. The themes were culled from historical novels, legends and heroic tales, but topical events were also interpreted on the Kabuki stage. In the technique of *kakikae*, the "mixing of worlds," various personages, actions and epochs were intermingled. At the same time this made it possible to avoid censorship in plays dealing with contemporary events. The actors were big stars: whenever they appeared in a new role this would be illustrated immediately by woodblock artists. Their influence, and that of the courtesans, on the fashion of their time is comparable to that of our star cult.

Among the *Ukiyo-e* artists, Okumura, Masanobu (1686–1764) stands out. Widely versed, as a young man he was already famous for his witty and elegantly composed prints with their dynamic lines, imaginative ornamentation and boundless fantasy. Like Nishikawa, Sukenobu (1671–1751), an artist from Kyôto, his presence can be felt throughout the whole of the early phase of *Ukiyo-e*. But neither of them lived to experience the emergence of multi-coloured printing (1765). All black-and-white prints of the epoch retain the character of the image carved out of the wood-block. The earliest known colouring appears as a strong yellow-orange (*tan-e*) and yellow, followed by colouring in carmine red (*beni-e*), yellow, blue and green. Metal powder and ink mixed with glue give a glossy effect (*urushi-e*). This early phase of *Ukiyo-e* is concluded by leaves printed using two or three blocks, which with their colour schemes of pink and green or yellow, carmine and blue, form a transition to the magnificent *nishiki-e* of the year 1765.

Gunhild Avitabile

9

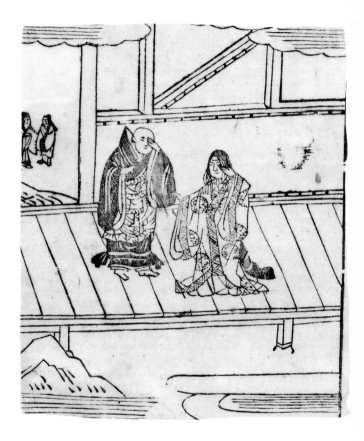

Plate 3
On a veranda *(engawa)* a Buddhist monk and a woman weep over a misfortune which they have experienced. Unidentified scene. Woodblock print from the Kan'ei Era (1624–1643). *Sumizuri-e,* 17 x 14 cm.

HASEGAWA, SHÔSHIN (KATSUCHIKA)
(mid-17th century)

BIJIN−E

Kakemono

Signature: Hen'un Rôjin
("The old man from the dispersing clouds")

Seal: "Shôshin" and "Hasegawa" (?)

Paper, paint and ink

98.5 x 24.5 cm (paper format)

Date: mid-17th century

A beautiful woman is depicted standing alone against a very narrow, empty background. Her hair is drawn up into a high bun, with a few short wisps of hair falling around her temples. Shielding her mouth with her left hand in a gesture of shyness, she holds the bow of her *obi* with her right hand. She is wearing several robes over each other, the outermost probably made of foreign brocade and decorated all over with large peonies.[1] In the upper part of the hanging scroll there is a Chinese short poem of seven syllables in four lines (*qi jue*):[2]

Perfume emanates from the kingfisher-blue sleeves of supple silk.
Her waist so slim and skin so tender − how fresh she looks!
With her rosy cheeks and green-glowing eyebrows she is so charming
That she would break the heart even of a man of iron.
Written by Hen'un Rôjin.

The lower of the three red seals can be identified as Shôshin (Katsuchika) and refers to a painter called Hasegawa, Shôchin about whom nothing more is known. He probably belonged to the painter family Hasegawa.[3] The pure Chinese poem without supplementary syllabic characters conforms to the rules of the Chinese art of poetry.

[1] Probably silk brocade made in China for the European market.
[2] Translation and linguistic analysis of the poem: Stella Bartels-Wu and J. Wu.
[3] To go by the seal cartouche on top.

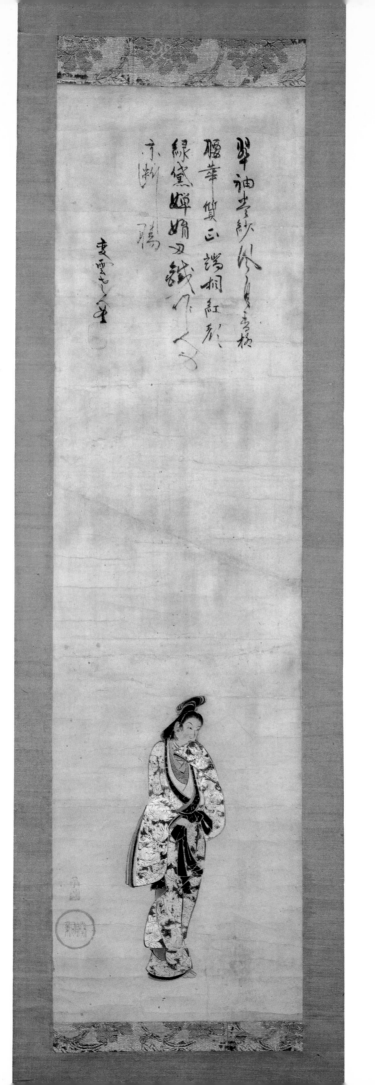

HISHIKAWA, MORONOBU
(1618?–1694)

In 17th c. century Japan, a diverse, unclassifiable range of handcrafted woodblock pictures was being produced by innumerable unknown woodblock carvers, with more or less identifiable artistic characteristics, who illustrated the shortlived printed matter of that time according to the latest fashion.

Moronobu's overriding significance lies in the fact that he was the first to succeed in drawing together all the stylistic trends of this epoch and, thus, in founding what might be called a school, which was shortly to become exemplary for the development of the *Ukiyo-e* school and whose influence was to reach far into the future. It was his personal abilities which made this possible: the drawing of lively, rhythmic lines, the sensitive use of deep black areas within a plane, and his sure feeling for the decorative perfection of his works. Many of these talents were the fortunate result of his arts and craft background: his father, Hishikawa, Kichizaemon from Hoda in the old province of Awa (today Chiba province), was the most famous brocade-embroiderer of this time. It can be assumed that Moronobu's first training took place in his father's workshop. His father died in 1662; a few years later Moronobu moved to Edo and began there his successful, indeed legendary, career as the first *Ukiyo-e* master to be known by name. His early works appeared shortly after 1670; illustrated albums and books, paintings, and innumerable *shunga* albums followed in quick succession. Every one of his works bore the instantly recognizable, unmistakably powerful mark of the Master. Moronobu died in 1694.

THE POETESSES DAINI–NO–SAMMI
AND AKAZOME–NO–EMON (circa 1000)

TWO LEAVES FROM THE WORK:
FÛRYÛ SUGATA-E HYAKUNIN–ISSHU
("Fashionable portraits of the hundred poets")

Leaves 20 and 21, selected from volume 2

The three-volume work contains 100 illustrations; volume 2, available here, contains 28 pictures.

Black-and-white (*sumizuri-e*), hand-coloured

27.5 x 18.5 cm

Date and information about publisher on the last page of volume 3: (Ryerson Collection, Chicago)

"On an auspicious day in the 4th month of the 8th year of the Genroku Era (1695), Ôdemma Ni-chôme, Kinoshita Jin'emon *han.*"

Date: 1694/95

This famous woodblock work was evidently created by Moronobu shortly before his death and was published by his son Morofusa in 1695 in memory of his father. Moronobu's death in 1694 can be inferred from his son's postscript. The "Fashionable portraits of the hundred poets" depict paired figures of poets on the facing sides of each double page. In the upper, demarcated area of each page the name, poem, and an explanatory text related to the figures are given. Each poet is accompanied by one, or at most two persons. The surroundings are indicated by just a few elements which relate to the poems.

On the right-hand side, the poetess Daini-no-Sammi (ca. 1000) the daughter of Murasaki Shikibu, is depicted.[1] Murasaki, the famous authoress of the *Genji-monogatari*, was twenty-one when she married the twenty-year older Fujiwara-no-Nobutaka, with whom she was deeply in love. Shortly afterwards, she bore him a daughter, Kenshi, who was later known by the name Daini-no-Sammi. Like her mother, she wrote poetry.

Daini-no-Sammi, dressed in a kimono ornamented with chrysanthemums, is lying stretched out in front of a folding screen, her head resting on her hand. The folding screen is decorated with a brushwood fence, behind which chrysanthemums are growing. In front of Daini-no-Sammi a young maid is kneeling. In the background, bare mountains rise up above the clouds. Bamboos swaying in the wind are suggested by just a few lines. Daini-no-Sammi's poem:[2]

Arimayama Inano	When the wind blows over the
sasa hara kaze fukeba	bamboo plains of Inano
ide soyo hitowo	by the mountains of Arima
wasureya wa suru.	how could I ever forget him.

Interestingly, the page contains a reference to a play on the well-known Chinese poem by Tao Yuanming (372–427), the theme of which has entered art history under the title Motif of the Eastern Fence. The poem speaks of the retreat into solitude of a poet, who "picks chrysanthemums at the East Fence" gazing towards the southern mountains, while the wagons of the higher officials busily clatter past the gate.[3] The other leaf shown here is dedicated to the poetess Akazome-no-Emon (ca. 1000). She is the authoress of the *Eiga-monogatari*.[4] Her poem:

Yasurawade	Oh, I have been looking at the moon,
nenamashi	Until the night drew on
mono wo	And the moon went down;
sayo fukete	It would have been better
katabuku made no	To have gone straight to sleep
tsuki wo mishikana.	Without delay.

The poetess, turning slightly, grasps her robe and glances back towards her maid, who is accompanying her bearing a candle. The full moon floats above the clouds. Akazome-no-Emon, in deep melancholy, inclines her head towards the candle, which, burning down unremittingly, symbolizes her fruitless wait as the night strides on.

[1] S.Hisamatsu, (1982), p. 79.
[2] Transl. Rickmeyer, (1985).
[3] C. Birch, (1965), p. 184. (The poem is entitled "Written while drunk.") The motif is one of the favorite images of East Asian art. Usually a suggestion of a fence and a few sprigs of chrysanthemum suffice to evoke the association, as in this picture.
[4] KHT, I, p. 23.

HISHIKAWA, MORONOBU
(1618?–1694)

RECEPTION ROOM IN A BROTHEL

Leaf 7 from a 12-part series *Yoshiwara-no-tei* (Scenes from Yoshiwara)

The title of the series is to be found on the first side; the publisher's name Yamagata-ya, and the address are given on the last leaf of the set.

Dai-ôban, yoko-e, 31.6 x 47 cm

Black-and-white (*sumizuri-e*), hand-coloured

14 Date: ca. 1678

Around 1700 the city of Tôkyô, which a hundred years previously had consisted merely of a collection of a few houses, had become one of the biggest cities of the known world, with half a million inhabitants. This development was accompanied by the growth of a new, self-confident middle class together with the emancipation of a middle-class ethos, which transformed the concept of *ukiyo* as a transitory world lacking in gratification into its opposite. *Ukiyo* now stood for the floating world; since life here is so short, one should grasp every opportunity and enjoy it to excess. The favourite means to this end were the theatre and the brothel, and these were to become the chief subject matter of *Ukiyo-e* artists' pictures in the following hundred years.
Moronobu's earliest large-scale woodblock print series, which were liberated from the tradition of book illustrations, answered an avid demand for illustrations of the famous pleasure houses and the favourite courtesans. At the same time, they established the accepted form of *Ukiyo-e* woodblock prints for the next two centuries, drawing on the tradition of *Ukiyo-e* painting, which was already flourishing. *Ueno-hanami-no-tei* (Flower-Viewing at Ueno) from 1680 and *Yoshiwara-no-tei* are examples of such series. In *Yoshiwara-no-tei* the viewer of the series of pictures is led, like a visitor, through all twelve scenes: on the way to Yoshiwara, entering through the great gate, sojourning in the prostitute district, the courtesans and their guests in the ante chambers, the interior of the brothels, a glance into the kitchens, and finally the guests departing into the distance. Our leaf (leaf seven) shows the reception room of a brothel, where expectant guests pass in and out, and can approach the ladies of their choice. At the centre, in front of a room separated from the street and ante-chamber by an open window, a *samurai* is standing, his face hidden under a large straw hat to avoid recognition. The pretty girls sitting on *tatami* mats making music, and the large mural with landscape and waterfall are intended to give a cosy impression. The composition of the picture is simple and described with an instinct for the essential. As on a theatre stage, Moronobu succeeds in relating all the participating actors to one another; they interact in an exciting juxtaposition of full and empty planes within the picture.
J.G.G.
Provenance: Sidney Ward Collection.

TNM, I, Ill. 1–12.
M. Narazaki: *The Japanese Print: Its Evolution and Essence*, Tôkyô, (1966).
S. Kikuchi, (1969), Ill. 2–13.
S. Takahashi, (1972), Ill. 4.50.

HISHIKAWA, MORONOBU
(1618?–1694)

PARTY AT A CHA-YA (TEAHOUSE)

Leaf 8 of the 12-part series *Yoshiwara-no-tei* (Scenes from Yoshiwara)

The title of the series appears on the right side of the first leaf; the publisher's name is given on the last leaf of the set.

Publisher: Yamagare-ya of Tôriabura-chô

Dai-ôban, yoko-e, 31.6 cm x 47 cm

Black-and-white (*sumizuri-e*), hand-coloured

Date: ca. 1678

In a leaf like this one, the strong relationship of early *Ukiyo-e* to contemporary paintings of the Tosa School, which were more sophisticated and traditional, as well as to the Yamato-e of the past, is clearly evident. The way in which Moronobu presents the inside of the teahouse for view by doing away with the roof, looking from a high viewpoint down into the scene, is a stylistic medium known in traditional painting as *fukinuki yatai* (the blown-away roof).
With no obstacles present, one can look into the ample room, complete with veranda. Nothing seems to disturb the pleasure and amusement of the scene. The three enthusiasts of Yoshiwara have arrived after a long and tiresome journey, presented on the preceding leaves. They have nearly reached the aim of all their desires.
Ten employees are busy taking care of important guests. Two gentlemen, one with a fan, the other with a flat drinking bowl, are being pampered by an *oiran*. A third one, who seems to be slightly older, sits aside with a melancholic, skeptical expression on his face. Two *shamisen* players, a man and a woman, and a man playing the shoulder drum *(tsuzumi)* accompany a graceful female dancer. A little maid helps with food and drinks, which are set up in front of the guests. Two servants leave the scene with a deep bowl and a tea kettle. A man on the right side supervises the whole procedure, together with a maid. Behind a screen decorated with the character *doku* (to be at one's ease) and a short poem

| *Yu doku sô gen shu* | To be alone |
| *Ka kore ai* | with the sound of strings and sake, that is pleasure |

a shelf with books and a little black table are hidden. Although the costumes show the fashions of the time, the composition of the scene seems to be related much more to traditional representations of an interior scene rather than to contemporary portrayals.

J.J.G/G.A.
From the Walter Amstutz Collection.

TMN, I, III, pp. 1–12.
M. Narazaki, *The Japanese Print, Its Evolution and Essence,* Tôkyô, 1966, III, p. 1.
S. Kikuchi (1969), III, pp. 2–13 (shows the complete set).
S. Takahashi (1969), III, p. 450.
H.P. Stern (1971), III, p. 2.

18 UNSIGNED

The artist of this work is usually taken to be HISHIKAWA, MORONOBU (1618 ?–1695), but it has also been attributed to YOSHIDA, HAMBEI (active 1664–1689), or to one of his pupils.

KOREAN ART OF RIDING

Publisher: Kawachi-ya Rihei Yanagi-no-Baba Nijô agaru (Kyôto)

Ôban, yoko-e, 26 x 38 cm

Black-and-white (*sumizuri-e*), hand-coloured

From a series of twelve prints

Date: ca. 1683

Korean horsemen are displaying their riding skills in front of their ambassadors and Japanese dignitaries. It is known that in the year 1682 Korean emissaries came to Japan, and are reputed to have been accompanied by acrobats on horseback. The *shôgun* was present at their performances in Edo. It may well be that the woodblock prints were published in this context.
Text (left): "Looking backwards" *(ushiromi)*
(right): "Two men on one horse" *(futarinori)*
(below left): "Eleven"
Provenance: Gillot Collection (cat. no. 30); Collection Otto Jaekel.

Cat. Strauss–Negbaur, (1928), no. 10a.
Crighton, (1973), no. V,1.
E. Kondo, (1982), no. 73, ill. 29 (dated leaf from the Schindler Collection, no. 516).

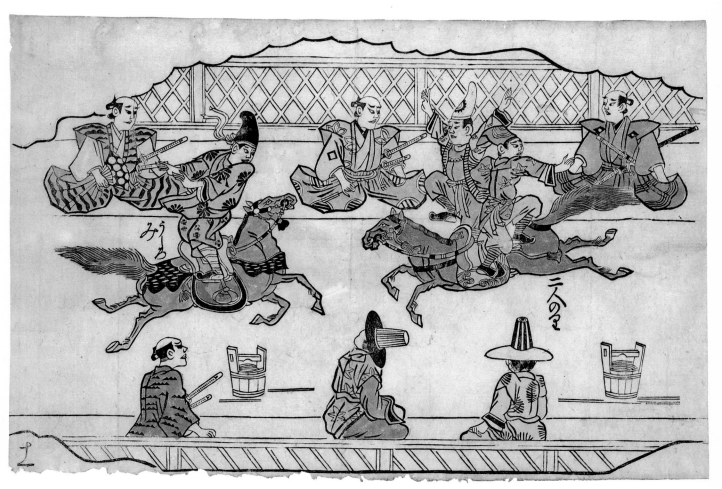

**20 UNTITLED
SUGIMURA, JIHEI'S CIRCLE**

BIJIN-E

Hanging Scroll

Mounted on silk

Paint on paper

79 x 29.5 cm (picture size)

Date: ca. 1680

On an empty background, a woman leans in a restrained manner towards the right-hand picture margin. This movement displaces the darkest area of the picture, namely the heavy coiffure (*tamamusubi* hairstyle), well away from the centre of the picture. The figure is thus thrown off balance, but is really stabilized by the dark border of the robe in the lower part of the picture, with its decoration of stylized waves. In the lighter space between these two poles – the dynamic contours of the hairstyle and the quiet area of the black border – all the colourful elements are displayed, which lend to the figure, and thus the picture, its actual identifiable meaning.

On the sleeves and shoulders float clouds with stylized flashes of lightening. The robe is fastened together with a wide belt decorated with cherry blossoms and a narrower belt in *shibori* technique (negative imprints created by binding the cloth with thread). The voluminous bow of the obi with its soft blue colour offers a counterpoint to the decisive contours of the drawings on the robe in the lower left third of the picture. The central axis of the image incorporates the angry dragon with its gaping jaws. With her hidden right hand, the woman lifts up the sleeves of her kimono, supported by the visible left hand. This gesture has been retained in Japanese dances to this day.

The black and red bands of the border and the black scaly pattern of the dragon's body, which is never shown in his entirety – as if he were really wrapped around the figure – provide accents which are taken up by the black area of the hair. The facial features and the generous patterns of the robe are reminiscent of the pensive female figures of Sugimura, Jihei. The painting should be attributed to his circle.

The dragon is one of the mightiest of the fabulous creatures of the Chinese cultural region. In China he represents the Emperor himself. However he is above all an aquatic animal, and is therefore often shown as ruler of lakes, rivers, or the sea. He is regarded as the most powerful creature of all.[1] In his image, Chinese and Indo-Buddhist conceptions are clearly interwoven.[2] In India, the snake goddesses (*Nâga*), which correspond to the dragons of China, are accorded the same functions. In Japan, such Chinese and Indo-Buddhist conceptions intermingle in ceremonies such as *Gyôdô* as early as the ninth century A.D. Even then, their main functions were to make rain or to stop the rainfall. For example, the dragon dance *Ryô (Ryû)-ô* of *Bugaku* is still performed for this purpose today. The dragon winding around the women's robe may, however, also point to another contextual background. Among the many forms of the Bodhisattva of Mercy, *Kannon* (skr. *Avalokiteśvara*), appears the figure *Ryû-zu Kannon* ("Dragon's head" Kannon)[3] in the form of a female figure embraced by a huge dragon. This theme enjoys great popularity in applied arts; e.g., in *inrô, netsuke* and also in sword decoration.[4]

[1] E.g., *Tamatori-monogatari*, Jenkins, (1971), pp. 24f. s.a. Gabbert (Avitabile), (1983), pp. 17, 25.
[2] Gabbert (Avitabile), (1972), I, pp. 142f.
[3] Sawa, R., *Butsu-zô zuten*, (1951), p. 76.
[4] KHT, I, p. 478.

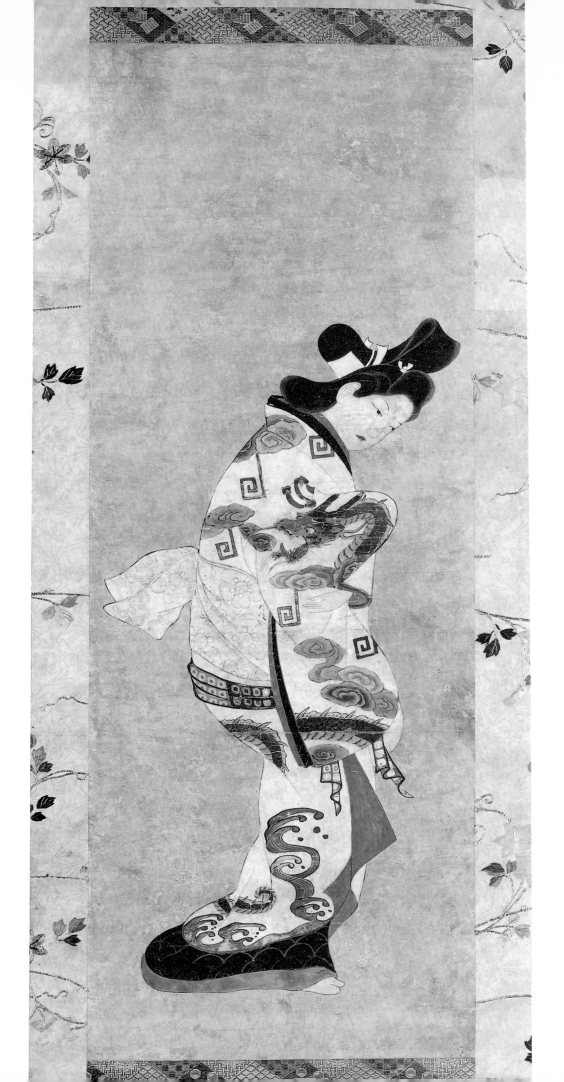

22 SUGIMURA, JIHEI
(active 1680–1698)

About sixty years ago a second, previously unrecognised artist was identified as a distinct personality in the extensive work of Hishikawa, Moronobu, largely as a result of research by the Japanese scholar Kiyoshi Shibui. The artist's name was Sugimura, Jihei. Today it seems incredible that he was forgotten for almost two hundred years and that his work could not be distinguished from that of Moronobu, although the identifying characteristics of his pictures are obvious, and his signature can often be found on the robes of the figures – even though transformed into decoration and half hidden.

The greater part of his work is concerned with erotic scenes, which have always been favourite motifs of the *Ukiyo-e;* sensual pleasure also seems to pervade works which do not obviously depict intimate situations. In Moronobu's works depicting the act of love, the pictorial composition often develops out of the scenic conditions and allows, indeed demands, an emotional participation in the events shown. Sugimura, on the other hand, creates distance by means of a stricter division of the picture, often a radical triangular composition to which all the parts are subordinated right up to the margins of the page. The aesthetic appeal of his designs ensues from the tension and rhythm of the lines and the unerringly decisive arrangement of the deep black areas. When the viewer is able to appreciate the more abstract beauty of Sugimura's prints, an occasional loss in illustrative variety compared with Moronobu does not disturb him as much. The energy of the composition declines in later works and, as a result, the effect becomes blurred and a descent into mere illustration is inevitable.

Virtually nothing is known about the artist's life. All that remains are a few illustrations for novels and picture books, a series of erotic works in folders of *ôban* format, and some woodcuts in *kakemono* format.
J.G.G.

UNTITLED
SUGIMURA, JIHEI

LOVERS AND YOUTH

Black-and-white (*sumizuri-e*) with some colouring in *tan* and brown

Unsigned, album leaf

Ôban, yoko-e, 25.8 x 37.8 cm

Date: ca. 1685

A pair of lovers in stormy embrace are being watched by a young man who is hiding under a heavy blanket adorned with a garland of small leaves. The courtesan's robe is decorated with grapes and vine-leaves. In this leaf, Sugimura's individual manner of composition is demonstrated in especially pure form. All parts of the picture emanate from a heavily emphasized point displaced somewhat away from the centre towards the edges, reducing the density of the composition without ever upsetting the equilibrium.

Faces, body shapes, decorative patterns are all subordinated to a conscious compositional strategy which excludes any superfluous elements. Everything which happens seems to serve the composition and becomes integrated into the richly structured space. There is not even a hint of illusionary spatial perspective. The dynamic action is intensified through the "billowing" black area of a section of the man's robe which flows away from the woman's head. This energetic movement is broken by the calming pose of the youth.

No other impression of the leaf is known to date. It is shown here for the first time.

Provenance: Otto Jaekel Collection.
J.G.G.

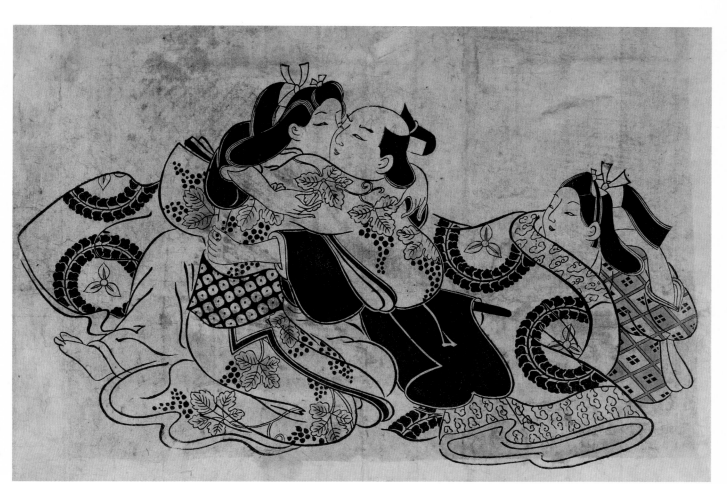

24 UNTITLED
SUGIMURA, JIHEI

COURTESAN WITH LOVER AND MAID

Black-and-white (*sumizuri-e*)

Unsigned, probably the title page of an erotic album

Ôban, yoko-e, 25.2 x 34.8 cm

Date: ca. 1685

A scene from a brothel. The guest is lying stretched out on the
floor; an *oiran* playing on the *shamisen* has seated herself on
his lap. Her young *kamuro* is touching the man's shoulders
with her hands. Their robes are lavishly decorated: wisteria
leaves and bamboo canes adorn the courtesan's wide jacket,
while the lover's outer robe bears sprigs of brushwood. The
maid's kimono is decorated with sea animals and waves. A
spatial effect in the background is suggested by utensils for
eating and drinking. A further impression of this woodblock
is known. It is to be found in a private Japanese collection.
J.G.G.

Kiyoshi Shibui, (1928), pl. XXI.
Lane, (1962), ill. 21, p. 53.
Ukiyo-e-Art, no. 40, ill. 63.
Portheim Foundation, (1975), II, 5.

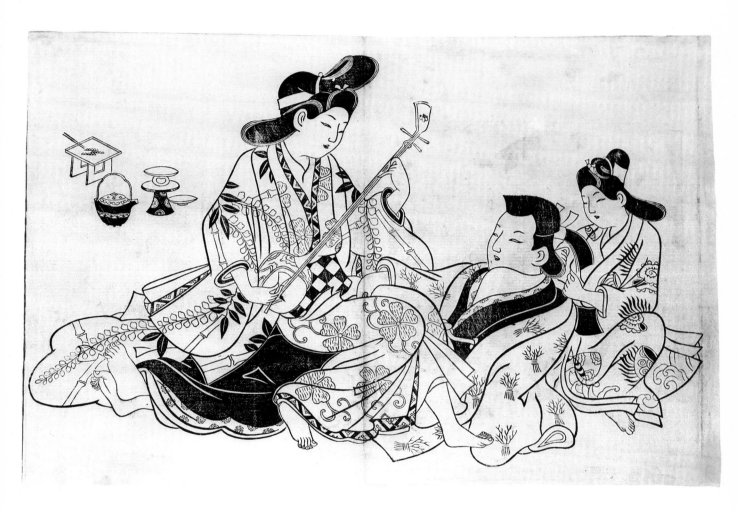

26 UNSIGNED
TWO ACTORS COMBING HAIR (*KAMI-SUKI*)

Kakemono (Hanging scroll)

Paper, paint and ink.

Picture size: 54 x 15.5 cm

Date: ca. 1700

An *onnagata* actor is preparing another actor's hair for youthful roles *(wakashûgata)*. The kimono of the female impersonator is decorated with rushes in a watercourse. He has let down a heavy cloak with red lining (*uchikake*) and red maple leaves as far as his waist. The *kiri* crest, which cannot in this case be attributed to any particular actor by name, appears on the shoulders and sleeves. His long hair hanging down his back is tied low, while his bare-shaven forehead is covered with a scarf (*yarôbôshi*). His partner sitting in front of him is wearing a robe decorated with pine twigs over a plain garment. On his shoulders, a cherry blossom is combined with a square to form a *mon*. This crest also could not be identified. The scene comes perhaps from one of the innumerable *Soga* dramas.

According to the strict directives of the Tokugawa *Shôgunate,* no real love scenes were allowed on stage. Sensuous love was therefore expressed by means of various symbolic gestures. Combing the hair was one of these, and was a sign of especially deep affection.[1]

[1] See p. 30, footnote 12. Barth, (1972), p. 289.

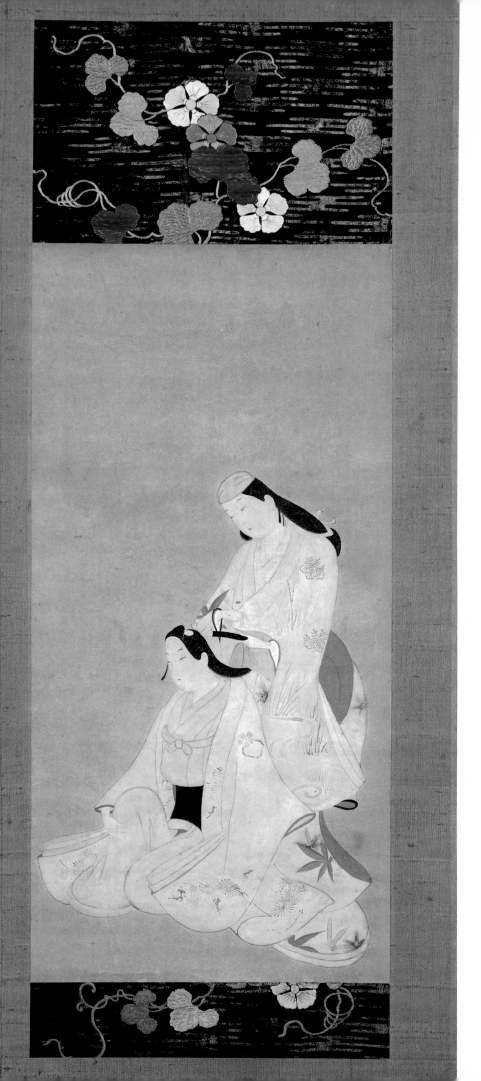

ISHIKAWA, TOMONOBU (RYÛSEN)
(active ca. 1680–1713)

Ryûsen was at the same time woodblock master, writer and cartographer. He worked mainly on book illustrations as a follower of Moronobu, but also produced some black-and-white print sheets in horizontal *ôban* format, his most important contribution to woodblock art.
J.G.G.

THE THREE-DAY MOON (*MIKAZUKI*)

Signature: (on the folding screen) Kama-tsuken Ryûshû ga

No publisher's mark

Ôban, yoko-e, 25.4 x 35.2 cm

Sumizuri-e

Date: ca. 1686 (Jôkyô 3)

This and the following leaf are from an album of twelve illustrations dating from the year Jôkyô 3 (1686). Six are by the hand of Ryûsen and six by Furuyama, Moroshige (1684–1695), a pupil of Moronobu. They illustrate Ihara, Saikaku's novel "*Kôshoku gonin onna*"[1], "Five Sensuous Women." The leaf in question bears Ryûsen's signature in the form of his *gô* (artist's pseudonym). To judge by the shape of the cartouche and the style of this and the following leaf, they come from the same album.[2] Another impression of the first leaf is to be found in the Tôkyô National Museum.[3] The second leaf has not previously been published in any of the literature available to us. Both come from the collection of Friedrich Succo, the well-known woodcut researcher of the beginning of the century.[4]

In the room of a brothel – its name, Ichino-ya, is written on the folding screen – a young man is sitting on the ground, leisurely puffing at his pipe. The sign "*ichi*," the brothel's crest,[5] appears twice in circles on his robe. Three inscriptions can be read on his knees: *jû* (ten), *ryô* (wonderful) and *hei* (standard), from right to left. At first glance these appear to represent an advertising slogan for the brothel. However, several hidden allusions are certainly intended.[6] The man is looking up at a pretty girl who has obviously just entered. With her hands hidden inside of her robe, she is looking down at the floor in embarrassment. Her kimono is embellished with carnations, her *uchikake* with big wheels. A kimono with a design of snow crystals on a black background is hanging on a large clothes stand. Incense is burning on a black lacquered table in the *tokonoma*. An iron candelabra next to the man illuminates the room. It is night. Behind the screen there is a ghost in the form of a woman with long flowing hair and tortured facial expression. She is holding a slender walking-stick in her hands. Her white kimono is bare of decoration. Since the lower half of her body, including her feet, is missing, she is most certainly a ghost. She is probably the jealous, unredeemed soul of a woman who, though dead, is still unable to free herself from earthly bonds, or the jealous ghost of a living woman.[7] Since the young man in the kimono bears the emblems of the establishment, he is more likely to be a member of staff than a guest. The artist has written a seventeen-syllable poem, *senryû* (or *zappai*) in the chartouche:[8]

Mikazuki wa	The Three-day moon,
mitsumu mitsumu ni	an acquaintance
suguru en.	which passes,
	while one is still staring after it.

The "Three-day moon" (*mikazuki*) is the slender sickle of the moon which can be seen only for a brief interval in the evening sky and which soon goes down. Before one has had time to fully savour the beauty of its appearance, and before one has established a "relationship" (*en*) with it, the moon has already set. *Mikazuki jorô* is the name used in the brothel district, in which the depicted scene is set, for young prostitutes who appear for just a short time and then vanish before the guests have had time to establish a "relationship" (*en*), either because they have found a rich admirer or because they do not want to continue working in this profession. Ryûsen's rendering of the word "*mikazuki*" employs instead of the number "three" (*mi*), the polite prefix "*mi*." He thus offers an interpretation of the poem which, in view of this modification, should be rendered as follows:

Like the Three-day moon –
As one stares after it
The relationship is already over.

Japanese resarch has also failed to identify the content of the scene. Ryûsen may, however, have based it on an event from the *Genji-monogatari*, namely the attack at night of the jealous ghost of Princess Rokujô, who killed Genji's secret mistress Yûgao in front of his own eyes.[9] The carnation decoration on the girl's robe, the ghost, and the night-time setting may provide sufficient references. Other elements should be noted. In this and the following leaf, the wheel, the Buddhist symbol of fate, appears on the robes of the people entering the scene.[10] Snow crystals on the robe in the background, and the moon mentioned in the poem, remind one of the story of the Chinese orphan, Ryôto, who was so poor that he could not afford light for his nightly studies. Ryôto collected snow in front of his window, which reflected the light of the moon. As we know from other leaves, too, Ryûsen purposely interchanged phonetically similar characters. The two characters on the young man's left knee may also be read as "Ryôto," thus referring to the persevering young man of the Chinese legend.
Ishikawa, Ryûsen is also the author of the *Kôshoku Edo murasaki* ("The Purple Colour of Sensuous Edo"), for which Furuyama, Moroshige created illustrations running to twelve album leaves.[11] On a double page from the five-volume work owned by Mr. and Mrs. J. Hillier, we can see the considerable interdependence of both artists as far as the illustrations of *keisei* (courtesan) themes are concerned. Figures and their surroundings are proportional to each other. As in the leaf by Ryûsen described here, the artist Moroshige places his signature on an object within the picture, namely on the picture scroll in the *tokonoma*. The use of the same props is also of interest. There is an identically packed parcel, a toilet case, lying in the *tokonoma* of Ryûsen's second woodblock, as in the aforementioned leaf by Moroshige. The black lacquered table with curved legs and inserted vase of flowers is repeated in another leaf by Moroshige in the Buckingham Collection, Chicago,[12] in which the said toilet case also appears.
Whether it is admissible to interpret the letters on the young man's knees as also representing the artist's signature – in a similar manner to Sugimura, Jihei, who sometimes signed his works in this way – is a matter for discussion. Both characters on the young man's left knee in the reading "*Ryôjû*" are perhaps another name for *Ryûsen*, while the character "*hira*" could refer to Moronobu's talented pupil Morohira (worked late 17th c/beginning of the 18th), who is chiefly known as an exceptional colourist.[13]

1 This date is given in all the publications available to us. It is also considered to be the date of Kôshoku Edo Murasaki's work discussed further below, for which Ryûsen wrote the text and Moroshige created the illustrations (Jenkins, [1971], p. 49. cat. no. 39). I am grateful to Dr. Rose Hempel for the information that both leaves discussed in our catalogue are illustrations for the aforementioned work by Saikaku (Ihara Saikaku [1642–1693] haiku and prose writer).
2 Yoshida, II, p. 271, provides comprehensive details about the artist; the work mentioned above and a woodblock are discussed in I, p. 357.

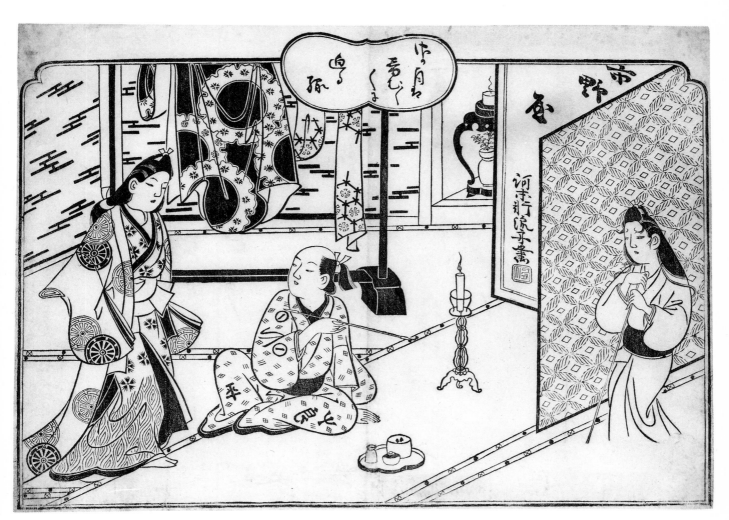

3 TNM, I, no. 324. The leaf is coloured.
4 He is the author of the work *Utagawa, Toyokuni and His Time,* 1924.
5 The actor Ichikawa, Monnosuke (died 1729), a member of the actor family Ichikawa who wrote their names with identical first characters, uses this character "one" in his *mon* as a substitute for *ichi* (market).
6 The characters all have three phonetic readings. They can be used to form the most varied combinations. For example, in the combination *Heijûryô* they can also stand for the first name of the hero. For other interpretations, see text.
7 The agonized expression of the unredeemed is to be found in the *Nô* masks typical for this theme. The lack of lower extremities is the identifying feature of ghosts in the history of *Ukiyo-e* well into the late 9th c. Cf. Joly, (1968), p. 175.
8 Translation and interpretation, E. May.
9 Benl, (1966), chap. 4. Yûgao's daughter Tamakazura is described in later chapters as the child of the carnation.
10 JEBD, (1965), p. 234.
11 See footnote 1; on Moroshige: Roberts, (1976), p. 113.
12 Gunsaulus, (1955), p. 17. See Shibui, (1926–28), pl. XXXIII, print of Moronobu, showing an open toilet case with combs. See pp. 26, 31.
13 See Roberts, *Comments on Sugimura, Jihei,* see p. 26.

ISHIKAWA, TOMONOBU (RYÛSEN)
(active ca. 1680–1713)

THE HÔRAKU-DANCE AND THE BUTTERFLY PAIR

25.2 x 35 cm

All details as on p. 28

Date: 1686 (Jôkyô, 3rd Year)

A young couple are sitting in an interior room. The girl is wearing a long, trailing, courtly *hakama,* her outer robe is decorated with plum blossoms. Leaning on an armrest, she is listening to the words of a young man in courtly attire. His outer garment is adorned with clouds and fragments of *Shintô* shrine architecture. Large cherry blossoms embellish his trousers. His sword with its cock's head identifies him as a court noble. A parcel of books and a toilet case are lying in the *tokonoma.* Incense is burning on a small lacquered table. The door opens. An ugly *samurai* looks in angrily with wide open eyes. He has two swords in his belt, and his robe is decorated with large, stylized wheels.

The poem in the cartouche reads:[1]

Hôraku no	The *Hôraku*-Dance –
mai ya kochô no	a butterfly pair
futarizure.	together.

It is possible that the joke in these *senryû* verses (humorous satirical versions of the *haiku* which also have seventeen syllables) lies in the fact that *Hôraku* is not only the name of a sacrificial dance but in popular speech usually means "enjoyment, pleasure," and may also allow association with the *Bugaku* dance *Kochô-raku* ("Butterfly Dance").[2] *Kochô* (butterfly) is written in the poem with the popular but erroneous character for *ko* (small) instead of *ko* (Hu-barbarian). This is another scene which can scarcely be identified. But the setting of the event does not seem to be a 17th c. brothel. The courtly attire of the two young protagonists suggests an earlier period. One is tempted to identify the young couple as *Soga, Jurô* and his mistress *Oiso-no-Tora,* the rough *samurai* as Asahina. But cherry blossoms are not found as emblems of the *Soga* brothers.

1 Translation and interpretation by E. May.
2 *Kochô-raku,* together with the "Pair Dance" *Karyôbin,* the "Dance of the Paradise Birds," belong to the works which were also performed as a contribution to the "Ten kinds of sacrificial offerings" to Buddha. They are always interpreted by youths, mostly young temple novices or nobles. In the *Genji-monogatari* there are various descriptions of such dances. (Gabbert, [1972], pp. 14, 207). The butterfly and plum symbols (on the maiden's robe) stand in Chinese mythology for long life and virgin beauty respectively (Eberhard, [1983], p. 256). The butterfly is also a sign of a man in love.

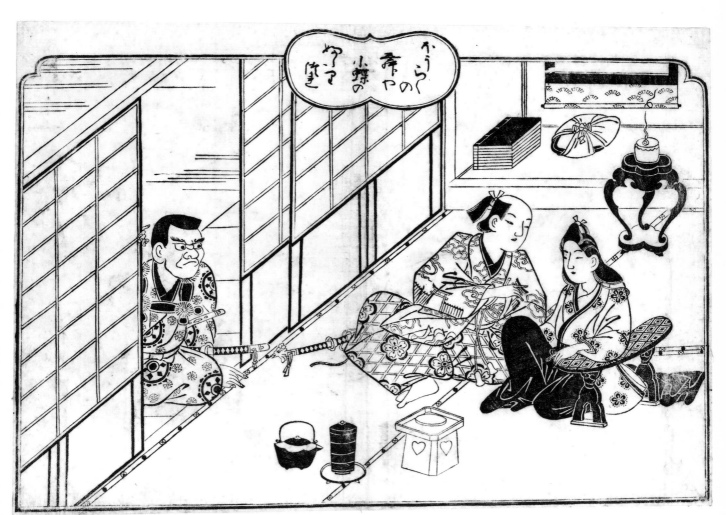

TORII, KIYONOBU I
(ca. 1664–1729)

Kiyonobu was born into a family of artists; his father was Torii, Kiyotomo, who was an artist and painter of theatre posters in Osaka. In 1687 the family moved to Edo, and it was here that Kiyonobu set out on a successful career as a painter of book illustrations, following in the footsteps of Moronobu. Towards the turn of the century, Kiyonobu, together with Kiyomasu I, created a new style, which makes it rather difficult to distinguish between the two artists. However, this new style was of fundamental importance to the woodblock art of their time and the following years. Perhaps Kiyonobu's compositions are somewhat more generous and expansive than Kiyomasu's, while the latter's works are more flexible and graceful.

The information handed down about the relationships between the most important artists of the early Torii School has always been confused and it will never be possible to clarify it absolutely. In recent years, Howard A. Link has made the most thorough study of this subject.
J.G.G.

32 THREE LEAVES FROM THE WORK *KEISEI–EHON*

Signature:
(on the last leaf) *Wagôkô Torii Shôbei Kiyonobu zu*

Seal: Kiyonobu

Publisher: Izumi-chô Hangi-ya Shichirôbei *han*

Oribon, original size

Black-and-white (*sumizuri-e*) 1 volume, 19 illustrations

Date: Genroku 13th year (1700)

The sheet is a leaf from a book without numbered pages.

The book: *Keisei-ehon* ("Picture book of courtesans" or "Picture book of castle conquerors")[1] is also cited with the title: *Shôgi-gachô* ("Picture book of prostitutes").
Five different editions are known altogether.[2]
This work must have had a considerable influence on book illustrations of this theme in the years around 1700. Ômori, Yoshikiyo (see p. 34) certainly drew on its example in his *Shidare yanagi.* Okumura, Masanobu (see p. 52) was inspired as a 15 year old in 1701 to produce his woodblock work *Genroku Tayû Awase Kagami* ("Courtesans of the Genroku Period reflected in facing mirrors") or his *Hokkaki Bigichô* (see p. 53).

[1] The characters are different, but the pronunciation is identical. "To break into a castle." This phrase alludes to the power of a beautiful woman over a man who is so distracted that he abandons his castle to the enemy without a fight. F. Rumpf, OZ 6/1930, p. 90 gives the title: *Mei-gi jûhachi kô (shu).*
[2] Yoshida, I, p. 336. On *Keisei-ehon*: Jenkins in: *Ukiyo-e Art,* no. 36, 1972, pp. II ff.; Jenkins, (1971), p. 62, no. 62.

THE COURTESAN KO-MURASAKI

The leaf shown here, leaf one, shows the courtesan Ko-Murasaki[1] ("Little Murasaki") against an empty background. Her personal crest is the four-leaved blossom in tortoise-shell pattern. She grasps her robe as she strides forward. The areas circumscribed with circles are decorated with susuki grass, *hagi* (bush clover) and other autumn grasses and flowers. These motifs refer to the poetess of the *Genji-monogatari,* Murasaki Shikibu. Ko-Murasaki, the name which the courtesan depicted here adopted, was a famous heroine of the *Ukiyo* world. Hishikawa, Moronobu[2] devoted a single volume of woodblock prints to her in 1677. Ko-Murasaki and her lover Gompachi appear in a love story of the 17th c.[3] Gompachi, a young *samurai,* kills a comrade in an argument. Held captive in a house of bandits, where Ko-Murasaki is also held prisoner, he fights against these robbers. He travels to Edo. After a while, he meets Ko-Murasaki again, who has meanwhile sold herself to a brothel in order to pay her parents' debts. With robbery and murder, he tries to amass the money needed to buy Ko-Murasaki's freedom. In the end he is captured and put to death. Ko-Murasaki commits suicide on his grave.

[1] The courtesan Ko-Murasaki is also illustrated in the above-mentioned work by Masanobu, but with another pose, while composing her poetry. See R. Vergez in: *Ukiyo-e Art,* no. 42, 1974, pl. 1.
[2] Yoshida, I, p. 377.
[3] KHT, I, p. 223.

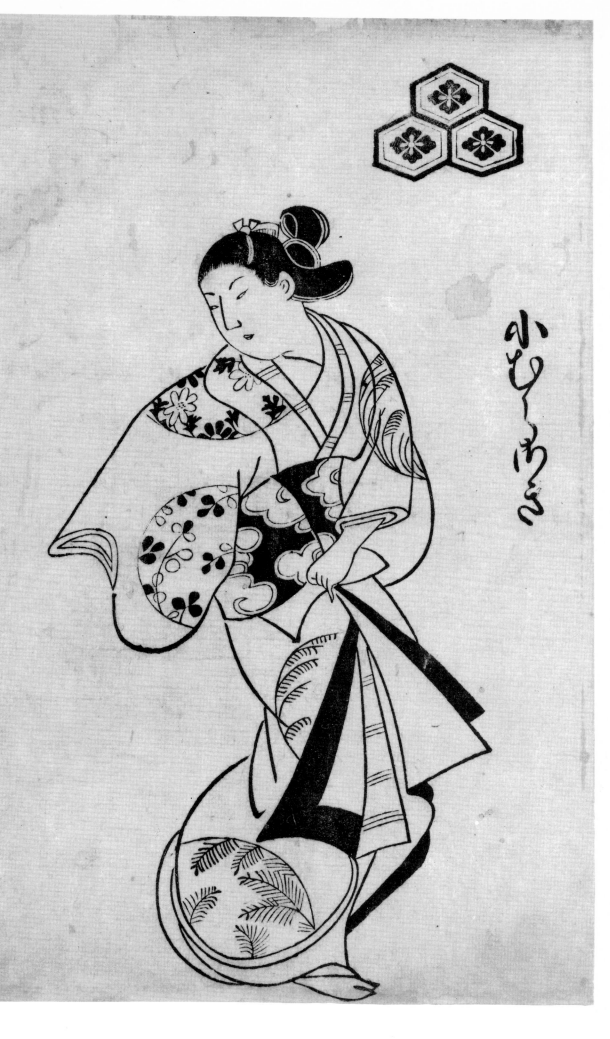

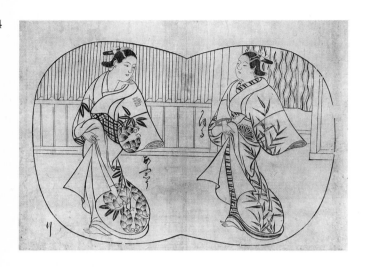

ÔMORI, YOSHIKIYO
(active ca. 1702–1716 in Kyôto)

DOUBLE SHEET FROM THE *SHIDARE YANAGI*
(Weeping Willow)

Album with 23 pictures from the life of the courtesans of the Yanagi-ya House in the Shimabara city quarter in Kyôto

Publisher: Kanaya Heiemon, Kyôto

Ôban, yoko-e, 26 x 37 cm

Black-and-white (*sumizuri-e*)

Date: Genroku 15 (1702), page "*ri*" (probably the 9th illustration)

The courtesan Ôshû appears on the left side of a cartouche in the form of a fan (*uchiwa*). Her gown is decorated with ginger roots and leaves. Opposite stands Kaoru in a kimono with chrysanthemum and bamboo-leaf patterns.
The influence of Kiyonobu is easily identified in Yoshikiyo's style; Kiyonobu's depictions of courtesans in the *Keisei-ehon* of 1700 served Yoshikiyo as a model.
J.G.G.

Lane, (1962), p. 127: (1978), p. 56.
Jenkins, (1971), p. 79, no. 99 (another leaf of the series)
in: *Ukiyo-e Art,* no. 36, 1972.
Yoshida, III, p. 416.
Reading of the names: E.K.

TORII, KIYONOBU I

THE COURTESAN TAKAO

Leaf two shows the courtesan Takao as depicted in the sixteenth illustration of the book. She is sitting with her head resting thoughtfully in her hands, leaning on an armrest. Sheets of paper with writing are lying on her raised knees, while an open writing case lies nearby. Her kimono is decorated with elements of a *Shintô* shrine (*torii* and the roof of a house), pine trees and an arched bridge. Takao's crest, a maple leaf, refers to the village Takao near Kyôto, which is still renowned today for its maple trees. A poem by this courtesan has survived, in which she addresses an unfaithful, vacillating lover thus:

And as for you,
you are like the cuckoo,
flying over the Komagata-dô.

Hiroshige still depicted this temple near the Azuma-bashi (bridge) in Tôkyô with a cuckoo flying over it (Series *Meishô Edo Hyakkei* ["Famous views of Edo"], publ. 1856–1859, Sheet No. 55).
The cuckoo (*hototogisu*) has inspired innumerable verses by Japanese poets since the Middle Ages. It is known not only as the bird heralding the coming of Spring, whose song coincides with rice-planting, but also as a symbol of unfaithful love. The cuckoo flies up and away and does not repeat its call again, just as unfaithful love passes once and for all. In the *Shidare yanagi* Takao is the model used for the courtesan Karahashi (double sheet "*ho*").

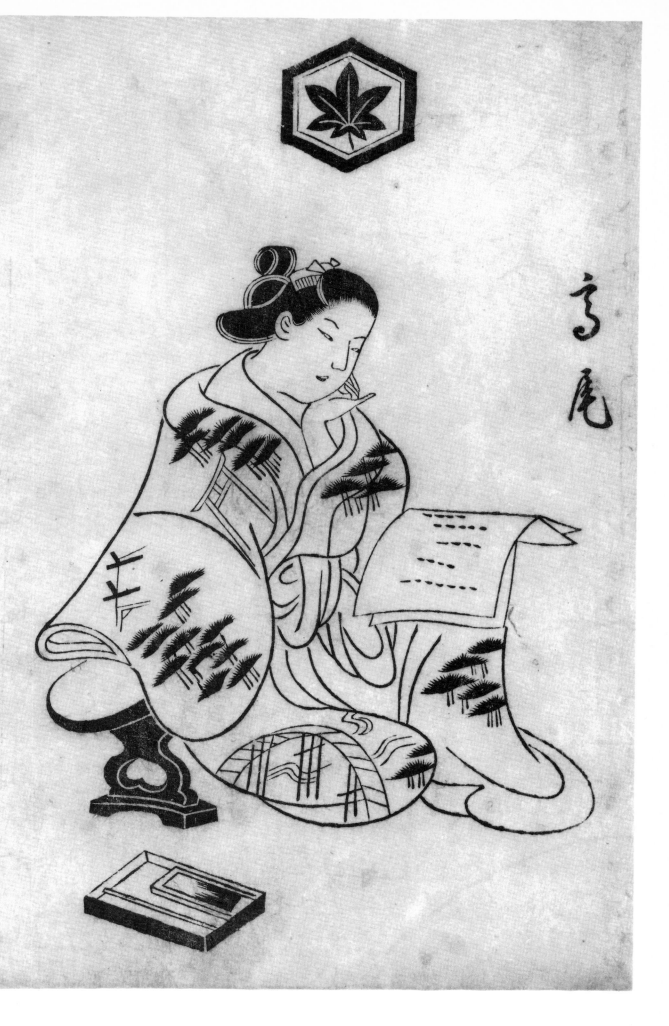

高尾

THE COURTESAN USUGUMO

The courtesan Usugumo ("veil of clouds") marches with energetic strides to the left. A small *kamuro* clutches at her loose sleeves, looking backwards. The impression of this movement is increased by the parallel stripes of the courtesan's kimono. Her crest, an ivy leaf (*tsuta*), appears in a circular *mon*.
The courtesan's name was most probably inspired by chapter 19 of the *Genji-monogatari*.

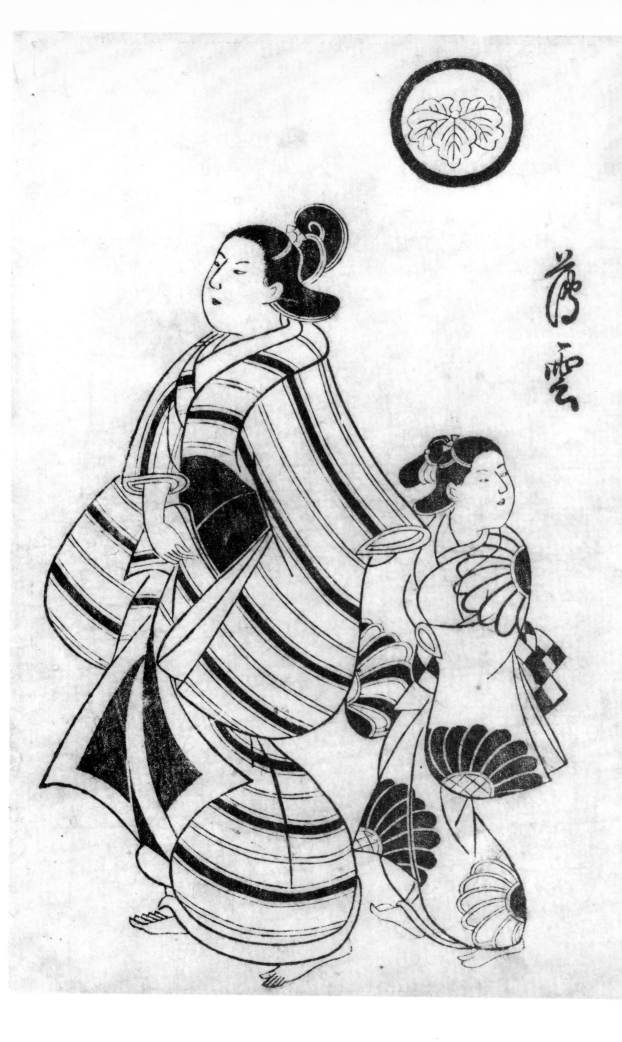

UNTITLED
TORII, KIYONOBU I'S CIRCLE

MITATE WITH THREE ACTORS

No publisher's mark

Tan-e

Hoso-e, 33 x 15.4 cm

Date: ca. 1710

Three actors are depicted in a diagonal arrangement, one above the other. Their names and roles are supplied beside them. A large pine tree occupies the upper right-hand part of the leaf. Below left, the characters are buried among slender blades of grass. At the centre stands (Ichimura), Takenojô, (Uzaemon VIII), theatre director of the Ichimura-za from 1703 on, and actor.[1] Taking the form of a youth, he rides on a hobby-horse (*take-uma,* "bamboo horse"). According to the accompanying inscription he is meant to portray the war hero *Asahina* from the legends about the Soga Brothers.[2] Katsuyama, Matagorô[3] as a youthful hero, described as *Tanenao,* with unshaven head, and Ikushima, Shingorô (Shinzô)[4] as *gejo* (maid) hold the hobby-horse by its thick reins. This leaf, of which only this one, exceptionally well-preserved print exists, satirically depicts three actors and their interrelationships.[5]

Even without the written identification of persons and roles, there would be no doubt that the leaf can be regarded as a travesty of the play *Jinriki Teika Azuma Asobi* ("The journey of the Divine Powers, Teika, to the east"), which was performed in the year 1710 (Hôei 7th year), in the 11th month at the Nakamura-za. The hero of this play is the court poet *Teika,* Fujiwara-no-Sadaie (1162–1241), the compiler of the anthology *Hyakunin Isshu* ("One Hundred Poems by One Hundred Poets").[6] An unsigned woodcut[7] in the Watanabe Collection, Tôkyô, shows a similar scene to that in our leaf from this play: the poet (played by Ikushima, Shingorô) on a horse, which is being led by means of thick ropes by Ichikawa, Danjûrô as *Ôe-samon* and Arashi, Kiyosaburô as the faithful female leader of the horse, *Naishinnô,* a "Princess of noble birth."[8] Another woodcut in Minnesota[9] shows the same scene. In the upper part of both leaves are scenic references to the places visited on the journey.[10]

The motif of a woman on a horse led on strong reins by two men is also to be found in another woodcut (previously Saitô Collection and Hiraki Collection, Riccar Museum, Tôkyô).[11] Arashi, Kiyosaburô plays the famous *Aoi-no-Ue,* the first wife of Prince Genji[12], Nakamura, Denkurô plays *Hyôgo-kerai Ansaemon* ("the vassal from Hyôgo") and Katsuyama, Matagorô the *Tokiwa Hyôgo-no-jô* ("the ever faithful helper from Hyôgo")[13]. His pose is repeated in reverse on our leaf.

A boy would hardly have been in a position to lead a theatre. Nonetheless, his choice of the name Takenojô, which he made as a ten-year-old in 1708, witnesses his self-confidence. Here he is shown, however, as a little boy on his bamboo horse in a debut dance for child actors (*kogata*).[14] The depiction of Takenojô without his family name, as the "*jô* of the bamboo" and as a "beginner" represented as a child, but bearing the name "*Asahina,*"[15] the great hero of theatre war plays, is certainly to be seen as a form of personal ridicule. The accompanying allusions to the courtly cavalier *Teika* and to the main person in the jealous drama *Aoi-no-Ue* underline the irony. Katsuyama, Matagorô as the hero *Tanenao* was in fact well past his youth, while Ikushima, Shingorô is not an *onnagata* actor[16], but rather plays as *Teika* himself – as for example in the above-mentioned woodcut in the Watanabe Collection. In our leaf he does not appear in a role costume but in the clothing of an *onnagata* actor off-stage, with a female hairstyle and *yarôbôshi* (scarf for the forehead), as well as a sword.

Interestingly, both actors no longer performed in the Ichimura-za theatre in the years around 1708–1710.[17] To all appearances, the artist of this woodcut intended by way of the dramaturgical device of *kakikae*[18] to make fun in this *mitate* of the little-regarded boy theatre director Takenojô, who was not taken seriously, and of his relationship to the two actors Matagorô and Shingorô, who also held him "on a lead."

Stylistically one can attribute the work to Torii, Kiyonobu I or to his immediate circle around the period 1708–1710.

1 Ichimura, Takenojô (Uzaemon VIII), from the Ichimura family. Since 1703 director of the Ichimura-za theatre following the death of his brother Takematsu II, 1703 (debut 1702). From 1737: Uzaemon (Barth [1972], p. 243) – his crest is the orange blossom (here half visible). See Yoshida, I, p. 54. Yoshida gives no date of birth. Barth, (1972), p. 243, footnote 649: 1698–1762. He acted from the age of four and called himself Takenojô from the age of ten. Takenojô excelled in the roles of youths and young women. Names of persons and role identification of the other two actors E.K. For the syllable *jô* in the actors' names, see p. 104, footnote 2.
2 Soga legends: see KHT, II, p. 325. Asahina is a famous strong hero who fearlessly visited even the lords of Hell.
3 Born probably in 1689, active 1707–1723. From 1707 *tachiyaku* (actor of male roles). See the leaf discussed above of the Saitô Coll. and Hiraki Coll.
 Tanenao, a hero of the Heike wars as elder, faithful brother hurried, although badly injured himself, to his younger brother *Shun'ei,* in order to be hanged in his place. Nô play, see Bohner (1959), p. 383 *(Shun'ei).*
 Just as *Asahina* is the strong, fearless hero of Japanese hero legends, so is *Tanenao* the self-sacrificing elder brother, faithful unto death.
4 Ikushima, Shingorô (1671–1743) came from Ôsaka, first played in 1689 at the Nakamura-za using the name Noda, Kuranojô, and then changed to Shingorô in 1697. Shinzô is made up of the first character of his later name and the first character of its earlier Sino-Japanese reading (*zô-kura* ["treasure"]). He was involved in the Enoshima scandal concerning a court lady of the *shôgun,* was exiled for twenty-eight years in 1714, and returned in 1742. His two crests appear on shoulders and other parts of the robe. Barth (1972), p. 225.
5 E.g., Kabuki-nempyô. Information from E.K. A Soga play from this time is not known.
6 See R.H. Brower (1978).
7 Illustration: *Ukiyo-e zenshû,* (1957), vol. 1, fig. 31; Jenkins (1971), cat. no. 55 (Kiyonobu I attrib.). Title of scene: *Semimaru wara-ya no toko* ("The bed in the straw hut of Semimaru")
8 The name of the woman leading the horse is given in the Minnesota woodcut as "*Nowake*" ("Strong wind").
 The name *Naishinnô* is reminiscent of the imperial princess *Shôkushi,* with whom *Teika* fell in love. See Nô play: *Teika.* Bohner, (1959), p. 366.
9 Ill.: Jenkins (1971), cat. no. 64 (previously Stoclet/Wakai/Gale [Colls.], today Minnesota Museum).
10 See Gunsaulus, (1955), p. 118.
11 Link, (1977), no. 108 (Hiraki Coll., Riccar Mus., Tôkyô) and previously Saitô Coll. Judging from the different impressions, there are two leaves. The latter: *Ukiyo-e zenshû* (1957), I, fig. 25. Declared as "an important cultural treasure." (See footnote 12.)
12 *Genji-monogatari,* chap. 9, Benl (1966), p. 263. A mistress of the Prince *Genji, Rokujô,* is insulted by the servant of *Aoi-no-Ue,* She changes herself into a jealous demon and kills *Aoi-no-Ue.* A famous Nô play; see Barth (1972), p. 102.
 The pine tree is part of the stage set of the Nô.
 On the Nô play, see Bohner, (1959), p. 375.
13 Hyôgo: old division into districts (Harima, Tajima, Awaji, parts of Settsu and Tamba prefectures; capital Kôbe).
14 The murder of the actor Ichikawa, Danjûrô I in 1704 in the Ichimura-za is an example. Takenojô IV, the first bearer of the name and co-founder of the Ichimura-za, had retired into monastic life (1654–1718). On the debut dance: Michener Coll., Honolulu, Link, (1980), p. 207.
15 On Asahina see footnote 2 above.
16 "Female role impersonator."
17 According to E.K.
18 *Kakikae* ("Transposition into another world").

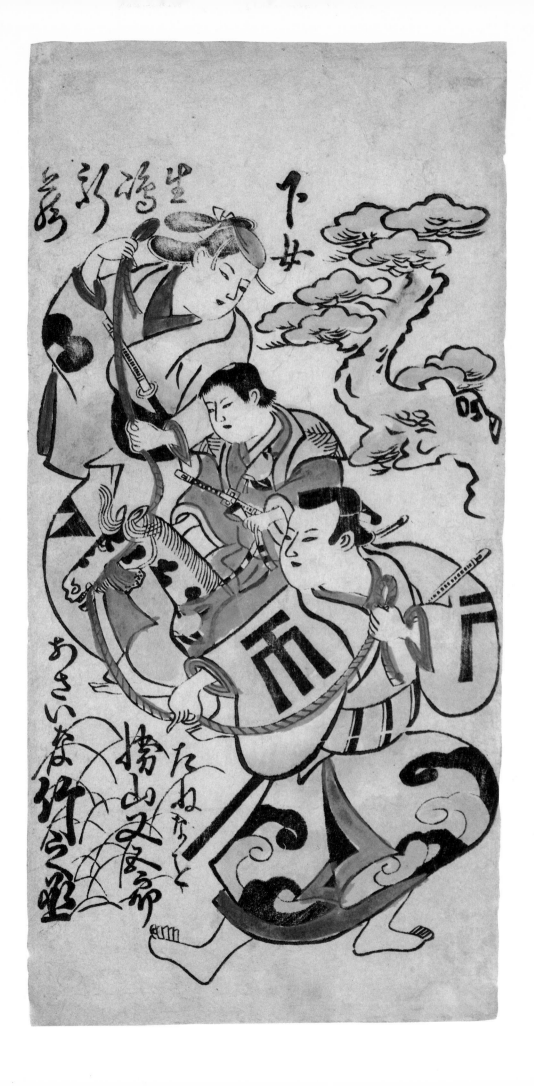

UNSIGNED

FAIRY TALE

Ôban, 25.5 x 38 cm.

Black-and-white (*sumizuri-e*)

Date: ca. 1690–95

40

The scene takes place in the middle of the night. The crescent of the moon illuminates a ghostly scene somewhere in the wilderness. Two young vixen are enjoying themselves, vivaciously playing around a fox trap, attracted by the rat hanging in it as bait. One of the two vixen jumps in a capriol, stretching her legs high in the air, and with a joyful expression on her little face turns her head to the moon. With a toothy grin, she seems to laugh loudly. The other one, sitting on her hind legs, seems to be disturbed in her play, and turns her head around as if irritated by some sudden, unexpected noise. In fact, we discover two men hiding themselves in a humble hut with a straw roof, close to a tree without leaves. Bamboo grows on the ground. The roof's support pillars are made of the raw trunks of trees, one of which has to be supported by another piece of wood so that it does not tumble down. The brushwood walls are bound together in thick bundles.

The two men seem to be of very different moods. The one spying through the "window" of brushwood bundles crouches on one leg, his right hand on his knee. With the other hand he closes his jacket, making a gesture as if shivering. His face is half covered by a scarf, but his fearfully pressed lips, beard, and eyes, opened wide in a terrified expression, are shown nevertheless. He appears to be exposed to a deadly and fearful danger, in every sense of the word. Equipped only with a stick, he seems to be a humble traveller or peasant. Another man, in similar dress but with a sword, kneels in an obviously comfortable position. He supports himself with one hand on the ground, while his head, slightly bowing to the right, rests in his other hand. With an assumed smile, he looks at his companion as if he had brought him out into the wilderness in order to purposefully frighten and make fun of him.

In China and Japan, the fox has always been an object of superstition. It was believed that vixen could transform themselves into beautiful young women in order to bring evil, or even death, to men. We do not know which one of the numerous fairy tales about foxes is illustrated here. But the print seems to be related to a group of five anonymous illustrations of fairy tales published by Sadao Kikuchi.[1]

All prints share the same size and stylistic elements. One of them portrays a quarrel between a man and a badger; another depicts the story of a fox disturbing a caravan of merchants. Some of them can be identified, like the story of the sparrow whose tongue was cut or the story of the peach boy (Momotarô).

The forms of the roofs of the huts are very similar to those found in the works of Hambei or Moronobu, and the tree without leaves can be recognized in other illustrations done by these artists in the later days of their careers. But unlike Moronobu, this unknown artist has not borrowed from contemporary painters of the Tosa School, although he might have borrowed from realistic representations of the Kanô School.

[1] S. Kikuchi, *A Treasury of Japanese Wood Block Prints Ukiyo-e,* New York 1969, nos. 26–29 (black and white illustrations). See also, anonymous, *Mibu kyôgen e-zukushi* ("A collection of pictures showing scenes played at the Mibu temple"), dated to early 17th c. and in The Donald and Mary Hyde Collection of Japanese Books and Manuscripts, sold for the benefit of the Pierpont Morgan Library, at Christie's, Oct.7, 1988, Lot 114.

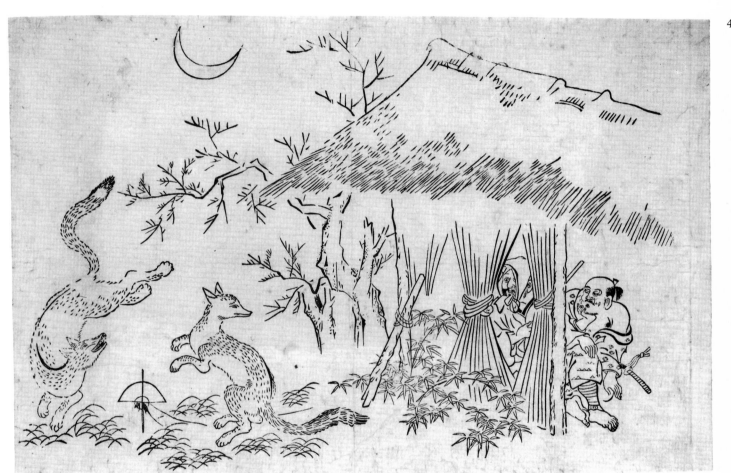

TORII, KIYOMASU I
(active ca. 1690–1720)

Almost nothing is known about Kiyomasu I's life. Yet compared with Kiyonobu I, his œuvre is more extensive and offers more variety. The high point of his work is represented by the large-format illustrations of courtesans, which enabled him to develop his originality to the greatest extent.

BIJIN-E

Signature: Torii, Kiyomasu, Seal

Publisher: Nakajima-ya

Kakemono-e, 55.8 x 31 cm

Sumizuri-e

Date: ca. 1715

The confusion of calligraphic brush strokes, which at first sight seems entirely erratic, is not in fact without order: but the underlying principles are other than those of a system of compositional rules. The ease with which writing and drawing, drawing and writing, flow into each other allows the imagination to assemble the picture into a whole. Here is a courtesan with her novice. A letter which the girl is reading aloud to her mistress – a thank-you letter for a message received – can be taken as the pivot of the remaining graphic events. The letter contains calligraphy which is legible – if with some difficulty. The same calligraphic movement within the rectangular page escapes over its borders, loses its sense as writing and proceeds to "describe" the figuration of the image of the woman, drawing on an apparently inexhaustible stock of wonderfully varied means of graphic expression. Lines, patterns and symbolic images, a head and a hand, a wheel and a book, all these elements are integrated into a work of art which combines brittleness of substance with richness of form, a product of the traditions of an ancient culture confident of its own strengths. When we immerse ourselves in the movements of the handwriting, we come into closer contact with the person and nature of one of the great masters of Japanese woodblock art, Torii, Kiyomasu I – nearer than we could possibly expect, considering the very limited nature of the historical records, the passage of time, the topographical remoteness and a foreignness which is almost beyond our reach.
No other impression of this woodblock has survived.

From the Kobayashi and Werner Schindler Collections.
J.G.G.

Reproduced:
Ukiyo-e-shûka, (1981), vol. 14, pl. 28, p. 64:
Kondo/Suzuki, (1985), pl. 1, p. 17; Gianadda/Gard/Tikotin/Kondo, (1982), no. 78.

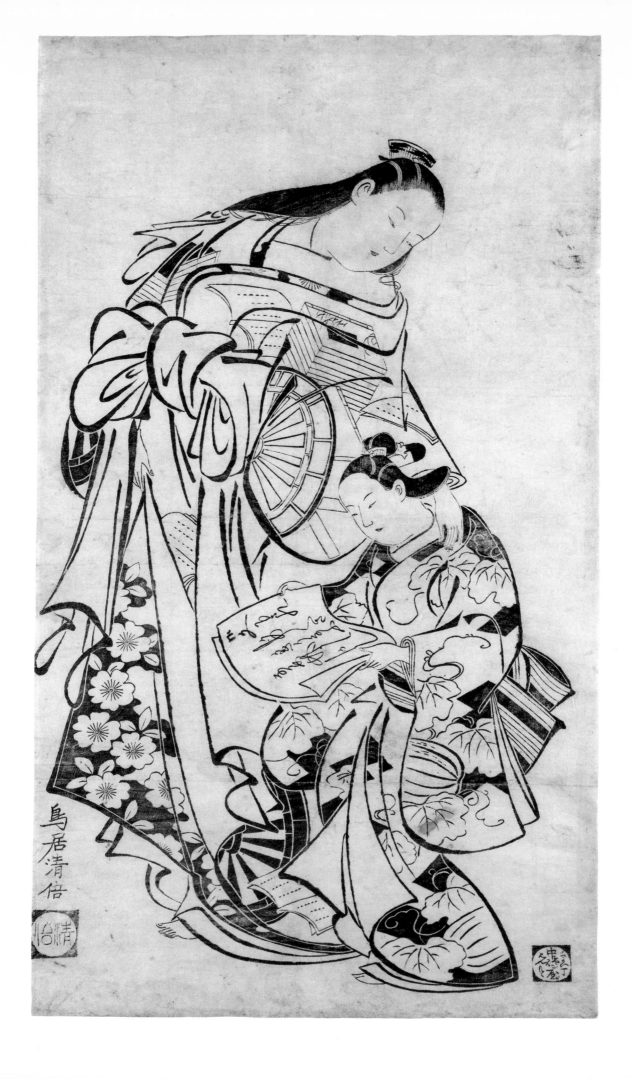

TORII, KIYOMASU I
(active ca. 1697–1720)

COURTESAN (*OIRAN*) WITH MAID (*KAMURO*)

Signature: Torii, Kiyomasu

Seal: Kiyomasu

No publisher's mark

Kakemono-e, 70 x 30 cm

Black-and-white (*sumizuri-e*), hand-coloured

Date: 1710–1715

A courtesan is taking a walk with her maid through the winter snow. Just a few brush marks at the feet of the two women and on the umbrella serve to suggest the snow-covered scenery. Similarly, wintery landscape reappears in the heavy kimono of the *oiran* with its large, snow-laden pine trees, creating a second, artificial landscape which is more prominent than the scenery indicated in the background. The contained power of the *oiran* with her plump face, contrasts with the lightness, grace and trustfulness to be seen in the profile of the youthful maid, who offers the *oiran* the umbrella she is holding with both hands. The inclination of the two faces towards each other directs our attention to the slender hand of the *oiran* who grasps the umbrella. The maid's jacket displays moons, probably empty crest circles, while artfully folded love letters float along the border. Above the border of her kimono, large plum blossoms lie on the crossed planks of a bridge.[1] Pine and plum trees are winter's faithful companions and are symbols of constancy and friendship. They also stand for the ever-present vitality of nature, which slowly comes to life in the first months of the year even in the numb rigors of the winter cold. Snow, moons and blossoms (*setsu-gekka*) stand for a motif which refers to a poem by the Chinese poet Bo Juyi (722–866?), who was already very popular in the Heian Period.[2]

In this large format leaf, Kiyomasu emphasizes different brush-strokes which, according to East Asian principles, should be employed when painting different materials or themes. The robes of each woman are painted in strong, waxing and waning lines, bows and curves, which attempt to imitate the folds of sumptuous silk. They underline the powerful corpulence, particularly of the *oiran*. Finer, more sensitive, but nonetheless structured lines are used by the artist for faces and hands. Absolutely even lines are used to depict the soft snow and the umbrella as geometric shapes. Within the closed composition, additional accents are given by way of just a few black areas – the hair of the two women in the upper part – and the wrap-around cloak of the *oiran*, as well as the crossed planks on the *kamuro*'s robe, in the lower part. A better preserved impression of this woodblock is in the possession of the Ainsworth Collection, Allen Memorial Museum, Oberlin College, Ohio. Our copy probably comes from the Yamamoto Collection, Tôkyô.[3]

[1] KHT, I, p. 362, II, p. 254.
[2] Schmidt, (1971), no. 45.
[3] Keyes, (1984), no. 6.

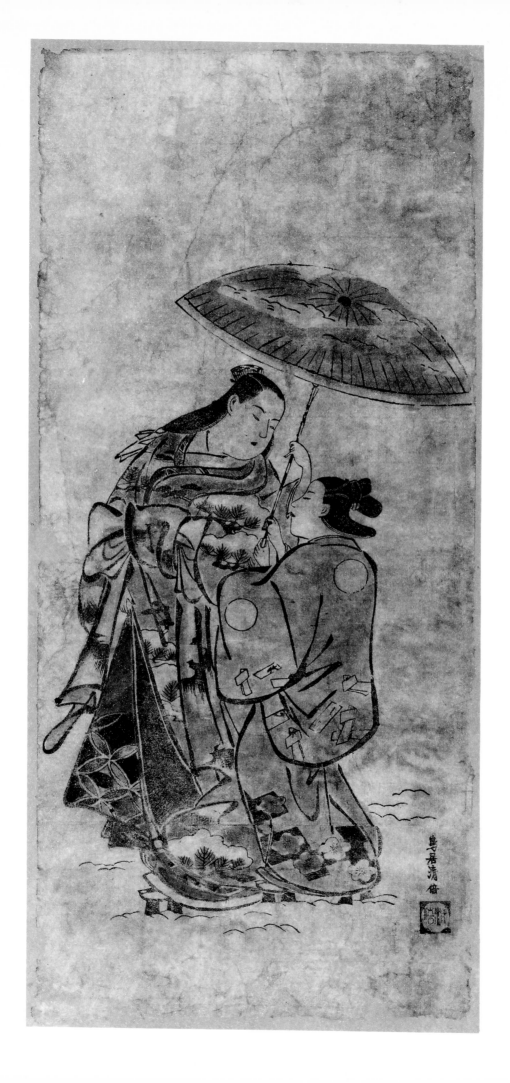

UNSIGNED

SERVANT CARRYING A SPEAR *(YARIMOCHI-YAKKO)*

Ôtsu-e

Paper, watercolour

32.5 x 23.8 cm

Date: ca. 1685

A bald man walks on the empty paper ground. Although barefoot, he is dressed in a black jacket and orange coloured trousers with black leggings. Two long swords are in his girdle. The square yellow and green crest is in the form of rice measures that stack into each other *(mimasu)*, showing he is the retainer of a famous lord. Balancing a long spear in his right hand, the man looks up with a comical expression, his face resembling a *Kyôgen* mask of the *Kentoku* type. The brushwork reveals the rapid, broad brushstrokes, characteristic of this popular category of painting.

This painting belongs to a popular tradition of paintings identified as the *Ôtsu-e* (paintings from Ôtsu). This art form may have begun before 1650[1] although the earliest mention of an *Ôtsu-e* painting occurs in 1661 on the occasion of an amateur *renga* (linked verse) party, where a painting of Tenjin, the patron of literature and poetry (see p. 74), was hung. At the beginning of the tradition, mostly Buddhist and *Shintô* subjects were depicted, showing the evolution of *Ôtsu-e* from prints produced in temples for pious pilgrims. In fact, the earliest known *Ôtsu-e* shows a frontal Amida made with the same kind of stencil used since the Tenshô era (1573–91) in the Nishi Hongan-ji.

Ôtsu-e paintings seem to have been produced in the area of the modern city of Ôtsu and villages of Oiwake and Ôtani, an area that was famous for pilgrimages. In addition, it was the final station on the highway before the old capital of Kyôto and, thus, the last place to buy an *o-miyage* (gift) for the loved ones at home or the friends at work.

Around the beginning of the 18th century, approximately three hundred different motifs were produced. When Ôtsu area artisans invented an instant, ready-to-hang, painted mounting complete with bamboo rollers, they outshone the Buddhist temples which later adopted the same method. This first religious painting done by the common people themselves appealed to men of letters of the epoch because of its freshness and spontaneity.

The theme of *yarimochi-yakko* is related to the numerous processions of *daimyô* on the highways running back and forth from the capital. For the common people these processions were a continuous nuisance. Each time a procession passed, they had to leave their places of business and prostrate themselves on the street. The arrogant, stupid *yarimochi-yakko* became a favorite laughingstock among the populace. Representations of *yarimochi-yakko* came into fashion with the Jôkyô era (1684–88); our example belongs to this early period. Portrayals of these processions became a favorite theme not only for *Ôtsu-e* artists, but also, in a more stylized manner, for *Ukiyo-e* artists from the time of Moronobu (see p. 5) until the period of Utamaro.[2]

46

[1] Hauge, V. and T., *Folk Traditions in Japanese Art,* (1978/79), Cleveland, New York, San Francisco, pp. 18, 230.
[2] TNM II, no. 2046, 2047, from "Souvenirs of Ôtsu, Buyable in Edo".

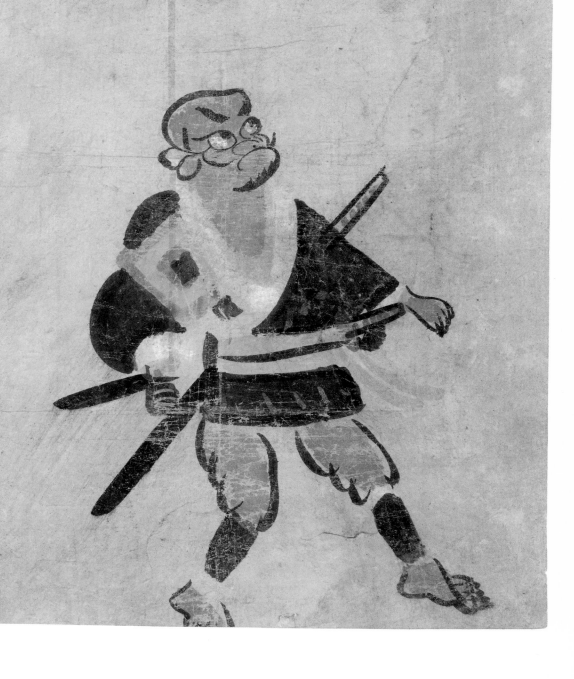

48 *EMA* (VOTIVE PICTURE)
IN THE STYLE OF THE TORII SCHOOL

TWO HEROES FIGHTING

Paint on wood

50 x 61.5 cm

Date: 1719 (Kyôhô 4th year)

Ema[1] are wooden votive pictures. They were mostly made by painter-craftsmen for private customers in various traditional styles of painting. Accompanied by fervent wishes, as an offering, the *ema* were hung in *Shintô* shrines and Buddhist temples. It was inevitable that *Ukiyo-e* would become the dominant painting style, considering that such petitions were concerned with the conditions of contemporary, bourgeois life. Thus, famous woodblock masters also painted such ex-voto. Thematically, they retained their repertoire of motifs.

The artistic style of the period is unmistakable, as in this *ema* dated 1719. It depicts a well-known event from the civil war of the 12th c. *Taira-no-Kagekiyo* tears off *Minamoto-Mio-no-Yashirô-Kunitoshi*'s *shikoro* (armour protecting the neck) in the battle of Yashima (1185), after *Kunitoshi*'s sword has broken.[2] The scene is known as *shikoro-biki*. The feuding of the *Taira (Hei)* and *Minamoto (Gen)* clans, a historical event, took place in the years from 1160–1185. The war ended with the victory of the Minamoto. The culture of the court in the Heian Period was largely destroyed and a new social stratum, that of the warriors, determined the course of events in the land. No longer emperors, but military rulers governed the land as *shôgun*. The emperor merely fulfilled cult functions.

The *Heike-monogatari* describes the battle of the two clans with much legendary embellishment.[3] Not all the personages can be proved to have existed historically. The comprehensive version with the title *Gempei seisui-ki*[4] provided the basis for a Kabuki play which was performed at the Morita-za in Edo in 1711.

The popular rough style of acting of *aragoto*,[5] with its expansive movements and dramatic gestures, found corresponding expression in the painting style of the early *Torii* masters. This *ema* also demonstrates the typical stylistic means of this school and depicts the dramatic climax of the battle. The inscriptions indicate that the *ema* was piously dedicated to the shrine by Nakamura, Hisaemon.[6]
J.G.G./G.A.

[1] *Ema* were ex-voto, which originally merely showed representations of horses (as a substitute for the real horse offerings in *Shintô*). Later, all kinds of animals, objects, or events were depicted. The ex-votos of the Itsukushima shrines are famous. KHT, I, p. 158.
[2] Joly, (1968³), p. 243.
[3] The *Heike-monogatari* was written towards the end of the 12th c.
[4] "Report on the Rise and Fall of the Gen and Hei." In addition to this well-known text there are a number of other novels with this theme.
[5] *Aragoto*; see glossary.
[6] The Nakamura were actors and theatre proprietors in Edo. The Nakamura-za theatre existed from 1624–1841. Barth, (1972), p. 209.

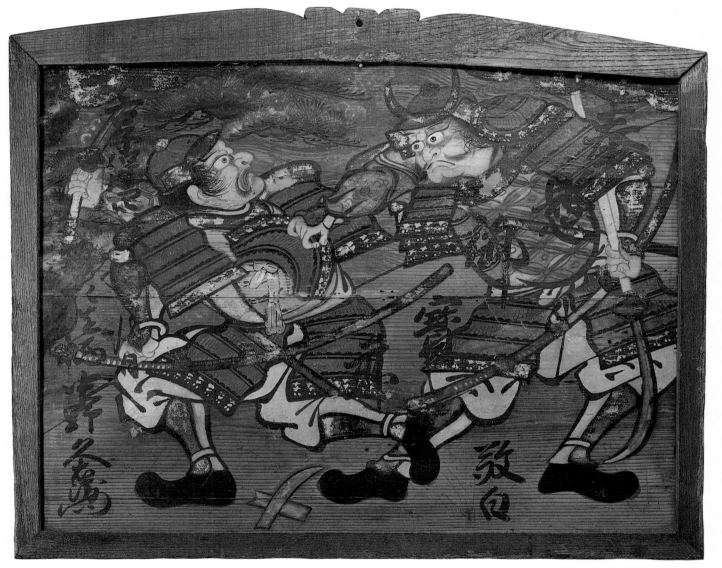

50 UNSIGNED

A STREET IN YOSHIWARA

Black-and-white (*sumizuri-e*) with rich hand-colouring

Unsigned album leaf

Ôban, yoko-e, 26.1 x 36.3 cm

Date: ca. 1710

We are witnesses to a scene typical of the side streets of Yoshiwara, the pleasure district of Edo, a situation which resembles a part of the course of events depicted in magnified form on a large sheet by Moronobu (p. 15). Although thirty years have passed since the first version of this leaf was produced, the habits in this quarter do not seem to have changed very much, except for the hairstyles of the courtesans.

The little *kamuro* is the only figure in motion. She has been sent by the *oiran,* who stands patiently waiting, with a message to the *samurai.* Motionless, he hides his face under a large straw hat, hoping to avoid being recognized by anyone, for it was strictly forbidden for any *samurai* to enter the pleasure district. The servant kneels on the floor indifferently, much like his predecessor of thirty years earlier in Moronobu's woodblock print. The whole scene is permeated by a smell of tobacco, the "plant of happiness in love" (*koi no inochigusa*), emanating from a tobacco boutique "Oiso-ya." From the shop's sign we learn that the tobacco obtainable here comes from the most remote provinces and the most famous places (*shokoku meisho tabako*). The trader cuts tobacco leaves next to a whetstone.

The leaf has been attributed to Kiyonobu I for as long as it has been known. But around 1710 the black-and-white leaves by Kiyonobu I and by the young Masanobu were often indistinguishable from one another, so that the latter could also have been the author of this leaf. The colouring of such album leaves in the period around 1710 was undertaken by dilettantes with varying success, according to their artistic talent. Here, an attempt was apparently made to make the woodblock print approximate a painting as nearly as possible. The page is the third from an album.

J.G.G.

E. Kondo: *L'art japonais dans les collections suisses*, Geneva, (1982), cat. 75 (ill.).

OKUMURA, MASANOBU
(ca. 1686 to 1764)

For more than half a century, Okumura, Masanobu was the most influential woodblock artist alongside the Torii Masters in the early period of this art. He was still practically a child when his extraordinary talent led to the publication of his first work *Keisei-ehon* in 1701, a catalogue of courtesans of Edo. Although this series of illustrations of women was still strongly influenced by Kiyonobu I, it is already possible to identify Masanobu's special quality: the ability to integrate figures and space into a harmonious composition. Book illustrations, picture albums and single woodblock prints then followed in quick succession. The great variety of themes and the broad scope of his graphic means show that he was an artist who was widely acquainted with classical art and literature. He is thought to owe his literary erudition to the *Ukiyo* poet and novelist Fukaku (recorded 1687–1692, Yoshida, III, p. 159).

Not satisfied with perfecting his artistic abilities, Masanobu also investigated a variety of technical possibilities for the realization of his ideas. Many innovations were based on his inventions. He succeeded in exploiting the possibilities of black-and-white printing in horizontal format to the full, often with a quite humorous touch. He himself claimed to be the inventor of *hashira-e,* the long narrow pictures on pillars. He tried to imitate European perspective. Lastly, he also participated in the beginnings of the development of multi-coloured printing. His concern for preserving his independence and for preventing his pictorial ideas from being stolen, led him to found his own publishing house in 1723, Okumura-ya, and create his own stamp of authenticity.
J.G.G.

A LEAF FROM THE WORK: *GENROKU TAYÛ AWASE KAGAMI*
("A courtesan of the Genroku Era in facing mirrors")

Publisher: Kurihara Chôemon Hasegawa-chô

26.3 x 17.2 cm (mounted: 30 x 19.8 cm)

Oribon, Colophon: last side

One volume, 16 facing illustrations

Black-and-white (*sumizuri-e*), hand-coloured

Date: Genroku 14th year (1701)

(Signed last side: Yamatogakô Okumura Gempachi Masanobu zu)
This rare album was influenced by the *Keisei-ehon* of Torii, Kiyonobu I. Masanobu was probably only fifteen years old at the time. Two copies have survived. This leaf comes from the Vever Collection and originally was part of the complete copy in the Drukker Collection. After auction at Sotheby's (1974), it was divided up and sold as individual leaves.

The courtesan Au-saka ("Passway of the meeting") sits on the floor dressing her hair, and attaches a carnation-shaped hairpin with a graceful gesture. Her kimono is decorated with large calabashes. For this courtesan, Masanobu chose Masatsune as his model from Kiyonobu's *Keisei-ehon* (see p. 32). There, however, she is seated on a small bench. In Yoshikiyo's *Shidare yanagi* the courtesan Sangô is shown in the same pose – namely, sitting on a bench. Masanobu's omission of the bench causes the girl to appear as if floating in space, this, however, clearly works to the advantage of the visual effect. Her *mon* appears in the upper right.
Provenance: Vever Collection, (I,11).

Jenkins, (1971), p. 62, no. 24;
Link, (1977), p. 36, no. 27: (Colophon), p. 89.
Jenkins, in *Ukiyo-e Art,* 1972, no. 36, ill. 3.
(Further example of Masatsune: Jenkins, (1971), no. 52, p. 56.)

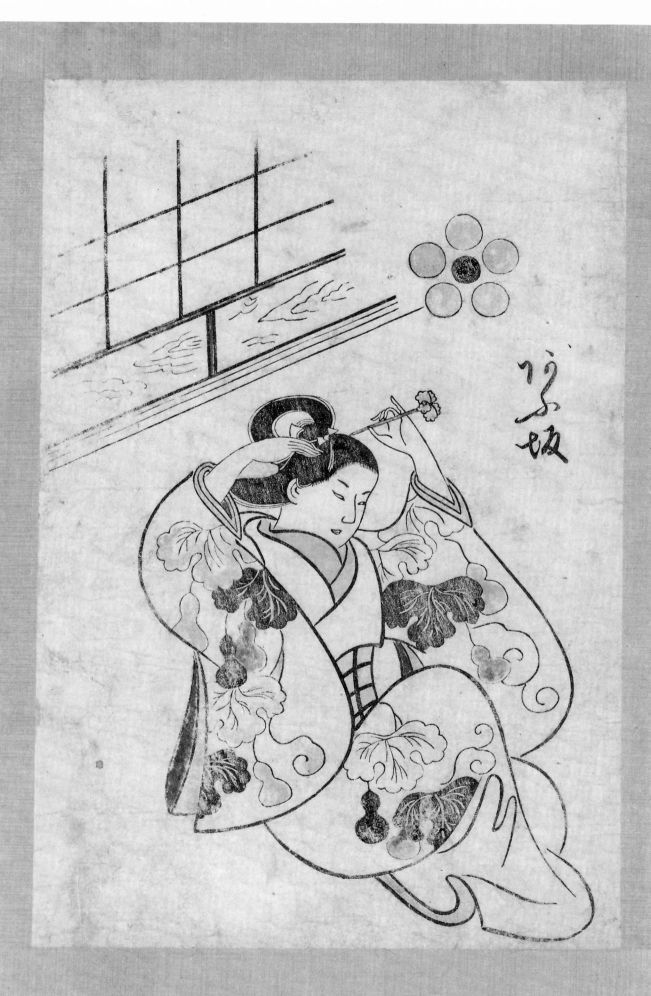

OKUMURA, MASANOBU
(1686?–1764)

A LEAF FROM THE WORK: *GENROKU TAYÛ AWASE KAGAMI*

26 x 17 cm (mounted: 30 x 19.8 cm)

Black-and-white (*sumizuri-e*), hand-coloured

Date: 1701

(further details see p. 52)

The courtesan Teika is leaning against a bench holding a long pipe in her left hand. Next to her there is a round lacquered tray containing various utensils. Her kimono displays blossoms and leaves in snow-crystal shaped patches, while her *obi* is decorated with fan ornamentation. Masanobu created the figure of Teika from three different courtesans in Torii, Kiyonobu I's *Keisei-ehon* (see p. 32).

The way she holds her head and the position of the sleeves correspond to the courtesan at the end of the colophon.[1] The lower part of the kimono is similar to that of the courtesan Hatsugoe,[2] while the pipe and tray are taken from the illustrations of the Hanamurasaki.[3]
Like Yoshikiyo in *Shidare yanagi*, Masanobu has also supplemented the isolated figures depicted in empty space by surrounding them with some details of interior architecture.
Provenance: Vever Collection.

[1] Link, (1977), p. 14, fig. 1.
[2] Jenkins, in *Ukiyo-e Art,* 1972, no. 36, fig. 2.
[3] Jenkins, (1971), fig. 6.

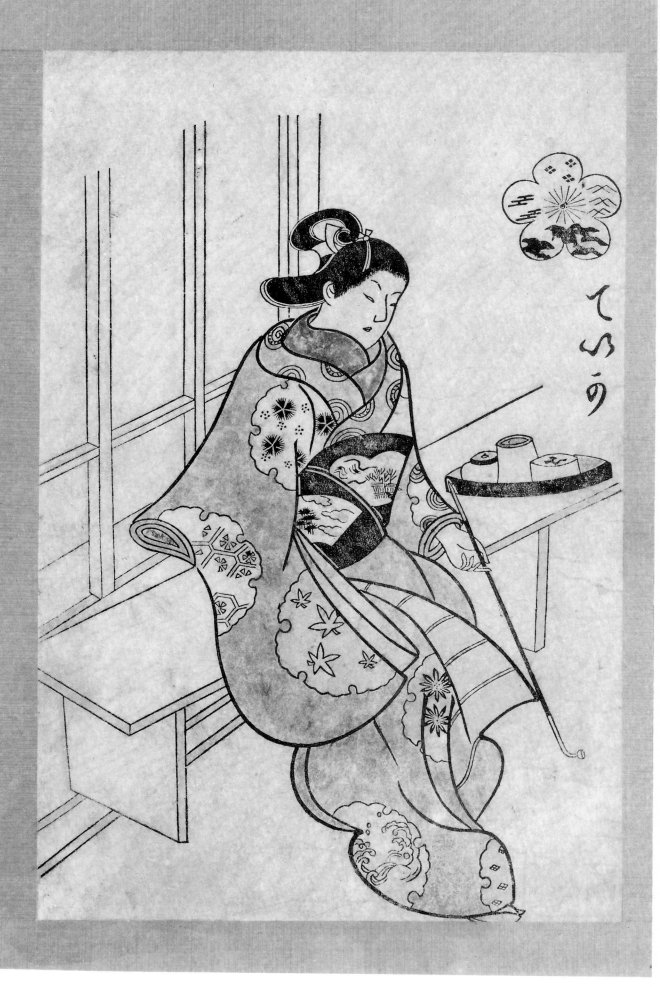

てらり

OKUMURA, MASANOBU
(1686–1764)

COURTESAN

Signature: Tobu Yamato eshi Okumura Masanobu zu

Seal: Masanobu

Publisher: Hishiya Mishima machi chô

Kakemono, 56 x 32 cm

Black-and-white (*sumizuri-e*)

Date: ca. 1715

From 1715 Masanobu clearly became ever more free of the influence of the Kaigetsudô School and the masters of the first Torii generation. Their depictions of statuesque, mature women had dominated Japanese woodblock art in the first decade of the 18th c. In fact, right up to the turn of the 19th c. this almost architectural severity was considered the appropriate manner in which to portray the well-paid, seemingly unapproachable courtesans who were the target of all male longings in Japanese middle-class society during the Tokugawa period.

The leaf is in many ways unusual for its time. This applies particularly to the composition, which is based, formally speaking, on two lines of movement which cut across each other diagonally where the body of the young *oiran* and the trunk of the willow tree intersect. The diagonal created by the tree trunk is extended beyond the figure of the *oiran* by the lines of her obi. In the other direction, the upper margin of the calligraphy forms a bridge linking the trunk to the crown of the tree which, above the figure of the *oiran*, surrounds her head like a garland as she looks back. Thus, the impression is created of an interweaving of human figure and nature which could hardly be more removed from the traditional, statuesque monumentality of the old school.

The girl is young and maintains a sorrowful pose – which, however, also seems a little mannered. Between her teeth she holds a love letter by the corner, and rolls it out with her hand.[1]

The lines of the three groups of words are arranged at an angle from upper left to lower right instead of vertically. The middle group is clearly written in bolder characters (and therefore printed in capitals in the translation).

somosomo		*chitochito*
mijika	KONO ATARI WA	*kuken*
yo	MONOSAMISHIKI	*to*
no	TOKORO	*kanji*
monousa	NITE	*mairase sôrô*
ude	SHIKA NO	
itodo	KOE	
kimi no	KIKU	
koishiku	TOKI WA	
mo nashi	OMOIMAIRASE SÔRÔ	

Alas –	I AM	These are
in the short summer night	AT THAT MOST LONELY	only a few,
my arm has lost	OF ALL PLACES.	a very few,
all feeling.	ONCE UPON A TIME	of the hellish tortures
	WE HEARD TOGETHER AT THIS PLACE	I endure.
However much I long for you,	THE PASSIONATE CRY OF THE STAG –	
there is no reply.	SO THINK OF ME, TOO, I BESEECH YOU.	

The kimono is decorated with autumnal grasses and dewdrops. Stirrups (*abumi*) are dispersed in the grasses. Everything serves to indicate that it is autumn and that the young courtesan and her absent lover are lamenting the passing of summer.

The bunch of chrysanthemums in the bamboo case could represent the chrysanthemum crest of herself, or of the brothel where she was working. This detail is not integrated into the composition as a whole and is not stylized.

J.G.G.

[1] The approximate translation of the characters and text would not have been possible without the help of Martina Schönbein and Bernd Jesse, both members of the Department of Japanese Studies at the Johann-Wolfgang-Goethe University, Frankfurt am Main.

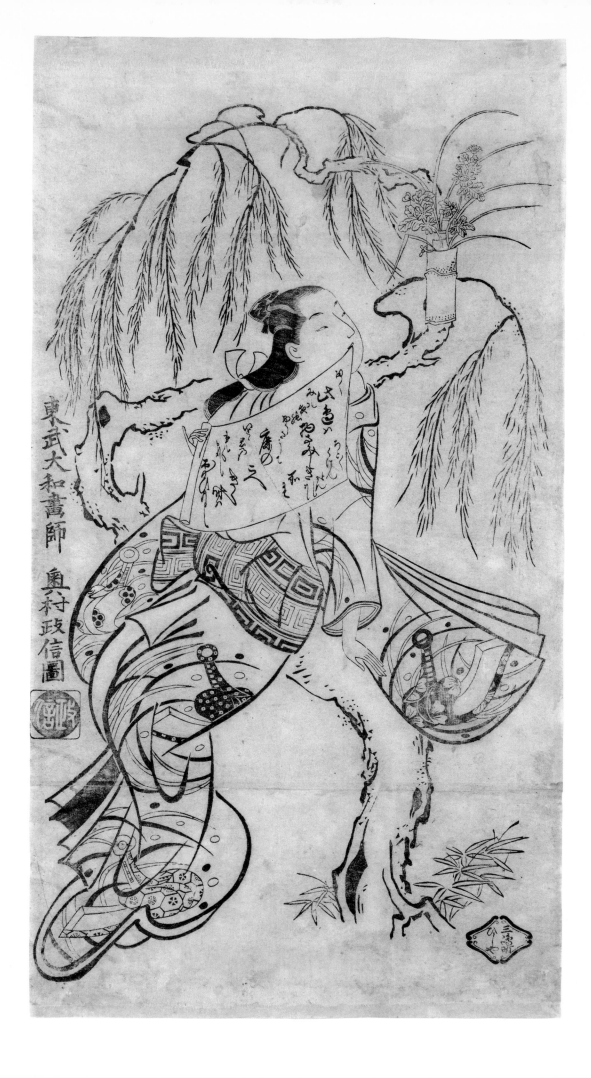

OKUMURA, MASANOBU
(attributed)

TRAVESTY OF THE *YOSHIDA KAIDÔ*

No signature

No publisher's mark

Ôban, 27.3 x 38 cm

Sumizuri-e

Date: ca. 1705

In front of a house situated by a winding watercourse, a young couple are walking on high, black-painted *geta*. [1] The young man with unshaven head (*tategami* – standing hair) is thoughtfully holding an open umbrella over his graceful companion. He has casually slung a checked *haori* over his dark-lined kimono decorated with sparrows. One hand is tucked away under his sleeve. A sword is fastened in his belt. On his sleeve the *mon* of the actor Matsumoto, Kôshiro I can be identified. His companion, a person in elegant, feminine attire with long swaying sleeves turns towards him while walking, with a somewhat condescending expression, both hands hidden under broad kimono sleeves. Wavy lines with inserted four-petaled ornaments are the only form of decoration on the robe. On the shoulders, the *mon* of the *onnagata* actor Ogino, Sawanojô can be seen,[2] a *kiri* leaf with blossoms. The person attired in woman's clothing, with a highly fashionable hairstyle, is revealed on closer inspection to be a young man. The bald shaved patch on his head, a sign of his masculine maturity (*gempuku*), is half hidden under thick locks of hair. A sword is fastened in his obi.

In the first storey of the house three girls sit conversing or gazing out in boredom onto the street. The central figure bears on her kimono the *mon* of the eleventh chapter of the *Genji-monogatari, Hana-chiru-sato* ("The village of falling blossoms").[3] Next to the house there is a bronze water container in Chinese style with a wooden cover, a bamboo ladle on top of it, on a small ornamental rock.[4] Two slender nanten branches (bot. Nandina domestica) with their fruits grow next to this, as symbols of autumn.

In elegant handwriting, a poem renders the atmosphere thus:

Kao mitashi	Eager to see his face,
kasa furi yabure	I wished that
yoko shigure.	a shower of rain as strong
	as in late autumn
	would rip his umbrella.

The actor of the *wakashû* can be identified by his *mon* as Matsumoto, Kôshirô I (1674–1730), who was one of the most important *tachiyaku* of his time.[5] The *onnagata* Ogino, Sawanojô[6] (1656–1704) was one of the masters of his craft. From the eighties he appeared in Ôsaka, performed in Kyôto, then in Edo, where he often played opposite Danjûrô I. He was an exceptionally handsome man, his elocution was superb, and he was also a talented dancer. He especially excelled in love scenes (*nuregoto*). He was also famous for his interpretation of the roles in the Keisei world.[7] Just how "unique" (*zuiichi*) he appeared to his contemporaries in Japan can be seen from a critic's remark on his performance: "That would astonish even a god or Buddha." Another time it was said that "his way of moving could kill," or "his appearance cuts the life of others short." Sawanojô retired from the stage in 1698 and began trading in oil, but a year later he was acting again. After a guest appearance in Kyôto he played in Edo (Tôkyô) until his death.

The theme of the print under discussion here is the story of the young man *Kantô, Koroku* ("The small six from the Kantô area"), who is supposed to have been a ballad singer from West Japan. He lived in Akasaka in Edo and performed his *ko-uta* (folk songs) there. According to others he was a *jôruri* singer. His unusual beauty seems to have made a special impression on his contemporaries of the Keichô Era (1596–1615).[8]

A woodblock print dated ca. 1680 and attributed to either Sugimura, Jihei (see p. 22) or Hishikawa, Morofusa (p. 12) shows the scenery and the persona of our print with accompanying role identification.[9] The handsome youth is given the name *Kantô, Koroku;* his companion is named as *Ukiyo-no-suke* ("The helper of the floating world"). In our version only two girls instead of the three are depicted, of whom one bears the name *Miyako-no-Okuni*. [10] In a cartouche the title of the scene also appears: *Yoshida Kukai-dô* ("The way of bitter experiences to Yoshida").[11] The scene, which is similar to that in our picture, is set in front of a brothel on the thirty-fifth station of the Tôkaidô, Yoshida, today called Toyohashimachi. The river flowing past the house in our version is the Toyohashi River.[12] *Koroku* is also the hero of a Kabuki-Kyôgen (comedy) towards the end of the 17th c. Torii, Kiyonobu I depicted the singer with Danjûrô I as early as 1698; in 1699 a play with the title "Kantô, Koroku and Brocade from an Old Village" (*Kantô, Koroku furui sato no nishiki*) was performed at the Murayama-za in Edo. In Kyôto the popular portrayer of lovers Nakamura, Shichisaburô interpreted the role of the handsome young man; but he first won public acclaim after his return to Edo to the Yamamura-za.[13]

In our view, the woodblock print under discussion here represents a travesty of the theme which we can attribute with some confidence to Masanobu. The leaf probably comes from an album of literary travesties; one such album, which has been preserved in the Buckingham Collection, Chicago, is remarkably similar both stylistically and thematically. The twelve leaves of this series entitled *Yamato Irotake* dating from 1705, illustrate various themes of classical Japanese literature in a parodying manner and are based on Kabuki and puppet theatre plays (*jôruri*). Many famous actors of the time make an appearance, but they are not ascribed to identifiable roles and plays as was usual, but are randomly associated with characters from literature.[14]

The composition and the rhythm of the lines in our woodblock and in the leaves of this series are similar. As in the print discussed here, the curving lines of the clothing are of flowing gentleness. The straight, geometric lines of the architecture provide a strong contrast to these artistically flowing lines. The black areas provide rhythmic accents of musical charm. The proportions of the figures relative to their surroundings is also the same. The ornamentation on the clothes in our picture is also found on the robes of the *Irotake* series. The kimono of a man on page one is decorated with a finely drawn *Genji mon*. The sparse wave decoration of the kimono of *Kantô, Koroku* is repeated on leaf three,

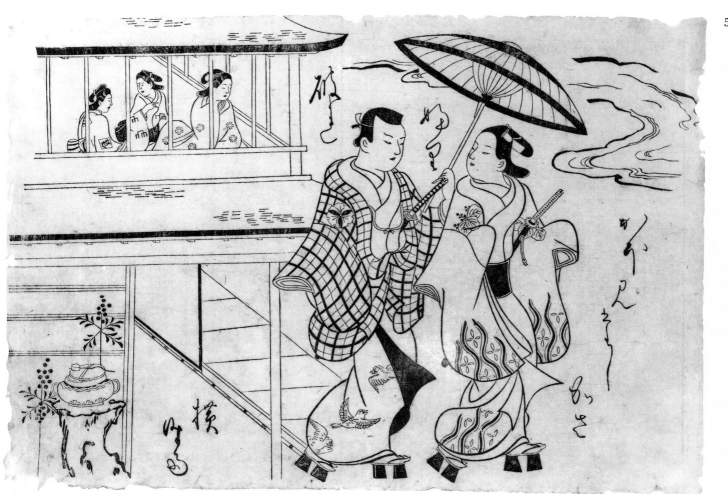

while the eye-catching checked pattern appears on the clothes of a comic dancer on page twelve. The *mon* of the *onnagata* actor can be identified on leaf ten as the *mon* of the famous *onnagata* performer Ogino, Sawanojô.

The artist evokes further associations by means of the poem. The topos of the young woman, who is protected by her partner with an umbrella, is known from literature as *ama-goi Komachi* ("The poetess Komachi praying for rain"). In the year 866 *Komachi* succeeded in calling forth rainfall after a long period of drought, by reciting a poem in a loud voice. It is to this that the poem used in the woodblock print refers.[15]

Since the *onnagata* actor in our woodblock print fails to appear in the costume of a particular role, but instead as a handsome youth in woman's clothing, this may reveal a possible relationship between the two actors.
A further print is to be found in the Pins. Collection, Tel Aviv, (1980), no. 66.

[1] *Geta* are sandals made of wood.
[2] About 1700 several actors used kiri leaves and blossoms in various forms. We suspect that here the actor Ogino, Sawanojô is to be seen. See also below.
[3] Benl, (1966), pp. 358–362.
[4] An identical water container also appears on the last side of an album by Masanobu with *Ukiyo-e* travesties for the *Genji-monogatari* (ca. 1710), Gunsaulus, (1955), p. 130.
[5] Matsumoto, Kôshirô; see Yoshida, III, p. 271.
[6] Ogino, Sawanojô cit. after Barth, (1972), pp. 226ff.
[7] *Keisei* ("Castle-conquerors") – Courtesan, see p. 32.
[8] Biography after Yoshida, III, p. 417; Schmidt, (1971), p. 43; Gunsaulus, p. 15. Kantô, Koroku was also active in the formative phase of the Kabuki and puppet theatres. The significance of the boy and youth artist is thoroughly analyzed by Barth. Koroku was also the contemporary of Okuni, who is attributed with the invention of Kabuki. However, the Kantô area lies in NE Japan.
[9] Several impressions of the woodblock are known.
[10] It is tempting to equate Okuni with the Okuni mentioned in footnote 8.
[11] Written in *hiragana*.
[12] S. Schmidt asserts that it is the 34th station. In Lane, Yoshida is decribed as the 35th station.
[13] Yoshida, III, p. 417.
[14] *Yamato Irotake*. Gunsaulus notes that on the leaves the actors are not arranged as in the theatre illustrations, but at random; e.g., on the 11th leaf of the series Danjûrô I, who was murdered in 1704, appears.
[15] KHT, I, p. 445.

OKUMURA, MASANOBU
(1686?–1764)

TRAVELLING WOMAN BOOKSELLER

Signature: Okumura, Masanobu hitsu/seal: Okumura

Publisher: Okumura, Masanobu's own publishing house Tôri-shio-chô with the comment: "Since these pictures may possibly be copied, we provide them with a calabash seal."

Hoso-e, urushi-e, 30.4 x 15.2 cm

Date: 1730–1735

A woman trader in books, poetry slips and music scores offers her goods for sale. She carries a huge wooden box on her back. Strapped together on top of the box are: a case of books containing the *Genji-monogatari,* as well as a bundle of poem slips (*tanzaku*) and coloured paper. The four letters on the lower side of the wicker basket *waka-shinan* ("A guide to writing *waka* poetry"), and three titles of works from different schools indicate the aim of her business. In addition to poetry slips she also sells literature for instruction in *waka* poetry writing. In the 17th c. and 18th c. such travelling saleswomen were the chief purveyors of literary products on the streets. In her hands she holds a calligraphy book (*tehon*) and a brush. Her robe is decorated with hats filled with cherry blossoms. She stands against a completely empty background.

At least two unsigned copies of this woodblock are extant. One originally belonged to the Tony Strauss-Negbaur Collection and was discussed by Fritz Rumpf in the auction catalogue of the collection (1928).[1] He also mentioned the existence of an identical but later leaf signed by Masanobu. A further impression of this woodblock, also unsigned, is owned by the Tôkyô National Museum.[2] These two leaves exhibit a different colouring. The *uchikake,* which is let down, is decorated with large lettering, hidden in our leaf by the black colour of the *urushi.* The later version of the print, in which the hairstyle of the woman conforms to the fashion of 1740, is reproduced by Rumpf.

Great numbers of street tradesmen and tradeswomen enlivened the street scenes of Edo. They traded in innumerable wares such as flowers, fans, combs, and hair decoration ornaments, tooth powder, wigs, *fukusa* (textile gift wrappers), and even votive tablets and *Ukiyo-e* woodblock prints. Famous Kabuki actors liked to appear in such picturesque roles. In the woodblocks of early *Ukiyo-e* they seem to have been especially popular between 1720 and 1745.[3]

[1] F. Rumpf, *Die Sammlung Strauss Negbaur* (Collection), (1928), no. 65; *Orbis Pictus* (Carl Einstein), Berlin, vol. 16, ill. 18.
[2] *Ukiyo-e Zenshû* I, fig. 66 (owned by the Tôkyô Nat. Museum). Publ. also S. Kikuchi, *A Treasury of Jap. Wood Block Prints Ukiyo-e,* transl. Don Kenny, New York, (1969), fig. 117.
[3] The number of street traders in the records is so great that the theme would warrant a special study, also for socio-historical reasons. In the main literature cited in this catalogue they appear in the woodblock prints of various masters.

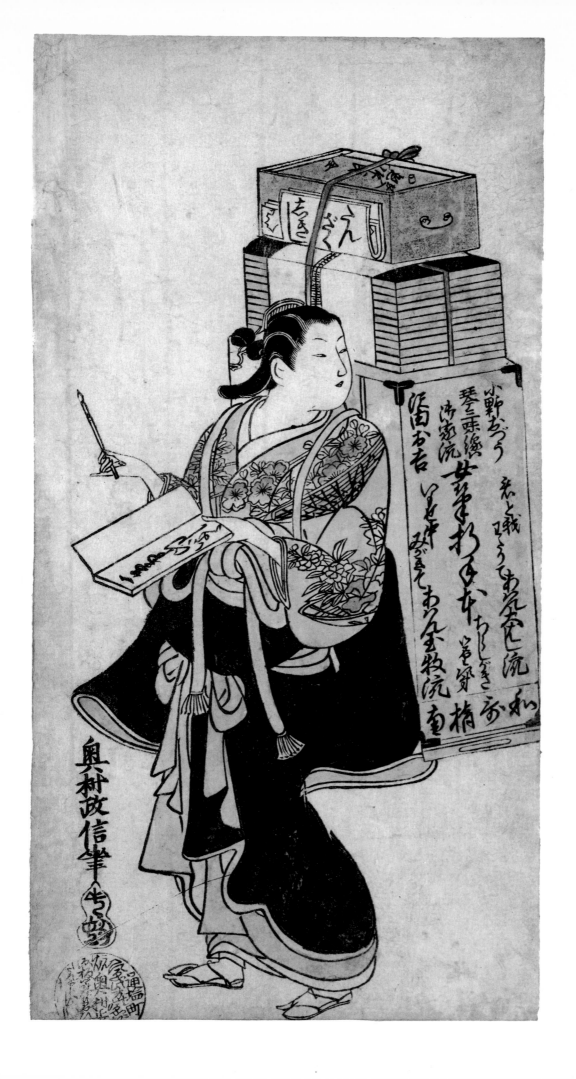

OKUMURA, MASANOBU
(Attributed)

SAIGYÔ SHIGURE-GASA
("Saigyô, the fine rain and the [two] *kasa*")

No signature

No publisher's mark

Ôban, yoko-e, 26.5 x 36.2 cm

Black-and-white (*sumizuri-e*), hand-coloured

Date: ca. 1710

The woodblock print is marked with the number "eight" as the eighth leaf of a set. Since only the last side of an album was normally signed, this leaf lacks identifying marks.[1] Bent over under the heavy weight of his pannier, the priest Saigyô (1118-1190) hurries through the light rain, indicated by fine parallel lines. The fluttering, black robe shows the holy man's haste. He has fastened his famous bamboo hat *(kasa)* to his pannier to create an umbrella *(kasa)*.[2] It is clear that the monk's predicament has come to the attention of a haughty courtesan, who waits for customers in the entrance to her abode with lowered gaze, apparently motionless. Quickly making up her mind, she sends a little maid *(kamuro)* after the holy man with her own umbrella *(kasa)*. Raising her left hand, the maid calls after Saigyô, in order to present him with the *oiran's* gift. The latter turns to the two women in surprise. The *oiran's* heavy bow causes her to lean backwards. Her kimono is decorated with black and white splayed banana leaves, a motif which seems to have been one of Masanobu's favourites.[3] The robe of the little *kamuro* is decorated with stirrups, blossoming twigs, and painted shells used for the shell-game.[4] The *mon* (crest) of the *oiran* on her shoulders is an *"e"* inside a circle. In fact, this is the first character of the word *eguchi* ("mouth of the river"). Eguchi was a settlement at the mouth of the Kanzaki river. In the Japanese Middle Ages it was one of the biggest domestic trade centres. This encouraged many courtesans to settle there. One of the most famous was Eguchi-no-Kimi, who is supposed to have used the personal name Tae. Saigyô begged her for "temporary lodgings" *(kari-no-yadori)* when surprised by rain, as recounted in the work attributed to him entitled *Senshûshô*. In consequence, the poetically gifted courtesan composed the following poem:

Yo wo itou	If one considers the people
hito toshi mireba	who avoid the world,
karino yado ni	one can only think of
kokoro tomuna to	not becoming attached
omou bakari zo	to temporary lodgings.

"Temporary lodgings" is to be understood as a metaphor for the transient world.[5]

The well-known *Nô* play *"Eguchi"* has the same subject.[6] In a dream the courtesan reveals herself to Saigyô as a manifestation of the *Bodhisattva Samantabhadra (Saigyô Fugen)*.[7] The joke of the print is disclosed by the characters in the cartouche. The text takes up a double-meaning of the word *kasa,* which when written with different characters can read "bamboo hat" or "umbrella."

Stylistically, the leaf resembles various prints by Masanobu from 1710-1715, which today are found in the Buckingham Collection, Chicago. A leaf from the series of *Ukiyo-e mitate* illustrations (ca. 1710) has as its theme the encounter between Saigyô and the courtesan.[8] Saigyô regards the girl, who sits in the boat accompanied by her *kamuro,* with the same devotion as the famous Mount Fuji (see title below:*Koi-no-kawa-fune Eguchi* ["Eguchi's river boat of love"]).[9] Another leaf by Masanobu depicts the priest standing in admiration in front of the courtesan, who is seated on an elephant. The title reads *Ukiyo Saigyô Eguchi-no-Sato ("Ukiyo* version of Saigyô in Eguchi village"). A boat, the river, which we also find in our print, and the huts of the village complete the scene (ca 1715).[10]

Saigyô-hôshi (1118-1119) was really called Satô, Norikiyo.[11] He was a member of the imperial bodyguard and enjoyed the favour of the Emperor Toba (reign: 1107-1123). At the young age of 22 (or 23), he abandoned his wife and children and entered holy orders. He adhered to *shingon*, the esoteric school of thought of Mahayâna Buddhism.[12] His various wanderings through North Japan are the subject of many legends. In addition to the encounter with the courtesan *Eguchi-no-Kimi* described here, the picture of the priest looking at Fuji is of importance in *Ukiyo-e*.
More than ninety poems by Saigyô have survived in the imperial anthology *Shin-Kokinshû,* which was compiled shortly after his death.

1 Although the series cartouche is similar to the cartouches on woodblock prints in the Buckingham Coll. mentioned below (see footnote 8), this leaf does not appear to belong to this series, which already includes a No. 8, but with another illustration.
2 Bamboo hat, pannier and walking stick are the invariable characteristics of Saigyô, in addition to the black costume of the wandering monks of the *shingon* sect.
3 See p. 64, see also Bohner, (1959), p. 301, *Nô* play *Bashô* (banana), in which it is stated that "the nature of the weak banana is fickle." It is not accidental that Masanobu loves the splayed banana leaf as the symbol of the transient beauty of prolific Nature, as decoration for *oiran* robes.
4 Shell-game (*kai-awase*). Each half of 360 shell halves is decorated with an identical picture from classical Japanese literature. They lie spread out in front of the players. At a given sign, each player must look for the shell half which matches his stock. The player with the most pairs is the winner. Utamaro depicted such a shell-game in his work *Shiohi-no-tsuto* ("Gift of Low Tide") (ca. 1790). Schmidt, (1971), p. 162, (cat. no. 350).
5 Portheim, (1975), p. 86; (Brasch, (1961), no. 12.
6 Bohner, (1972), p. 342.
7 *Fugen* is regarded as the embodiment of teaching, meditation and practice in contrast to *Monju* (skr. *Manjuśri*), which symbolized wisdom, knowledge and revelation. JEBD, (1965), p. 60.
8 Gunsaulus, (1955), pp. 131 ff. Series: *Ukiyo-e mitate-e* (ca. 1710), in which themes from classical Japanese literature, mainly of the *Nô*, are parodied.
9 Gunsaulus, p. 132, no. 43.
10 Gunsaulus, p. 135, no. 53 (ca. 1715). The courtesan's hairstyle resembles that of the courtesan in our print.
11 Hisamatsu, (1976), p. 146.
12 JEBD, (1965), p. 282.

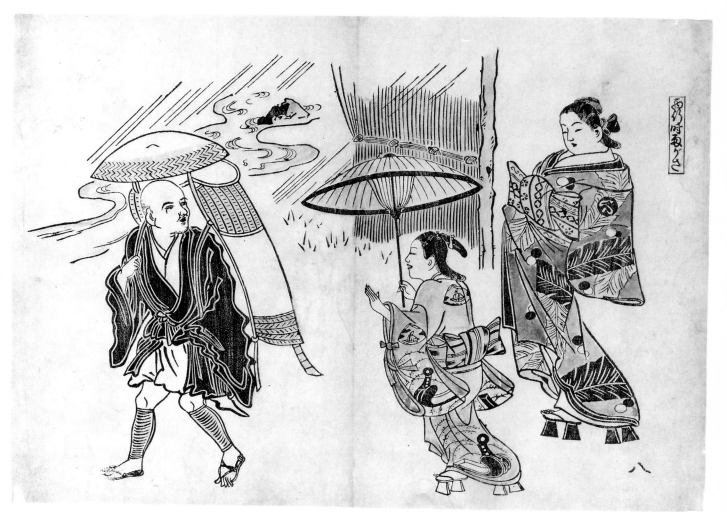

OKUMURA, MASANOBU
(1686?–1764)

KANADARAI–NO–BANSHÔ
("Evening chimes of the lead pots")

One of eight leaves from the album *YOSHIWARA HAKKEI*
(Eight views of Yoshiwara)

Ôban, yoko-e, 27.3 x 37.5 cm

Black-and-white (*sumizuri-e*), hand-coloured

Date: ca. 1715

Series title: Cartouche in the shape of a closed letter:
Kanadarai-no-banshô

64

Poem:
[The girl] puts the pretty face flower [iris] in the vase – thus
make yourself up for the evening

All eight brothel scenes of this album are parodies (*mitate-e*)
of the famous eight views of Lake Biwa. In 1500 Konoe,
Masaie and his son Hisamichi sang the praises of the
individual natural beauties of this lake, which lies to the east
of Kyôto. Their poems were copies, modeled after the
Chinese eight natural beauties of Lake Dongting where the
rivers Xiao and Xiang flow together. This had become widely
known in Japan through several pictures by famous painters
of the Song Period (960–1279). The Chinese themes were
taken up in painting from the 14th c. and the Japanese Lake
Biwa from the late 17th c.
The scene depicted here is a parody of the poem "Evening
chimes of the Mii Temple." The lead pots – there is no doubt
as to the crude allusion of these utensils – replace the bells of
the venerable old temple; its chimes in the original poem fill
the lover with longing.

Three courtesans are busily occupied with preparations for
the evening: one leans over a washing-bowl and colours her
lips, as was fashionable. Seated at an angle to a veiled mirror,
another one shaves a colleague's forehead. A maid brings a
vase in the form of a slender wooden tub, from which a bunch
of irises protrudes. On reading the poem, the name of the
flower adds a further lyrical dimension. The melancholy of
the lines lends special fascination to the leaf, which is
distinguished by its high artistic quality. The transitory
splendour of the flowers set, as it were, against the lively
activity of the charming young girls is the only hint of
warning. The main intention, however, is to impress upon
the viewers the attractions of the brothel district Yoshiwara.

The flower patterns on the robes – narcissi, splayed leaves of
banana plant, cherry blossoms between black and white fans
– and the iris in the wooden tub, are symbols of spring. But
they also serve as important elements of the dynamic
composition. The wide belt and the bent narcissus and
banana leaves, together with the contours of the clothing and
hairstyles, direct the eye in a grand sweep from the right
towards the centre of the picture, and then on in dynamic
curves by way of a river bed painted on a folding screen, out
of the picture to the rear. This movement lends the image a
sense of hurried activity which pervades the atmosphere of
the scene.
B. Klein

R. Hempel, *Yearbook I,* (1982), pp. 132 f. and (1982), pp. 46f.
(other leaves from the series).

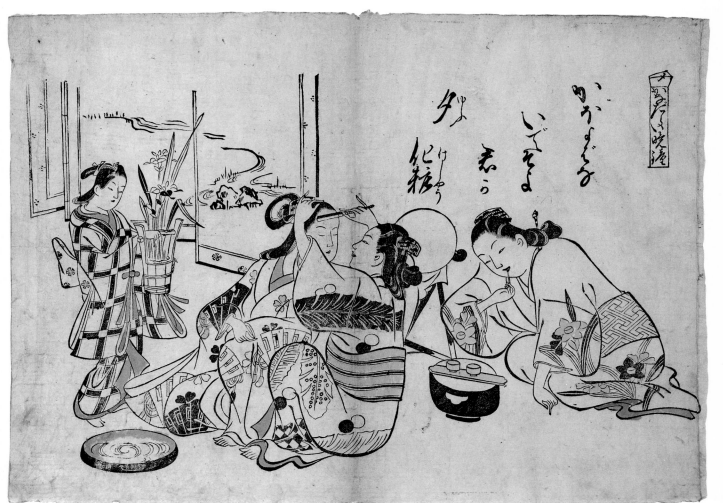

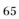

66 OKUMURA, MASANOBU
(1686?–1764)

KYÛTAI-NO-SHÛGETSU ("Autumnal Full Moon")

One of eight leaves from the album *YOSHIWARA HAKKEI* (Eight Views of Yoshiwara)

Ôban, yoko-e, 27.5 x 37 cm

Black-and-white (*sumizuri-e*), hand-coloured

Date: ca. 1715

Series title: Cartouche in the shape of a closed letter: *Kyûtai-no-shûgetsu* ("Autumnal Full Moon").

Poem:
Now he gazes at the rising moon of gold leaf,
Now shyly at the basket filled with melons.

A courtesan leaning on her pipe and accompanied by her maid converses with a visitor. The standing screen (*tsuitate*) behind her is decorated with a typical autumnal motif, the full moon, seen through swaying *susuki* grasses. This theme enjoyed great popularity from the golden epoch of the Momoyama Period (1573–1603), which was golden in a literal sense. On surviving folding screens the full moon is actually mounted in gold leaf, or in silver, or sometimes as applied metal spheres. The kimono patterns of the two women, pine and bush clover (*hagi*), also correspond to the season of the year.

The shining full moon is to be understood in the first instance as a lyrical allusion, with which one can associate maturity,

beauty and luxury. But then there is the basket with long melons among ferns. Presented so prettily, this represents quite a substantial autumnal gift – even today in Japan, choice natural products are packaged in this careful manner – but a further meaning is also intended: the basket serves in both poem and composition as a pendant to the full moon behind the courtesan, which thus in turn takes on an altogether cruder symbolic meaning. The young man looks backwards and forwards between the moon and the basket. With a few lines Masanobu has succeeded in masterly fashion in portraying the undecided young man and the lascivious waiting courtesan. This leaf proves to be exemplary for the early phase of Japanese woodblock art which achieved a symbiosis, never to be repeated again, between coarse vitality of the image and absolute refinement of the artistic means.
B. Klein

The term *kyûtai,* which appears in the title, has several meanings. Here the allusion is probably initially to the meaning "round shape, round object." Reference is made in the poem to full moon and melons as "round shapes." The kneeling man is not gazing – as the poem would have us believe – at these objects, but rather, as if transfixed, at the face of the courtesan, which is thus associated with the other "round shapes." In literature the face of a beautiful woman is often compared with the full moon.
G.A.

Ukiyo-e-no-kenkyû, book 23, series F-6, Tôkyô, 1929.
Rose Hempel, (1982), p. 46, cat. nos. 6 and 7 (other leaves of the series) and *Yearbook 1,* (1982), p. 46.
R. Vergez in: *Ukiyo-e Art,* no. 42, 1974, p. IX, pl. 11.

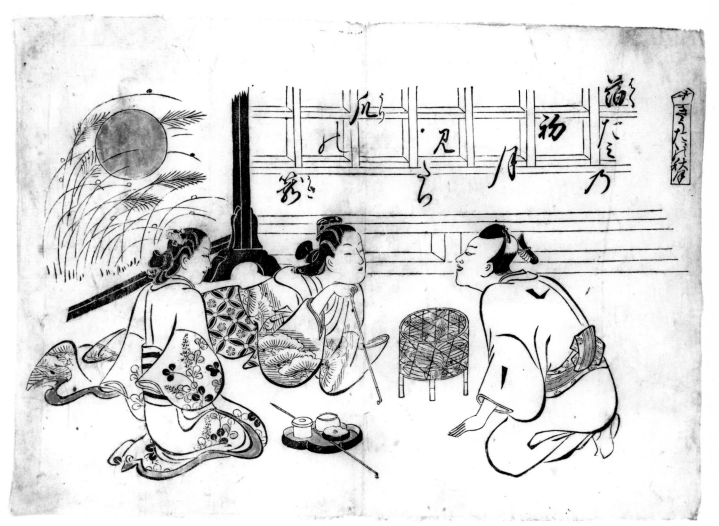

OKUMURA, MASANOBU
(1686?–1764)

KARASAKI–NO-YAU ("NIGHT RAIN OF KARASAKI")
A leaf from the series of *Ômi Hakkei* ("Eight Views of Ômi from Lake Biwa")

Signature: Nihon gakô Okumura Masanobu shôhitsu
(From the genuine brush of the Japanese artist Okumura, Masanobu.)
Title (in calabash-shaped cartouche): *Karasaki-no-yau,* No. 1

Hoso-e, 31.5 x 15.6 cm

Black-and-white (*sumizuri-e*), hand-coloured

Date: ca. 1730

The upper and lower parts of the picture are hidden behind bands of clouds. The theme is related in the two poems next to the cartouche containing the title. First there is a poem in Chinese form, a four-line poem (*qijue*), each line consisting of seven characters respectively. But its author was not Chinese; he was probably Japanese. Next to this, Masanobu added a slightly altered version of the famous poem about the night rain of Karasaki:

Yoru no ame ni	Its greenness paling in the night rain
ao wo yururite	serene in the evening breeze
yukaze wo	stands the famous pine tree
yoso ni mada taru	of Karasaki.
Karasaki no matsu.	

The Chinese poem[1] describes the view of the lake which the observer is offered at different times of day: the morning view of the lake's gently rippling, glittering surface; then in the evening the threatening clouds suspended over the filigree-like mountain villages; at night, the lively scene of the fishermen who, like the pine tree, must withstand wind and weather.

At the central point of the picture, the large pine tree of Karasaki[2] soars up next to a little *Shintô* shrine, dedicated to the *kami* (god) of the tree. A fisherman in a *mino* robe[3] strides past the *torii*,[4] a net over his shoulders, towards the promontory. To the right, two others in a boat go about their business. In the foreground to the left, another boat is anchored. On the lake, boats are returning home, with filled sails billowing. In the background the roofs of a village are hidden behind trees on the shore. Heavy rain is falling, indicated by parallel lines. Masanobu's landscape compositions are more organic than those of Shigenaga[5] in the series published by the publishing house Edo-ya (see p. 116), which is clearly more "archaic" and more indebted to the popular illustrations of the 17th c. stemming from the Tosa School. The leaf was originally in the Brettschneider Collection, passed on to the Stoclet Collection, and then to the Kaempfer Collection.
J. Wu/S. Bartels-Wu/ G.A.

Published: Jenkins, (1971), p. 100, no. 142.
Vergez, (1983), p. 43, no. 24.

[1] The poem has not been translated completely, but a provisional rendering has been prepared by J. Wu: "The curling waves of the lake glitter,/ the morning dew glows,/ the evening clouds hang over the charming mountain villages,/ the boatmen spend the night on the Karasaki Cape." (It was not possible to make sense of the fourth line because the last sign is illegible.)
[2] The pine tree of Karasaki today has a width of 60 x 45 m and is the largest of its kind.
[3] Raincoat, clothing of farmers and fishermen in the rain.
[4] *Torii* is the entrance to a *Shintô* shrine.
[5] Shigenaga also created other *Ômi-Hakkei* series, in which he was obviously inspired by Masanobu's series, see p. 120. Link, (1980), pp. 155, 156, Shigenaga, no. 23.

70 OKUMURA, MASANOBU
(attributed)

THE WARRIOR *MEGA MAGOSABURÔ NAGAMUNE*

Ôban, 27.9 x 37.3 cm

Black-and-white (*sumizuri-e*)

Date: ca. 1710

This leaf belongs to an unsigned series of illustrations from the *Taiheiki,* which all bear a cartouche in the shape of a *tanzaku* (leaf of poetry): two further leaves from the Nakajima Collection, also unsigned, have been published.[1] They show *Kamakura Gongorô* and *Tamura-maru,* two other heroes from the *Taiheiki.* The leaves closely resemble a woodblock print in the Michener Collection, Honolulu, which is signed with the name Okumura, Masanobu, and was published by Masanobu himself.[2] The inscription "Mega Magosaburô" enables the hero to be identified.

Just how closely the artist kept to the text of the *Taiheiki* is demonstrated by the following lines of the novel from chapter 8. In order to give an impression of the literature and the illustration, we reproduce them here in full.[3] The scene is set in Kyôto at the time of the capture of the city in the first half of the 14th c. The *Taiheiki* describes the Civil War of the 14th c. in forty-one volumes.

> *Mega Magosaburô Nagamune* from the province Harima, a descendant of *Satsuma-no-Ujinaga,* was a man of exceptional physical strength. At the age of about twelve, he began to practice *sumô* combat and was later able to beat every opponent in the whole land with one hand. It is said that people of the same type come together naturally. Thus it was that the other men of his clan, seventeen in all, were all stronger than normal people. Together they formed a fighting band, without a single foreign warrior in their rank, which succeeded in advancing to the crossroads of the Rokujôhômon and Ômiya roads (in Kyôto). There they came across three thousand horsemen of the Rokuhara company, who were just returning victoriously from battles at the Tôji Temple and near Takeda. The Rokuhara men surrounded them and killed all seventeen; only *Magosaburô* was left. "There would be no point in living any longer, if the Emperor's interests were not now more important," he said to himself. "Even though I alone have been left alive, I can still serve my master." Thereupon he tried to flee on horseback in a westerly direction, but a troop of fifty horseman followed him. One of these, a young warrior of about twenty, caught up with the fleeing hero on his own, rode right up to him and wanted to draw him into a hand-to-hand fight on horseback. But no sooner had he succeeded in getting hold of the protective arm-covering of *Magosaburô's* armour than the latter for his part effortlessly stretched out his arm, grabbed the youth by his armour, lifted him up, and rode on with him thus a good three hundred meters. "Spare his life!" cried the other fifty and went after him, for the youth was from a good warrior family. But *Magosaburô* turned half back to look at them and said: "Not all enemies are the same. If you imagine you can attack me easily because I am alone, then you are mistaken. But if you want this one here back, you can have him!" With these words he took the warrior, who was hanging in full armour from his left arm, in his right hand and threw him over the heads of the six horsemen following him, into the deep mud of a rice-field, where he sank almost completely. At this sight, the fifty riders turned their horses around and hurried away at top speed.

[1] Ukiyo-e zenshû, I, fig. 6
[2] Link (1977), no. 30, p. 38.
[3] Text and identification: Taiheiki, NKBT, pp. 260–266, 297, 298. Transl. K. Gottheimer.

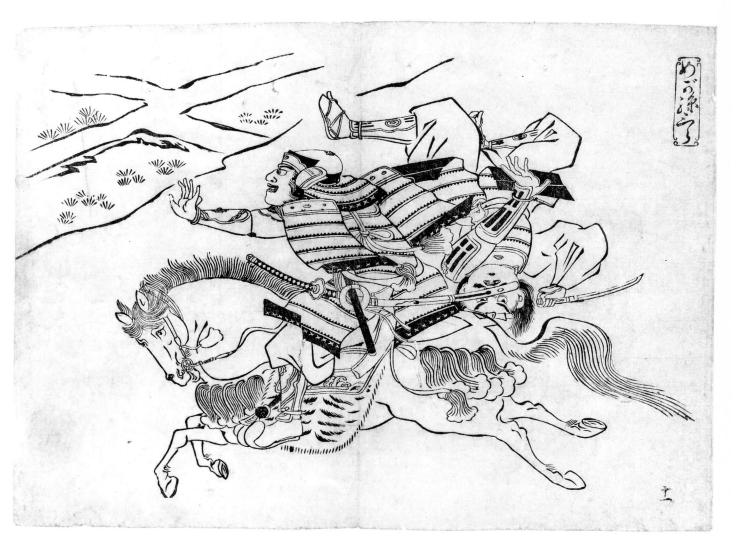

OKUMURA, MASANOBU
(1687?–1764)

FÛGA HIBACHI MUKEN-NO-KANE UKI-E KONGEN
("Original perspective picture of the elegant *hibachi* as the
bell of Muken-zan")

Signature: Nihon tôbu gakô hôgetsudô Tanchôsai
Okumura, Masanobu shôhitsu (genuine brush)

Publisher: Tôri-shio-chô Akaki/ Okumura-ya hammoto

Uki-e (perspective picture)

Urushi-e, 31.3 x 44.5 cm

Date: ca. 1740

In a brothel, the evening's business is underway. A young
Samurai, Kajiwara Genda Kagesuye, with two swords in his
belt, and wearing a *haori* decorated with plum blossoms, is
standing in front of the house accompanied by a little *kamuro*
and a servant wearing the sign for "happiness" on his sleeves.
The servant is holding a lantern with the *mon* of *Kajiwara
Kagesue* in the form of two arrow tails. The sign "happiness"
(*kotobuki*) appears again on the hanging scroll in the
tokonoma of the ground floor. On the upper storey the
courtesans are entertaining their guests in various rooms.
On the lower floor a courtesan lies asleep. But her colleague
is still awake. She strikes a bronze *hibachi* (brazier) with a
long pipe. At this, golden *ryô* pieces suddenly rain down from
the upper floor. A man has heard the banging and is throwing
gold pieces down to her.

This story[1] alludes to a folk tradition from the Tôtomi
province. He who strikes the bell (*kane*) of the Kannon temple
of Muken-zan (to the south of Shizuoka near Sayo-no-
Nakayama) will be blessed with riches in this world. But in
his next existence he will be thrown into a "Hell of Eternal
Tortures" (*muken jigoku*) (skr. *avici*). This is the worst hell, in
which beings endure boundless suffering without end. This
legend has inspired various theatrical plays. Usually the
lovers, wife, or parents sacrifice their own future bliss in
order to save their lover or their own children.

In 1698, the première in Ôsaka of such a *muken-no-kane* play
took place. The *onnagata* Segawa, Kikunojô (see p. 104)
produced a dance version (*shosagoto*) in Kyôto in 1728, in
which he replaced the bell with a washtub provided with a
scoop. In the play *Keisei fukubiki Nagoya*, Kikunojô made use
of the variation he had invented when playing the courtesan
Katsuragi, who beat the wash tub on behalf of her lover
Nagoya, Sanzo, producing a rain of gold coins. In the version
of the theme depicted here, the courtesan *Umegae* bangs on
a bronze brazier producing golden rain. She wants to help
her lover *Kajiwara Genda Kagesue*[2] to get his armour back
from the pawn-broker's. He had spent all his money on her

and finally pawned his armour as well. But Minamoto-no-
Yoritomo called him to arms. In the battle of Ikuta, he fought
with a blossoming plum branch in his quiver in her memory.
He fell in the year 1200 together with his father *Kagetoki.* Our
version of this theme is set, however, in the 18th c. The
courtesan's name, *Umegae*, is the title of a *Nô* play,[3] in
which neither a pot nor a bell are beaten but a drum. Further
impressions of the leaf discussed here are to be found in
Berlin and Chicago.[4] *Uki-e* (perspective pictures) were most
probably invented by the artistic genius Masanobu.[5]
Masanobu was reacting here to European perspective.[5]
Many of the *uki-e* appear agitated and crowded as a result of
the number of figures and the complex arrangement of the
rooms. But the emphasizing of the parallel lines of the
architecture in alternating directions lends to this woodblock
a cool calm. The shadows of the figures behind the *shôji*
(sliding doors) provide interesting accents, which in turn are
framed by the wide black lines of the roof. Thus the upper
area is strongly stressed. One discovers the lady protagonist
of the print on the ground level only at second glance.

[1] Barth, (1972), p. 245; S. Schmidt, (1971), p. 57; Gunsaulus,
(1955), p. 156.
[2] KHT, I, p. 364.
[3] Bohner, (1959), p. 372.
[4] See footnote 1.
[5] Keyes, (1954), p. 94, cites an article by Julian Lee, who
discovered that European perspective studies did not reach
Japan directly, but by way of a Chinese translation of a European
text. This tract was printed in about 1730 in Canton, and
reached Edo in about 1739. In his view, Torii, Kiyotoda drew the
first perspective picture at this time – the interior of a Kabuki
theatre. Unfortunately, Keyes does not mention where Lee
published his study.

73

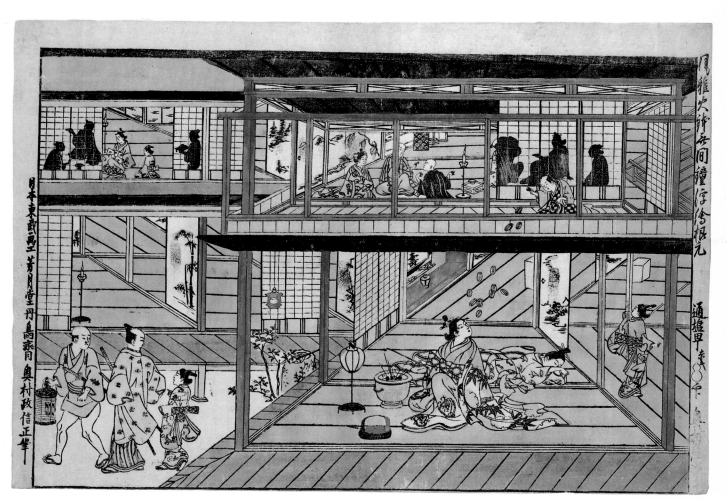

OKUMURA, MASANOBU
(1686–1764)

PORTRAIT OF SUGAWARA-NO-MICHIZANE

Signature: Hôgetsudô Tanchôsai Okumura Shinmyô
Bunkaku Masanobu kinzu (painted with respect)

Seal: Tanchôsai

Hashira-e, 64 x 23.5

Black-and-white (*sumizuri-e*), hand-coloured

Date: ca. 1735

The *Ukiyo-e* artist Masanobu used for this illustration of a great historical personality the traditional pictorial form – for him rather unusual – of hero veneration. It is at the same time a monument, which he devoted to the statesman, poet and calligrapher Sugawara-no-Michizane (845–903). This personage sits in court attire under plum blossoms and pine branches. His outer garment is decorated with his crest, *umeboshi*, a stylized plum blossom. In the early years of Japanese woodblock art, ca. 1720 to 1760, there were, in addition to Masanobu, a number of artists who created pictures of Michizane. Mostly one sees him in black court dress or in a scholar's gown, holding in his hand a blossoming plum twig, the tree he loved so much and lauded in poetry. Michizane's life was eventful. As a young man he served the Emperor Uda and won his favour by limiting the power of the Fujiwara clan. In 894 he was named envoy to China, but due to the fall of the Tang dynasty he was recalled. With the enthronement of the Emperor Daigo (897), he gained even more influence and became Minister of the Right in 899, while Fujiwara-no-Tokihira became Minister of the Left. Two years later he was the victim of a court intrigue of Tokihira and as a result, was exiled to Dazaifu on the island Kyûshû. There he died in 903.

Michizane composed many poems, some in Chinese, published important literary works, and was already celebrated in the Middle Ages as a god of literature (*Tenjinsama*). Many legends surrounded his life, which was described in more than twenty painted hand scrolls for the shrines devoted to him, mainly in Edo and Kyôto. He became more and more of a mythical figure. Natural catastrophes and epidemics were seen as the revenge of his restless ghost. He is the guardian patron of poets and calligraphers. His portrait was usually hung on the occasion of an amateur *renga* (linked verse) party, see p. 46. In exile during the last two years of his life, he dedicated the following poem[1] to the memory of the beauty of a plum tree in the court of his old palace:

Kochi Fukaba	If the East Wind should
Nioi okose yo	blow, waft your fragrance to me,
Ume no hana	Plum Blossom of mine:
aruji nashi to te	though you have no master now
haru na wasure so	do not forget it is Spring.

J.G.G.

Vignier and Inada, Coll. M. Ch. Salomon, Paris, (1909, 1911); Schmidt, (1971), no. 52, p. 59.

[1] Waterhouse, (1975), no. 30. p. 66.

UNSIGNED

GENRE ILLUSTRATION OF THE COURTESANS OF THE
THREE CITIES (TRIPTYCH)

15 x 24 cm

Urushi-e

Date: 1725–1730

The leaf illustrates one of the favourite themes of the *Ukiyo-e* of the 1720s and 1730s. It is unsigned and without a publisher's mark.

Arranged next to each other the three Courtesans of the Three Cities stand against an empty background. In the middle is the courtesan of Kyôto, to whom the artist accords the greatest importance. She is identified by the inscription *"Kyô(to) Jorô fûzoku"* (Genre illustration of the courtesan of Kyôto). The origin of the courtesan on the right is explained by the inscription *Ôsaka Jorô fûzoku* (Genre illustration of the courtesan of Ôsaka). To the left, the text of the inscription corresponds with the other two, but here the name of the city Edo (Tôkyô) is given.

The courtesan of Kyôto in the centre bends her body in a gentle curve to the left, but her feet are turned to the right. She holds her robes together with her right hand. The hand of the bent, splayed left arm is hidden under her sleeve in an odd, inexplicable pose.

The courtesan of Ôsaka on the right-hand side, in a costly robe with long, swirling sleeves, strides to the left. She pushes her robes up in a bunch with her two hands. Her body pose thus becomes strongly S-shaped.

On the left-hand side of the leaf, the courtesan of Edo also turns to the left. With her right hand she holds her robe together, but with a gesture differing from that of the Kyôto courtesan. The sleeves of her jacket hang loosely down from her shoulders. All three bear clearly visible crests on their robes.[1] The kimono of the courtesan of Kyôto is adorned with cherry blossoms and pine twigs, that of the Ôsaka courtesan, with fish-traps and seaweed, as well as filled plum blossoms. The robe of the courtesan of Edo displays spider webs and tablets bearing the inscription *kimbashi* (gold bridge). Splintered ice and clouds appear on the kimono underneath. The patterns seem too big in proportion to the figures themselves. The three women are of generous physical stature with full-cheeked faces. The hairstyles conform to the fashion of the late 1720s.

The theme of this leaf is one of the most popular inventions of *Ukiyo-e*.[2] The Courtesans of the Three Cities were first depicted by Okumura, Masanobu in the year 1717. This artist is also held to have created their iconography.[3] Masanobu places the courtesan of Edo – identified by the name of the city on her sleeve – at the top of his composition in the form of a pyramid. She hides her left hand under her left sleeve, in which she holds a tobacco pipe which projects. To the right stands the courtesan of Kyôto, who lets the empty sleeves of her robe hang loosely down from her shoulders. To the left, the courtesan of Ôsaka presents herself in her magnificent robe with long, flowing sleeves. When his pupil Okumura, Toshinobu (see p. 78 f.) copied the leaf in about 1720, he did not change either the positions of the courtesans or their characteristic appearance.[4] But on a copy produced somewhat later (1720–1725),[5] he described the figure at the top as the courtesan of Kyôto while retaining the appearance which Masanobu had given the woman in this position, save for the pipe which he omitted. The pose of the arm, which is also demonstrated by the courtesan of Kyôto in the centre of our leaf, thus loses its sense. The courtesan on the right side, originally attributed by Masanobu to Kyôto, becomes the courtesan of Edo in Toshinobu's version, without any change in the iconography of the figure in this position. Kiyomasu II retains the appearance and identification which Toshinobu had employed,[6] but positions the three courtesans in front of a restaurant, still next to each other in the same order. The names of the three cities appear in round cartouches on the curtains. Numerous different lesser and greater woodblock masters plagiarized the theme in the 1720s and 1730s, scarcely changing the iconography.[7]

Our triptych takes up the generous, corpulent, full-cheeked type of woman created by Kiyomasu II, but the three figures are less static in their movements. The unknown artist also exchanges their positions, but not the appearance of the two outer figures. Ôsaka, usually on the left-hand side, is placed to the right, Edo to the left. While the Kyôto and Edo courtesans hardly differ in their iconographic characteristics from the "Courtesans of the Three Cities" of Toshinobu and Kiyomasu II, the courtesan of Ôsaka, with her bunched-up robes with hands hidden underneath, diverges in form from the model.[8]

The most eye-catching example of this type of courtesan, with robe bunched up at the front pushing her body into a marked S-shape, is shown by Hanegawa, Chinchô on a woodblock dated 1718, of which there is a print in the Tôkyô National Museum and another in Chicago.[9]

The leaf reproduced here comes from the Julius Kurth Collection and was published as early as 1922 in his work *Die Primitiven des Japanholzschnittes* (pl. 28). It is the only known impression.

[1] The *mon* (crest) of the courtesan of Edo is usually associated with the *onnagata* actor-family Segawa, here probably Segawa, Kikunojô; the central position is occupied by Arashi, Kôroku (1708–1763), an *onnagata* performer from Kyôto. Nakamura, Kiyosaburô (who played from 1721–1777), who was also a performer of female roles, poses on the right (information gratefully received from R. Hempel).

[2] T. Paine has devoted an essay in *Ars orientalis,* vol. V, 1963, pp. 273–281, to this theme, which is comprehensively treated with many illustrations.

[3] Op. cit., p. 273, and fig. 1. Owner: Tôkyô Nat. Mus.

[4] Op. cit., p. 274, fig. 2 (TNM); a previously little noticed, unsigned leaf in the Portheim Foundation, (1975), II, 3, p. 79, shows the order and iconography used by Masanobu; thus the Edo courtesan at the centre also holds her pipe; the style of the faces and figures seems more inspired by Kiyomasu II; see also Bernabo Brea/Frabetti/Kondo (Estate/Autunno 1974), p. 37, nos. 25, 26.

[5] T. Paine, op. cit., p. 274, fig. 3, TNM. See footnote 4. Leaf in the Portheim Foundation.

[6] Op. cit., figs. 10 and 9.

[7] They cannot all be mentioned here. Paine describes and illustrates each one.

[8] One example by Okumura, Masanobu is illustrated in TNM, I, no. 260. A single sheet depicting the Courtesans of the Three Cities with the inscription "The figure style of the capitals" was probably produced later than our leaf.

[9] Hanegawa, Chinchô (1679–1754); also Hanegawa, Chinjû, TNM, I, no. 51; and Gunsaulus, (1955), p. 64, to be dated around 1718.

76

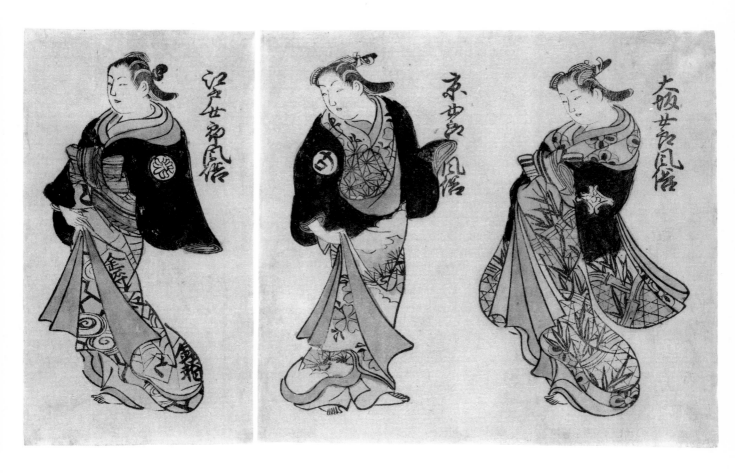

OKUMURA, TOSHINOBU
(active 1717 – ca. 1750)

During the period of time in which Masanobu created the most important of his *urushi-e*, the leaves by Toshinobu also appeared. Similarities are undeniable, but it cannot be said that they are copies, so clearly are these lacquered pictures distinguished by the bold elegance of the lines and the balanced style of composition of the images, which often include several persons. In such works, Toshinobu is of the same stature as Masanobu in his pictorial intensity; sometimes he surpasses him.

The proximity to Masanobu's work may also be explained if the supposition is true that Toshinobu was his adopted son. J.G.G.

78 THE THREE ACTORS ICHIMURA, TAKENOJÔ, SANJÔ, KANTARÔ II AND NAKAMURA, KICHIBEI

Signature: Yamato-e kô Okumura, Toshinobu hitsu

Publisher: Izutsu-ya (editor's mark in a cartouche in the shape of a well), Oroshi, Shiba shimmei mae hammoto.[1]

Hoso-e; 32.9 x 15.7 cm

Urushi-e

Date: 1722

The three actors are arranged diagonally one above the other to form a closed shape. Sanjô, Kantarô's face is on an axis with that of Nakamura, Kichibei. There is large-scale ornamentation decorating their robes. The actors are identified by inscriptions giving their names and their *mon* (crests).[2]

They act together in a play entitled: *Hinazuru katoku Soga* ("Soga play about young crane inheritor") which was performed in the 9th month of 1722 at the Ichimura-za theatre. According to the *Kabuki nempyô*, the *onnagata* performer Kantarô appeared as *Tatsuhime*, the daughter of *Itô Nyûdô*,[3] wearing a cap called a *zukin* and a *haori* "in the style of a doctor." Takenojô with unshaven head[4] as *Kudô, Suketsune* leaves the stage in the second act of the play with a *roppô*.[5] Kichibei appears in the comic role of *Yaheibei*.[6] The theatre play belongs to the area of the *Soga* legends.[7]

Takenojô plays the role of *Kudô, Suketsune*, who is usually known as the murderer of the *Soga* Brothers' father and presented as a villain. However, here he is the victim of the deceitful grandfather of the heroes *Soga*. This man named *Itô, Sukechika* (died 1081) was the feudal lord of Kawazu in Izu. His uncle, *Itô, Suketsugu*, allotted him the task of administering the executive area of Itô in Izu on behalf of his son *Suketsune*, who was not yet of age. No sooner was *Suketsugu* dead than *Sukechika* sent the young *Kudô, Suketsune* into secure custody in the capital, and appropriated his property. At a hunting event of the Minamoto-no-Yoritomo (see p. 102), *Suketsune* took his revenge on his uncle and on *Sukeyasu*, who was the *Soga* Brothers' father.[8]

Sukechika's daughter was married to Yoritomo's vassal named *Miura, Yoshizumi* (1127–1200); but in spite of her pleas on behalf of her father, *Sukechika* was forced to commit suicide.[9]

This theme is taken up by the action of the play, but it seems to have been a humorous version. This is supported by the depiction of *Kudô, Suketsune* as a young *samurai* by Takenojô, who exits in a style imitating that of an *aragoto* actor. *Tatsuhime* in her doctor's costume reminds us that the popularity of this theme was not limited to comedies of European countries of the 17th c. and 18th c.

The actor Kichibei (1684–1765), a member of the Nakamura family, appeared from 1716–1739 in *dôke-gata* (fool) roles.[10] Takenojô's biography has already been discussed on p. 38.

Sanjô, Kantarô II (1702–1763) appeared from 1712 in *wakashû* (youth) roles at the Yamamura-za.[11] From 1716, he performed as an *onnagata* (woman) and *wakashû* actor. In 1718 came his breakthrough in the role of *O-Shichi*, the daughter of a greengrocer (*yaoya*), in the play *Shichi-shû fuku-ju sô-ga* ("Seven kinds of happiness and long life through personal selfishness"). This drama, which was based on a novel by Ihara, Saikaku (1642–1693) from his work *Kôshoku gonin onna* (Five Sensuous Women), depicts a real event. When her house burnt down, *O-Shichi* found refuge with her parents in a temple. There she fell desperately in love with the temple page *Kichibei*. When her new house was ready and *O-Shichi* had to return, she set it on fire in order to go back to the temple and return to her love.[12]

Kantarô was one of the most important women impersonators of his time, alongside Segawa, Kikunojô (see p. 104). In 1775 interest in him began to wane, and by 1746 he seems to have lost his popularity. In the year 1763 he died at the age of 61. In *Ukiyo-e* he is depicted on many leaves. He took his name from Sanjô, Kantarô I, who was active between 1661 and 1680. The name Sanjô is possibly based on the city quarter of the same name in Kyôto.

Provenance: Otto Jaekel Collection.

[1] *Oroshi* means "wholesale merchant."
[2] Deciphering the name, identification of the role, and play: E.K.
[3] *Itô Nyûdô* ("Itô becomes monk") is surely Itô, Sukechika.
[4] Papinot, p. 216, see below. This hairstyle, "*tategami*"; i.e., "standing hair," is often worn by young warriors, but also by country vassals. Takenojô as an adult man already has a shaven head. The fact that the hairstyle is mentioned in the *Kabuki nempyô* supports the view that Takenojô no longer specialized in *wakashû* roles, being past his own youth, but adopted the role of a youth as an actor of male roles. He appears in the play as a young *samurai* with two swords.
[5] The actor leaves the gangway to the stage called *hanamichi* with six enormous leaps – typical of the manner of acting of *aragoto* actors such as Danjûrô I and II.
[6] Unknown character. His crest takes the form of a silver weight with the character "above."
[7] Thoroughly discussed on p. 102.
[8] Izu is one of the 15 provinces of Tôkaidô. On the history, Papinot, (1972), p. 224.
[9] Op. cit., p. 389. Kantarô clearly plays this daughter under the name *Tatsuhime*.
[10] Hempel, (1982), leaf, 15.
[11] Biography after Yoshida I, p. 400. His crest is a butterfly.
[12] Schmidt, (1971), p. 43, no. 15.

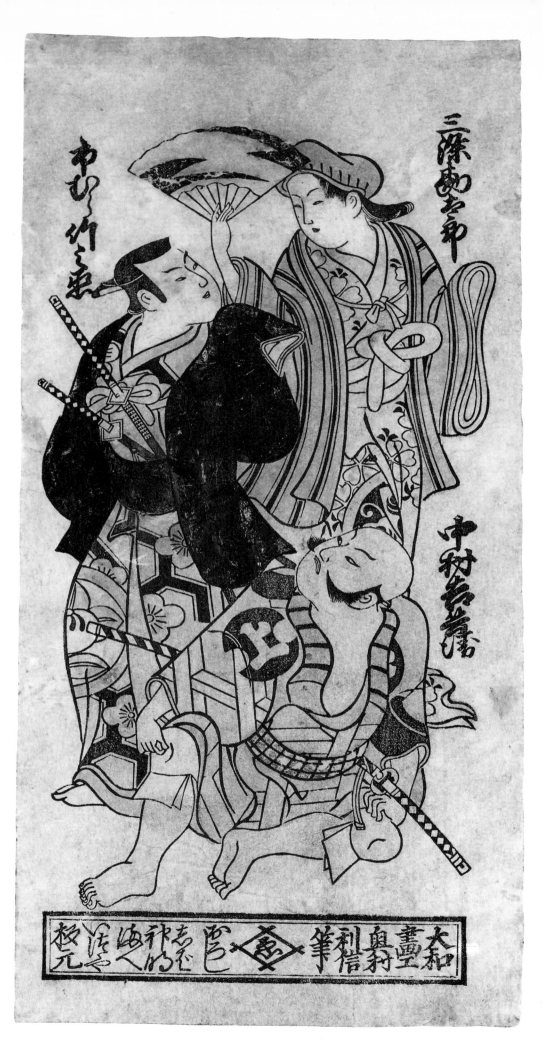

OKUMURA, TOSHINOBU
(active 1717-1750)

THE ACTOR SAWAMURA, SÔJÛRÔ I

Signature: Yamato-gakô Okumura, Toshinobu hitsu

Publisher: Izutsu-ya Shiba-shimmei-mae hammoto
(in regular cartouche, with "well"-mark)

Hoso-e, 33.9 x 16.2 cm

Urushi-e

Date: after 1720

The actor steps out on high *geta* (wooden shoes) towards the right, turning his head back. With his left hand he holds an umbrella, while the right hand is hidden under the sleeve of his kimono. Two swords are fastened in his belt.[1] The kimono is of the greatest elegance. On the shoulders and borders of the sleeves are black areas set off against a checked material. Sawamura's crest, the character "*i*" in *hiragana* script, appears several times on the lower, demarcated border area. An *inrô* hangs from the geometrically patterned belt, the ornamentation of which shows the Soga crest (actually that of Kudô Suketsune).
The leaf is unusually well preserved.

Sawamura, Sôjûrô I (1689-1756)[2] is the contemporary of Ichikawa, Danjûrô II (see p. 92), of Ôtani, Hirôji I, (see p. 128) and of Segawa, Kikunojô I (see p. 104). Sôjûrô came from a *samurai* family in Kyôto, who rejected him because of his lifestyle. At first he was received by the actor Sawamura, Chôjûrô in Ôsaka who, at Sôjûrô's insistent pleading, instructed him in the art of acting. But because the actor did not want to give Sôjûrô his name, Sôjûrô left him in anger and joined a wandering company where he performed as a player of supporting roles and as a flautist. In 1715 he returned to Ôsaka, was reconciled with Chôjûrô and appeared in his theatre using the name Zengorô. His big chance came in 1717 when the lead player of the role of *Coxinga* in the play *Kokusenya kassen* ("The Fight of *Kokusenya [Coxinga]*"), fell ill;[3] he substituted for him and was thus able to demonstrate his talent. At a guest appearance in Ise he met the actor Sadoshima, Chôgorô,[4] who advised him to go to Edo. In 1718 he was already playing at the Morita-za in Edo and from 1720 onwards he called himself Sôjûrô.

He appeared very successfully as *Soga, Jûrô* (see p. 100), and with Danjûrô II as *Soga, Gorô*. In 1735 he wrote a drama for the Nakamura-za with the theme of the blood revenge of the 47 *rônin* of Akô (*Chûshingura*).[5] In 1747 he visited his home city of Kyôto for a guest performance, after having given various performances in Ôsaka in 1743. However, he immediately hurried back to Edo, where in 1747 he went down in theatre history in the première performance of the season (*kaomise*), along with Danjûrô II and Segawa, Kikunojô I. This was the performance with the highest star fees of the century (*sanzen-ryô-kaomise*; i.e., "three thousand *ryô-kaomise*").[6] Meanwhile, he was calling himself Chôjûrô.

Sôjûrô's interpretation of *Yuranosuke* in *Kanadehon Chûshingura* in 1749 was even copied by the puppet theatre. In 1753 he called himself Suketakaya, Takasuke. He died in 1756, shortly after Danjûrô II had retired from the stage.

The actor Sôjûrô was well-educated, practiced tea ceremony, wrote poetry, and excelled in calligraphy. His theatrical art was more realistic and less indebted to the *aragoto* style of the Genroku Period than was that of Danjûrô. He placed less value on unusual costumes. His manner of speaking was more natural than that of his great rivals. During his career he played all the famous roles of the *tachiyaku* (male roles). To the question why Danjûrô had first place in the rank list of actors before him, he replied with gentle irony that this was because Danjûrô could also be understood by children.

[1] Here he plays a *samurai*.
[2] Barth, (1972), pp. 234, 240-244, 250, footnotes 646-649.
[3] The play describes the deeds of a Japanese-Chinese pirate, known as *Coxinga* in contemporary Western literature and as Kokusenya in Japanese, from the island of Formosa, who fought in the 17th c. as a loyal subject of the Ming rulers (1368-1644) against the Manchurians (*Qing*) (1644-1908). A play with the same title was written by Chikamatsu, Monzaemon in 1715 for the puppet theatre Takemoto-za in Ôsaka. It played to a full house for 17 months.
[4] Dancer and actor of *kamigata* (Ôsaka/Kyôto), Barth, p. 234.
[5] *Chûshingura, the Revenge of the 47 rônin*, is one of the first theatre plays of Japan to be translated into Western languages.
[6] The star actors of this time earned approx. 1000 gold *ryô* per season. See Barth, glossary: "*ryô.*"

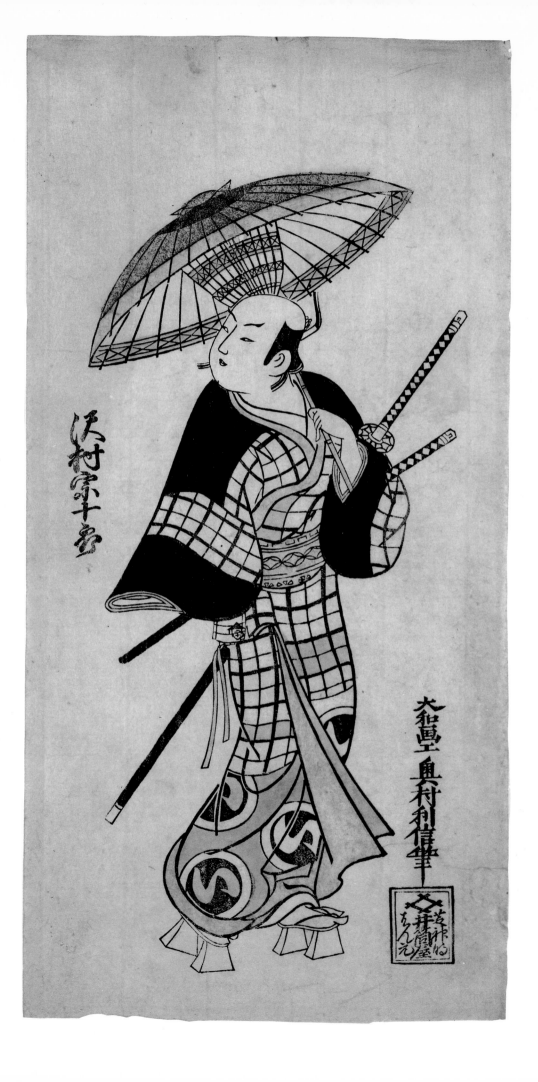

OKUMURA, TOSHINOBU
(active 1717–1750)

WOMAN IN FRONT OF A MIRROR

Signature: Yamato gakô Okumura, Toshinobu *hitsu*

Publisher: Yokoyama-shô Ni-chôme Ômi-ya

Hoso-e, 29.1 x 14.8 cm

Urushi-e

Date: ca. 1728

A courtesan is looking at herself in a mirror. She is wearing an *uchikake* with pine branches and twigs over a kimono decorated with dandelion plants and baskets. The woodcut and a leaf from the rare master Hasegawa, Yoshishige,[1] are both based on the same model. Yoshishige's leaf depicts the actor Sanjô, Kantarô II in the role of *Oiso-no-Tora*, the mistress of *Soga, Jûrô* (see p. 100), who teases a little kitten with an *origami* crane. Kantarô played this role in a Soga play in the Nakamura-za theatre in the year 1728. The handling of the lines is more or less identical in both woodcuts, but the patterns of the materials and the facial expressions differ.

[1] *Ukiyo-e taikei,* vol. 1, colour pl. 50.

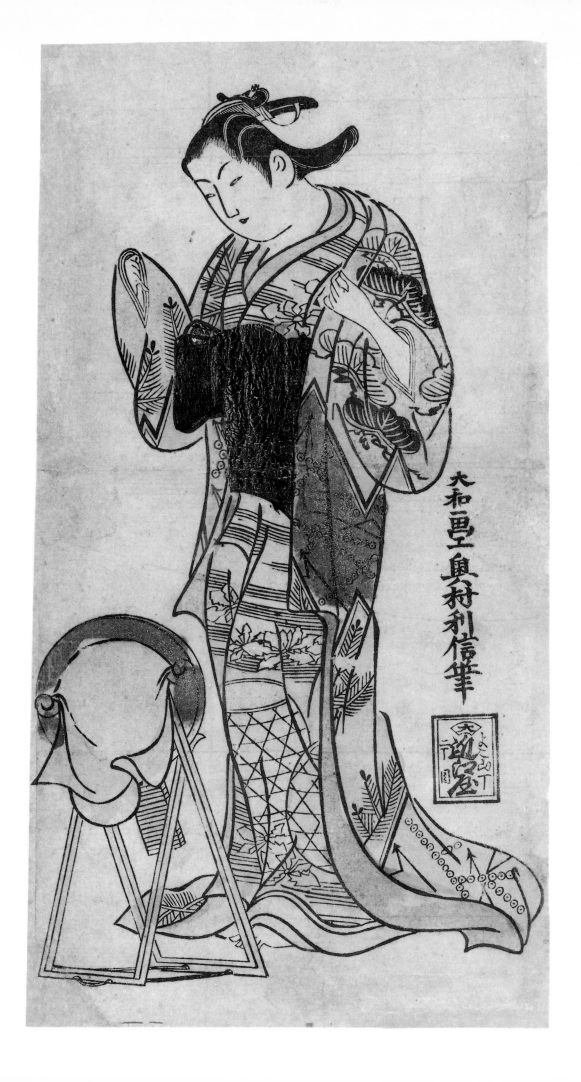

大和画工奥村利信筆

OKUMURA, TOSHINOBU
(active 1717–1750)

PREPARATIONS FOR THE *BON* FESTIVAL

Signature: Okumura, Toshinobu hitsu

Publisher: Emi-ya

Hoso-e, 29.5 x 15.6 cm

Urushi-e

Date: ca. 1727–1729

On a veranda *(engawa)* a small maid is dressing her mistress up for the "All Souls Festival" *(bon)*. In the background there is a hanging lantern *(kiriko-dôrô)*, characteristic of this festival. These lanterns are lit for the souls of the dead in a family at the *bon* festival from the 13th to 16th of July.[1] The *oiran*'s kimono is decorated with court caps and fence motifs, the girl's with *hagi* and moon hares.

Another impression of this woodblock, with another colour scheme, is to be found in the Tôkyô National Museum.[2] The models for this picture were a woodblock by Okumura, Masanobu[3] in the possession of the same museum, and a painting in which an identical figure of a woman is depicted in other surroundings.[4] Toshinobu has changed the ornamentation on the robes, the lower part of the *oiran*'s robe, has added accessories, and changed the surroundings. Yet, Toshinobu succeeds in lending his figures a completely different expression. In contrast to Masanobu's women, they appear austere and reserved.

Similar *kiriko-dôrô* lanterns, probably of Chinese origin, can be seen in two further woodcuts. On one leaf by Torii, Kiyotomo (active between 1720–1730), the actor Ichikawa, Danzô dances in front of a big *kiriko-dôrô* lantern, out of which the *onnagata* player Sanjô, Kantarô II (p. 78) is looking.[5] The play itself cannot be identified, but we know that both actors performed together in the years 1715–1729 and that Danzô adopted the crest shown in this leaf in 1728. Thus, the print under discussion must be dated around 1728–1729. The second print by Toshinobu,[6] the artist of our leaf, shows the *onnagata* Yamashita, Kinsaku (see p. 90) in the role of *Oiso-no-Tora*. He played this role in 1727. Large lanterns of various shapes appear on this leaf as well. It seems probable that the effective use of lanterns on stage inspired Toshinobu in the years 1727–1729 to depict them in our print. The leaf comes from the Vever Collection, cat. III, (1977), no. 20.

[1] KHT, I, pp. 64, 422.
[2] TNM, I, no. 306.
[3] TNM, I, no. 235.
[4] *Nihon-no-bijutsu* I, no. 248, colour pl. 19.
[5] Link, (1989), p. 83.
[6] Ibid., p. 138.

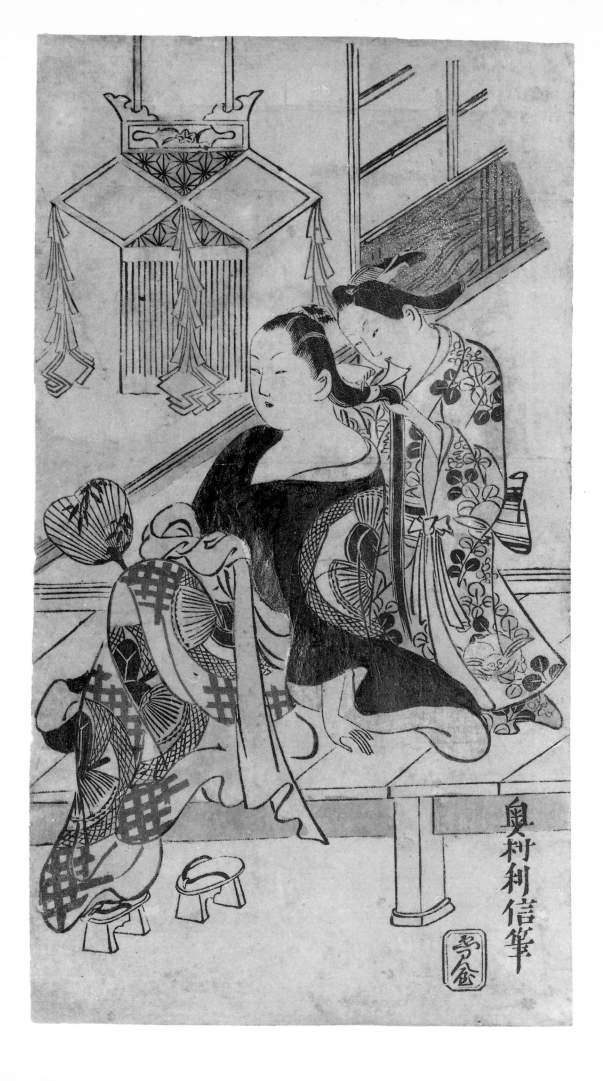

TORII, KIYOMASU II
(Recorded dates 1706–1763?, active ca. 1720 – ca. 1760)

The œuvre of Kiyomasu II is by far the most extensive of the early *Ukiyo-e* masters. In spite of the abundance of his publications, some of his works rank among the most important achievements of early woodblock art. In the variety of his themes he surpasses his contemporaries. In his latter years, he used two-and three-colour printing (*benizuri-e*), but did not achieve here the level of artistic expression of his "lacquered" pictures.
J.G.G.

THE ACTOR BANDÔ, HIKOSABURÔ I
AS THE HERO *TAWARA MATATARÔ TADATSUNA*

Signature: eshi Torii, Kiyomasu hitsu

Publisher: Urokogata-ya hammoto/Publisher's mark of three triangles

86

Hoso-e, 31.3 x 14.8 cm

Urushi-e

Date: Gembun 2nd year, 11th month (1737)

Bandô, Hikosaburô (1683–1751) began his stage career in 1715 at the Kamigata (Ôsaka/Kyôto).[1] He gave several guest performances in Tôkyô and moved there permanently in 1739, where he enjoyed great success in *budô* (warrior) and *jitsugoto* ("positive hero") roles. He is counted as one of the *"shi-tennô"* ("Four Heavenly Kings"), the best actors of the time – the others being Danjûrô II (see p. 92), Sawamura, Sôjûrô (1686–1756), and Ôtani, Hirôji I (1696–1747).[2] His crest was the crane (*tsuru–mon*). Bandô, Hikosaburô clearly played the above-mentioned role as a guest actor, as proved by the inscription given next to him: "Comes from Ôsaka" (*Ôsaka kudari*). The theatre play, performed at the Ichimura-za, under the title *Genji-gumo ôgi-no-shiba* ("The play of the folding fans [*ôgi*] of the Genji clouds") deals with the heroic deeds of the *Tawara Toda* ("rice sack") alias *Fujiwara-no-Hidesato,* here called *Tawara Matatarô Tadatsuna* ("Faithful Rope").[3] This hero from the wars of the 12th c. (Gempei) is the main character in many legends. His battle against *Taira-no-Masakado,* who had made himself ruler, is well known.[4] He fought against *Masakado* who could multiply himself, and killed him.[5] His battle against the *Mukade*, the deadly centipede, which he conquered with the help of the dragon spirit of Lake Biwa and his daughter, is also renowned.[6]
The print shows the hero with his *mon "ta"* – from his rôle *Matatarô* – on his jacket. He carries a big flag with the inscription *"Shô-Hachiman-gû."* The *Shintô* war god *Hachiman* was the guardian god of the *Minamoto (Gen),*[7] to which *Tawara-Toda* belonged. The actor is sitting with legs drawn up on a *shima-dai*, a table which served as a place to put the *shô-chiku-bai* (a combination of pines, bamboos and plums). Combined with objects bringing happiness and long life, they call to mind the story of *Jô* and *Uba*, the spirits of the pines of Sumiyoshi and Settsu.
Both are regarded as symbols of marital faithfulness. Their story is told in the *Nô* play, *Takasago.*[8]
Such *shima-dai* were displayed particularly at weddings and at the New Years Day.
In the print the three plants, harbingers of good fortune – pine and plum in the background and bamboo (*sasa*) on the hero's robes – complement the association.
It was not possible to discover the content of the scene itself.

[1] Barth, (1972), p. 243.
[2] Ibid., p. 240 (Sôjûrô); p. 242 (Hirôji).
[3] The term *shiba* in the play's title has a number of meanings. In combination with *iru* (remain seated) it means "to sit on the grass." In *Nô* performances, covered seats (*sajiki*) were erected for the nobles, while the general public sat down on grass. The term *shibai* was used as early as the Muromachi period (1392–1490) as a synonym for "theatre play." *Shiba* was also a term used in Kyôto to refer to "free space." Barth, p. 254 and footnotes 669, 670. An ever-filled rice sack (*toda*) was one of the gifts of the dragon god (see preceding entry text). Joly, (1967), p. 524, no. 956; KHT, II, p. 379. "Faithful rope" could not be interpreted.
[4] Joly, (1967), p. 321; KHT, II, p. 16.
[5] Ibid.
[6] Tawara Toda also received the famous bell of the Mii-dera from the dragon spirit, see p. 116 and footnote 3 below.
[7] *Hachiman* is an ancient *Shintô* god of the archers. He is one of the first *Shintô kami* (gods) to enter into a symbiosis with a Buddhist being in the *Ryôbu-Shintô* in the 9th c. In this school of thought, *Shintô kami* are explained as manifestations in another form ("left traces," japan. *suijaku,* skr. *avatâra*) of Buddhist beings. In this way the contradiction between the two religions was resolved.
[8] KHT, I, p. 348; KHT, II, p. 254, fig. 869; pp. 361f. *Ukiyo-e zenshû,* I, fig. 175.

TORII, KIYOMASU II
(Recorded dates: 1706–1763?, active ca. 1720–1760)

THE ACTOR NAKAMURA, SHICHISABURÔ II

Signature: Torii, Kiyomasu hitsu

Publisher: Iga-ya (Seal: Iga-ya)

Hoso-e, 34 x 15.9 cm

Beni-e

Date: ca. 1725

The actor Nakamura, Shichisaburô is shown against an empty background, standing slightly turned with his face raised. He is dressed as a young *samurai.* Two swords are fastened in his belt. Over a kimono with iris decoration, he has put on a wide, black jacket under which his hands are hidden. He can be identified by the crest on the jacket. The jacket is decorated with paper kites; the robe, with a kind of narcissus.
A tobacco pouch hangs from his belt and an *inrô* with the character "*kotobuki*" (long life). Nakamura, Shichisaburô's style of performance clearly followed that of his father, who was famous for his interpretation of beautiful, gentle lovers.[1]

[1] Barth, (1972), p. 223

TORII, KIYOMASU II
(Recorded dates: 1706–1763?, active ca. 1720–1760)

THE ACTOR YAMASHITA, KINSAKU

Signature: Torii, Kiyomasu hitsu

Publisher: Emi-ya

Hoso-e, 29.9 x 15.5 cm

Urushi-e

Date: 1725–1729

Yamashita, Kinsaku is standing in front of a court carriage (*gosho-guruma*) with a *shakuhachi* (see below). Over a robe decorated with chrysanthemums he wears another, a black robe with large *kaji* leaves (mulberry), which he has let down to his waist. In the background a cherry tree is in bloom.
Yamashita, Kinsaku was an *onnagata* (female impersonator), from Ôsaka. He performed during two periods of his career in Edo, in the years from 1711–1717, and from 1723–1729. He only returned again to Edo in the 1740s.
Kinsaku is represented in various roles on several woodblock prints by Kiyomasu II, always identified by his *mon*, the gentian flower (*rindô*). His corpulence distinguishes him from other *onnagata* illustrations by Kiyomasu II.[1]
Although the scenery of the court coach and the blossoming cherry tree points to one of the numerous court legends of the Heian Period, the scene could not be identified. It is unusual that in the leaf, Kinsaku does not play the flute, but a *shakuhachi*, a kind of oboe, which was not normally used in women's roles. It is the instrument of the wandering begging monks (*Komusô*) who, with their heads completely hidden under high straw hats, travelled through the land.[2]

[1] Pictures of Kinsaku by Kiyomasu II:
Link, (1977), no. 41 in the role of *Hanjô*; Michener Coll., Honolulu, (1980), Kiyomasu II, no. 3, probably as *Tora Gozen*; Kiyomasu II, no. 8 as a *Gagaku* female with a mouth organ. Also Hanewaka, Wagen (active ca. 1720) depicts Kinsaku as a corpulent figure selling tooth-blacking materials (Link, ibid.).
[2] The heroes in Kabuki plays frequently dress up as such begging monks, in order to track the murderer of a loved one undisturbed, or in any other situation where a person needs to disappear.

TORII, KIYOMASU II
(Recorded dates: 1706–1763?, active ca. 1720 – ca. 1760)

TWO ACTORS: ICHIKAWA, DANJÛRÔ II AND MIYAZAKI, JÛSHIRÔ

Signature: gakô Torii, Kiyomasu hitsu

Publisher: Omiya-ya-han

Hoso-e, 32.8 x 16.1 cm

Urushi-e

Date: 1727, 5th Month

The leaf shows the actor Ichikawa, Danjûrô II (1688–1758)[1] as *Araoka Genda* (Kajiwara Genda Kagesue)[2] in the role of the sword seller at the Boys' Festival (*shôbu-gatana*). He is standing with one foot on the actor Miyazaki, Jûshirô II (1708–1769)[3] in a role which is difficult to identify. The monologue of the sword seller in a dense mass of characters takes up the upper third of the print. Both actors are identified by their *mon*. They act in the play *Honryô Sasaki Kagami* ("Mirror of the Sasaki"), which was performed at the Nakamura-za in the 5th month of the year 1727.[4] The play seems to be written using the technique of "mixing different worlds" (*kakikae*). The original story is part of the body of legends surrounding the civil war in the 12th c.[5]
Genda, son of *Kajiwara, Kagetoki*, who had left the Taira and sided with Minamoto, had distinguished himself in several scenes (see p. 72). In order to be the first to reach the Taira enemies at the battle of the Uji River, he wanted to be the first to cross a ford which had been sought out by *Sasaki-no-Shirô-Takatsuna*,[6] who was acquainted with the area. But just as he had almost reached the other side of the river, *Sasaki, Takatsuna* called out that his horse's saddle-strap had come undone. As *Genda* was bending over, *Takatsuna* overtook him and was the first to reach the opposite bank. This episode gave rise to various dramas. In the play shown here, the rivalry between the two heroes has obviously been transposed into the bourgeois circles of the Edo Period, a treatment which other stories have also received. Since the play was performed in the fifth month, it can be assumed that the theme was presented on the occasion of the Boys' Festival (*tango-no-sekku*) in this contemporary version.[7] Danjûrô II (1688–1758) was the son of the actor Danjûrô I, who had dominated the theatre around 1700. When the latter was murdered in 1704, Danjûrô II was only sixteen years old.
At first he was treated coolly by the theatre and complained that he was given only bad roles to play. But in time, he succeeded in winning the acclaim of the public and his colleagues. Thus he became the most important actor of this time, with a determining influence on the theatre. His interpretation of roles in the *Soga* dramas was unique in that he liked to make use of the *kakikae* technique: the transposition of a story from one world to another. The presentation of the *Sukeroku* story as a transposition of the revenge of the *Soga* brothers from the 12th c. into the world of the Yoshiwara was his crowning achievement.

[1] Barth devotes several pages to the actor (pp. 235 ff). Identification of the name by E.K.: the inscription on the woodblock print reads "Araoka Danjûrô."
[2] See KHT, I, p. 364; Joly, (1983³), p. 243; see also below and p. 72.
[3] Identification: E.K.; she notes that the actor appeared with this name from 1723–1768. In our view he plays the villain *Sasaki Ganryû*; i.e., *Sasaki, Takatsuna* or one of his followers.
[4] *Honryô* also means "true being, character."
[5] See p. 48 (*ema*).
[6] KHT, II, p. 258; Joly, (1983³), p. 243.
[7] KHT, II, p. 373.

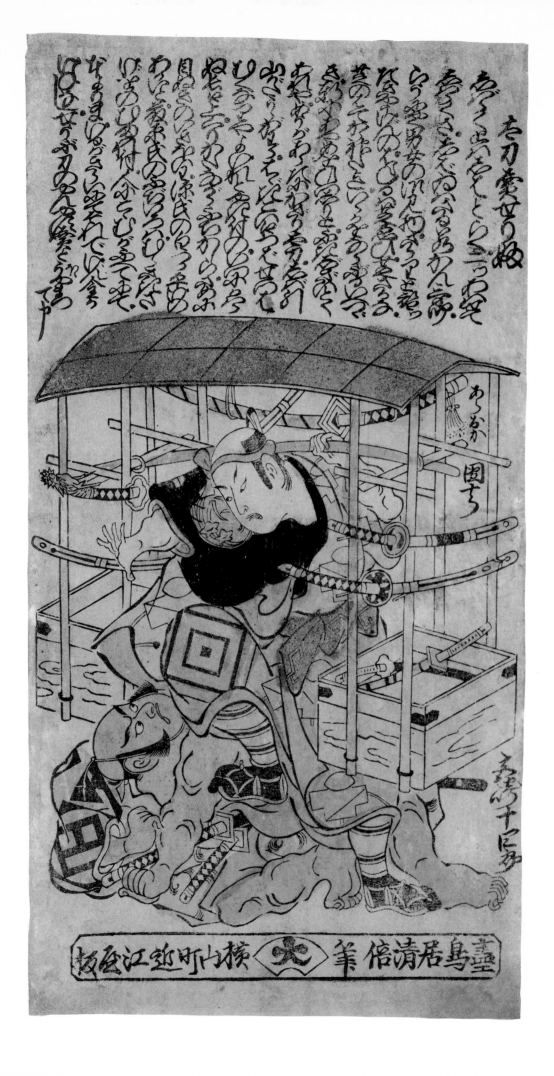

TORII, KIYOMASU II
(Recorded dates: 1706–1763?, active ca. 1720 – ca. 1769)

THE POETESS ONO-NO-KOMACHI

Signature: gakô Torii Kiyomasu

Publisher: Aikindô, Hirano-ya Kichibei (1720–1736)

Hose-e, 32.2 x 15.2 cm

Urushi-e

Date: ca. 1730

This leaf is the only known impression of the woodblock to have survived and was originally part of a triptych with the theme: the three poetesses of Japan's Middle Ages.[1] Here the poetess *Ono-no-Komachi* (9th c.) is shown, whose tragic life as a symbol of human growth and decline inspired various *Nô* plays.[2]
The title of the triptych appears in the cartouche on the upper left: *Waka-no-san-gô* ("The Three Empresses of Poetry"),[3] with the additional information: *"Ono-no-Komachi"* and the information that the image should be placed on the left-hand side of the group of three. Another surviving print, which is to be found in the Tôkyô National Museum, bears the name of *Soto-ori-hime,* one of the three gods of literature. It was placed at the centre.[4]
Seven episodes from the life of the poetess *Komachi* are classified as the *Nana-Komachi.*[5] Our leaf is based on one of these. The poetess holds a poem-slip (*tanzaku*) in her hand, on which the first lines of a famous poem appear:

Makanaku ni	No one planted you:
nani wo tane tote	so out of which seed therefore
ukikusa no	have you grown so abundantly
(nami no une une	from the furrows of the waves,
oi shigeruran).	you drifting grasses?

This poem comes from the *Nô* play *Sôshi-arai Komachi* ("*Komachi* washing the poetry book"). It is one of the *Nô* plays attributed to Kanami, Kiyotsugu (1333–1384).[6] *Komachi's* incomparable poetic art provoked the envy of the poet *Ôtomo-no-Kuronushi*. In order to demonstrate *Komachi's* incompetence, he maintained that she had not written a certain poem herself, but had copied it out of the *Man'yôshû,* the most famous Japanese anthology of poetry (8th c.).[7] As proof, he showed a copy which included the poem. But *Komachi* washed the book and the poem – newly inserted with fresh ink and with evil intentions by her rival – vanished. In the poem quoted above she comments on this event. Only this one impression of the woodblock has survived. Richard Lane, from whose collection the leaf comes, correctly regards it as one of the most beautiful portrayals of a woman in the *Ukiyo-e*. The poetess wears several robes over courtly pantaloons. Sleeves and borders are lightly puffed. Large, stylized *aoi* leaves and blossoms, as well as cherry blossoms, together serve to embellish the kimono with severe geometric patterns. Her long hair, held only by a comb, hangs loosely down over her shoulders. A single strand falls down over her cheek. Robe and hairstyle were depicted by Kiyomasu II as stylized Heian costume. The artist arranged the figure as a vertical triangular composition. From the R. Lane Collection.

Sadao Kikuchi, (1969), no. 146; Lane, (1962), p. 89, fig. 39.
Ukiyo-e zenshû 1, (1957), fig. 89a (together with the centre page of the triptych).

[1] The order of the images does not appear to have been defined. A woodcut – produced at roughly the same time, also in three parts – by Nishimura, Magosaburô (ca. 1739) from the Scheiwe Collection (Essen, [1972], p. 32, no. 40, plate 7) shows *Ono-no-Komachi* in the center, the poetess Izumi Shikibu on the right and the poetess *Ise* on the left; see also below.
[2] Bohner, (1972) p. 337, names three plays of Kanami and two further plays of Seami on the theme of *Komachi*, pp. 366 ff., see also Weber-Schäfer (1960).
[3] Based on the "*Waka-no-san-jin*," the "Three Gods of Literature": Sotoori-hime, favourite of the Emperor Ingyô (reign: 412–454), Kakinomoto-no-Hitomaro (died 724) and Yamabe-no-Akahito (9th c.). KHT, II, p. 444 (see below).
[4] The third leaf appears to have been lost, see footnote 1.
[5] KHT, I, p. 444 (*nana* – seven).
[6] This poem was deciphered with the generous help of Martina Schönbein, M.A. The translation was done by K. Gottheimer, Univ. Heidelberg, see footnote 2 by Bohner, (1972), p. 338.
[7] "Collection of Ten Thousand Leaves." The twenty-volume anthology includes 4496 poems, mainly *tanka* (thirty-six syllable poems) and *naga-uta* (long poems). They were compiled by Tachibana-no-Moroe in the 8th c. The poems are written in "*yamato*"; i.e., in Japanese syllabic script, not in Chinese characters.

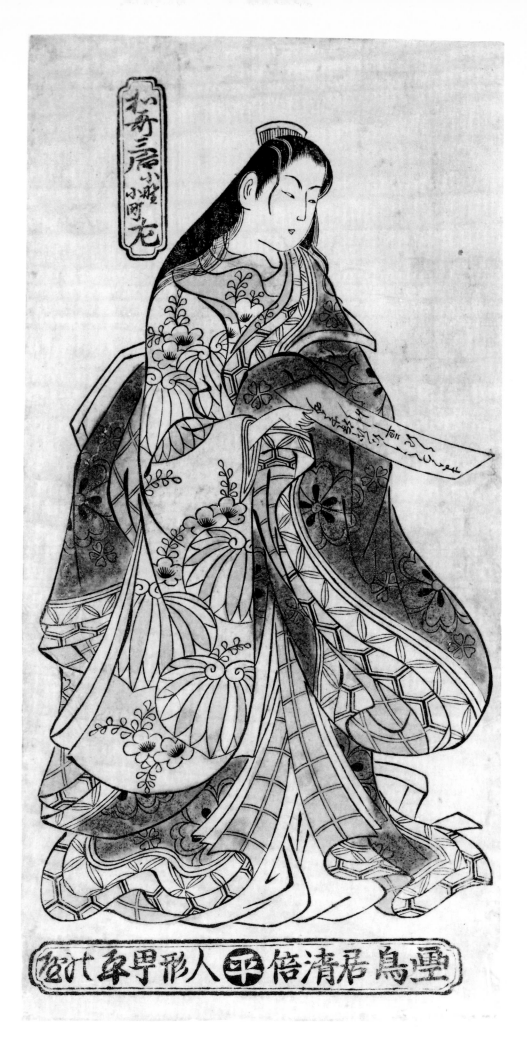

TORII, KIYOMASU II

THE ACTOR OGINO, IZABURÔ I
AS THE MEDICINE SELLER *ISHIYA, KINKICHI*

96 Signature: Torii, Kiyomasu hitsu

Publisher: (lower left as rectangular seal cartouche)

Hammoto, Odemma-chô (?), San-chôme, Moto-ya (?)

Maru-ya (Maruya Yamamoto Kyûzaemon)

Hoso-e, 33.8 x 15.9 cm

Urushi-e

Date: mid-1720

The actor Ogino, Izaburô I (1703–1738) appears in this woodblock print in the role of a medicine seller, *Ishiya, Kinkichi*. His wisteria crest is strikingly displayed on his black kimono. In his hand he is holding a small box on which the name of the medicine, *Wachû-san,* "Japanese-Chinese Medicine," appears, along with a circle (*maru*) containing the character "*Kyû*" (nine) as the crest of the publisher Maruya (Yamamoto) Kyûzaemon (recorded 1705/1782). He wears a sword in his wide belt. His hair is drawn up in the style of a youth.

Ogino, Izaburô I came from Kyôto.[1] It is said that he appeared in all three kinds of male roles (*aragoto, jitsugoto* and *wakashû*), playing sometimes even in women's roles. Before he advanced to become the public's darling, he performed in the capital city Edo after moving there, as one of the poor actors in the popular *Soga-Kyôgen*.[2] These folk-theatre plays were performed once a year at the beginning of the spring in Edo. They presented legends and events from the *Soga-monogatari,* in which the revenge of the Soga Brothers is portrayed (see pp. 100, 102). Such theatre groups can be compared to companies of travelling actors and jugglers who performed at the annual or parish fairs during the 17th and 18th c. in Europe.

Izaburô probably performed in women's roles at the Ichimura-za as early as 1724. In the eleventh month of 1728 he appeared as *Tora-no-Matatarô* – a youth role – in the play *Urashima-tarô-shichi-yomago,* as a woodblock print by Kiyonobu II shows.[3] In 1731 we see him in another theatre, the Nakamura-za, as a warlike heroine in the role of *Matsueda-hime* (pine twig [*hime*]). Okumura, Masanobu shows him defending himself with his fan against the sword blow of *Sodezaki, Karyû* in the role of *Hayasaku* ("Quick blossom"), another woman fighter. This play after the *Taiheiki* was also performed at the opening of the season in the eleventh month.[4] From 1738 he seems to have switched completely to the role speciality *tachiyaku* (male role). He died at the age of forty-five (1748).

Izaburô is one of those rare examples among Kabuki actors who succeeded in progressing from the world of popular theatre to the established world of Kabuki and its strictly defined actor dynasties. Such popular actors were normally treated with contempt.

G.A.

This leaf is a *hikifuda* (billboard poster), which was printed and disseminated in the Edo period to advertise a product or shop. Well-known literati and artists produced such *hikifuda* – in return for a substantial fee. In this case the actor Ogino, Izaburô in his role as *Ishiya, Kinkichi* advertises using a part of his Kabuki stage text for the well-known medicine Wachû-san, "an effective remedy based on an inherited secret family recipe," which was taken for colds, sensitivity to the weather and in summer for stomach upsets. The family firm was situated in Ume-no-Kimura village in Ômi province (today Shiga prefecture at Lake Biwa). According to the text, between Ishibe and Kusatsu there were lots of stores (selling the product) "roof to roof displaying their trade signs." But for "something to bring home" (*o-kunimoto e no miyagemono*), one did not need to travel as far as Lake Biwa, since there was a branch store, called "*Zezai*" (or "*Zesai*"), in the *shôgun* capital Edo in Ômori. The text of the role is full of allusions and puns and is almost impossible to relate in a meaningful form out of context. Thus, the name of the place (*Ume-no-kimura*) – literally the "plum tree village" – is associated with rapid growth (for which the plum tree was often a symbol in Japan) and achieving wealth through the medicine.

The metaphor comes from the Japanese nightingale (*uguisu*), which is thought to sit in the plum tree (defined iconographic attribution: "nightingale and plum tree" – "*ume ni uguisu*"). The text continues with another picture: the young nightingale "has hardly left the nest, her fontanel is not even secure" (literally!) – so quick was the success with this medicine, which was now already sold, even in Edo.

E. May

[1] Yoshida, I, p. 196.
[2] Shimura, p. 1299.
[3] *Ukiyo-e,* I, fig. 85. See also p. 112 of this catalogue, footnote 1. Gunsaulus, (1955), p. 67, Hanekawa, Wagen, no. 2.
[4] Ibid., fig. 36. Since he did not belong to any of the long established actor families which were set in their role specialities, he could allow himself this change of role speciality.

TORII, KIYOMASU II
(Recorded dates 1706–1763?, active ca. 1720 – ca. 1760)

FUYU: KOME OSAME ("WINTER: STORING THE RICE")

Leaf from the series: *Shiki-no-hyakushô* ("The four seasons of the countryman")

Signature: none

Publisher's mark: none

Hoso-e, 31.4 x 14.6 cm

Urushi-e

Date: ca. 1730

Torii, Kiyomasu II produced an identical series to this one for the Iga-ya publishing house, differing only in that a long explanation is given in the upper band of clouds, in addition to the artist's and publisher's signatures. However, in our print the title cited above is given to the left.
As in other landscape pictures influenced by *Yamato-e*, the upper and lower parts are hidden behind bands of clouds. The rice packed in bundles is being loaded onto horses in front of a farmhouse. An old man looks on. Two farmers, one with a parcel of rice, the other with a bundle of brushwood, are plodding up the mountain. By means of few elements, the artist depicts the final phase of the work of rice cultivation. As in the leaf by Shigenaga (see p. 116), the individual motifs are added one above the other.

Provenance: Otto Jaekel Collection.

Signed leaves: Buckingham Coll., Gunsaulus, (1955), vol. 1, p. 94 and TNM I, no. 98.
On the *Shiki-no-hyakushô*: Yoshida, II, p. 14.
Portheim, Heidelberg, (1975), III, p. 13.

TORII, KIYOMASU II
(1706–1763)

THE ACTORS ICHIKAWA, DANJÛRÔ III (WAJURÔ) AS *SOGA, GORÔ* AND BANDÔ, MATAHACHI AS *ASAHINA-NO-SABURÔ*

Signature: Torii, Kiyomasu hitsu

Publisher's mark: "*yama*" (in a circle); Maru-ya Kohei

Hosoban, 28 x 14.4 cm

Benizuri-e (pink-green print); probably issued later from the original block

Date: Ken'en 3rd year (1750)

100 The scene comes from the play *Kayou-kami Chidori Soga*,[1] which was performed on the fifteenth day of the first month of the third year of the Ken'en Era (1750) at the Ichimura-za theatre. The grimacing hero *Asahina-no-Saburô,* played by Bandô, Matahachi, kneels on one leg in front of a backdrop with a blossoming plum tree. With a furious expression he tugs with both hands at the bridle of a dappled horse, which tosses its head in the air defiantly. The younger of the two Soga Brothers, *Gorô Tokimune,* seems to be losing his balance on the horse. He stretches out his arms in a violent movement. In one hand he holds a long sword, with the other he makes a defensive gesture. This role is played by Ichikawa, Danjûrô III, here called Wajurô. The widely billowing sleeves of his robe were an indication in the Kabuki repertoire of a fierce struggle. Danjûrô's robe is decorated on the right sleeve with the *mon* (crest) of the Ichikawa family: rice measures, one inside the other. The other sleeve bears a tea blossom under a roof, the Soga crest. Butterflies on the robe are the identifying symbol of *Soga, Gorô.* Matahachi's robe partially reveals the crane *mon* of the Bandô clan. Next to this is the stylized character for "East" in one of the usual round cartouches. This is the second character of his family name.

The scene depicted on the woodcut print shows the episode known as "Tugging at the Reins."[2] The elder of the Soga Brothers, *Jûrô Sukenari,* has invited *Hatakeyama, Shigetada,* the strong and faithful vassal of Minamoto-no-Yoritomo.[3] Also present is *Asahina-no-Saburô,* the mighty hero. Then *Oiso-no-Tora,* who waits on the guests, makes the mistake of first serving wine to her lover *Jûrô,* instead of to the honourable guest, as was the custom. The latter is insulted and a fierce argument ensues. *Gorô* hurries to the aid of his brother. On his arrival at the gates, *Asahina* tries to pull him from his horse by force. But he does not succeed.[4] The actor Bandô, Matahachi achieved his breakthrough in the role of *Asahina* shown here, having already played on the stage since 1740. Following this success, he changed his name to Mihachi. He died in 1770. According to contemporary accounts, he was one of the best *aragoto* performers.

Danjûrô III,[5] who here plays the popular Soga hero *Gorô,* was an adopted son of Ichikawa, Danjûrô II (1688–1758) (see pp. 92, 102). Little is known about him as a person, but he must have made an exceptional impression on his contemporaries. It is considered certain that he was born in 1721 as the son of a businessman, the owner of the Edo-ya (publisher's shop?) in the Kobiki-chô quarter in Tôkyô. He began his stage career as a mere seven-year-old. Danjûrô II adopted him at this age, probably in 1727. A print from this year by Torii, Kiyonobu II shows him as a small boy in a heroic role, his toys at his feet. The inscription reads: "Ichikawa, Masugorô, adopted son of Ichikawa, Danjûrô."[6] The great actor had given him this name himself, which refers to the *mon* of the Ichikawa, the rice measure (*masu*). In 1735 Danjûrô II passed the name on to him and took for himself the name Ebizô (see p. 102). A sheet by Torii, Kiyomasu II identifies the young actor with his new name (1735).[7] But in 1740 he changed his name again to Wajurô (*wa* – Japan). We do not know the reasons for his abandoning the crowd-pulling name of his father. He appears with the name "Wajurô" on our sheet from the year 1750. He died at the age of 32 in 1753.[8] A short time afterwards, Danjûrô II adopted the actor Matsumoto, Kôshirô II (1711–1788), who is thought to have been his own, illegitimate son and who dominated the stage in the following decades as Danjûrô IV, (see p. 112).[9]

1 *Kayou-kami* is the guardian deity of travellers. He is also known as *Dôsojin.* Visitors to the brothel district also enjoy his protection. *Chidori Soga* may refer to the elder Soga brother, *Jurô,* whose robes were decorated with chidori birds, a kind of plover.

2 KHT, II, pp. 325 f. (Soga); KHT, I, p. 37 (*Asahina*). A better-known version of the episode is "The tearing off of the armour," in which *Asahina* tears *Gorô*'s armour off.

3 In the civil wars of the 12th c. (Gempei), the Minamoto conquered the Taira under Minamoto-no-Yoritomo, who was to become sole ruler of Japan (see pp. 86, 100).

4 See KHT, I. p. 37.

5 In the whole of Kabuki literature, little attention is paid to this actor, although his contemporaries must have been enthralled by this early maturing talent.

6 This woodblock print by Kiyonobu II is to be found in the Buckingham Coll., Chicago (Gunsaulus, [1955], p. 75). Following his debut in 1727, he was already looked upon the very next year as one of the most promising actors of his time. According to Western calculations, Masugorô was six years old. A further sheet by the artist from 1729 also gives him the name Masugorô (*Ukiyo-e zenshû* I, fig. 103).

7 Woodcut, repr., *Ukiyo-e zenshû,* I, fig. 88.

8 Barth, (1972), p. 239, writes that Danjûrô III had already died shortly after 1741. He fell ill at a guest performance with his father in Ôsaka, and returned shortly afterwards to Edo where he died. The reasons for his sudden departure could have lain elsewhere, however. Danjûrô II became fascinated by his young partner, the *onnagata* performer Onoe, Kikugorô I (1717–1783), whom he took with him to Edo after the guest performance. To everyone's great surprise, Kikugorô suddenly changed his speciality, which was unheard of up to that time, and excelled as *tachiyaku* (male-role performer) in *budô* (war-hero) and *jitsugoto* (positive hero) roles. (Barth, [1972], p. 244). Evidently Danjûrô III appeared only in *Soga* roles. Perhaps he had also failed to live up to his adoptive father's expectations. Perhaps the change of name in 1740, in which he gave up a famous name attracting the public for a name of no worth, Wajurô, is a sign of an estrangement between adoptive father and son.

9 Barth, (1972), p. 243.

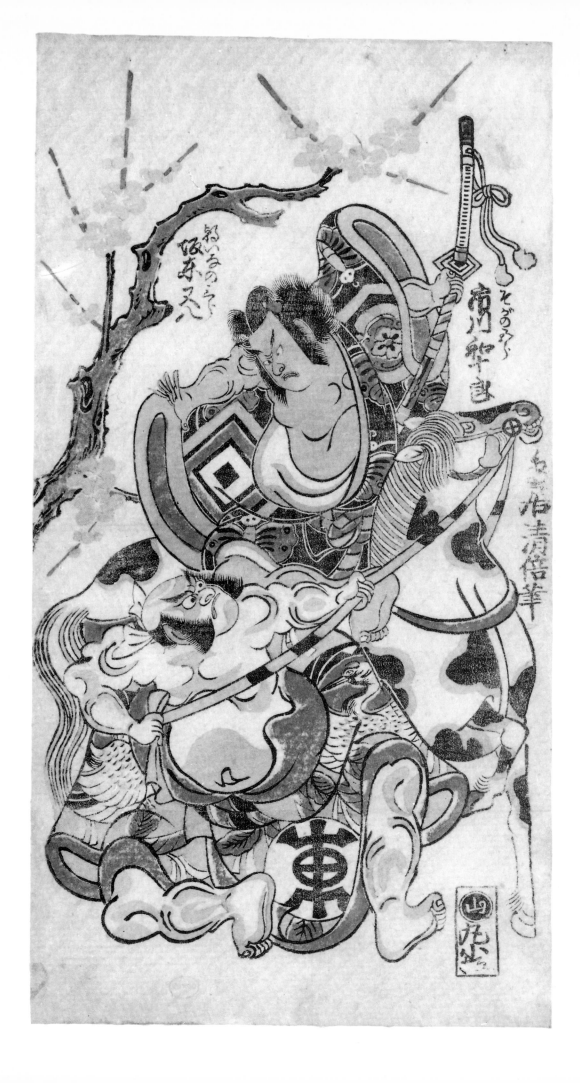

TORII, KIYONOBU II
(active ca. 1720 – ca. 1760)

Kiyonobu II may have been the son of the older Kiyonobu who took over his father's name at the latter's death. It is very hard to distinguish between late works of the old master and the early works of his son. Subsequently Kiyonobu II developed his own graceful, reserved style, which is, however, in its turn hard to distinguish from works by Kiyomasu II. Kiyonobu II's life extended into the period of *benizuri*-printing, which made the weaknesses of his compositions more evident than in the previous hand-coloured *urushi-e*.

THE ACTOR ICHIKAWA DANJÛRÔ II
AS *SOGA, GORÔ*
IN THE OPENING SCENE OF THE PLAY *YA-NO-NE*

Signature: Eshi Torii, Kiyonobu hitsu

Publisher: Maru-ya, Kyohei; i.e., Yamamoto

Marked: hammoto (publisher), Ôdemma, San-chôme, Yamamoto

Hoso-e, 32 x 15.4 cm

Urushi-e

Date: ca. 1735

This famous leaf comes from the collection of Julius Kurth, who reproduced it in his two important publications of 1921 and 1922.[1] He attributed the print to Torii, Kiyonobu I. Meanwhile research supports an attribution to Torii, Kiyonobu II. It is the only known impression of this woodblock.[2]
The actor Danjûrô II (1688–1758)[3] played *Soga, Gorô Tokimune,* the younger of the two Soga Brothers. The revenge of the two brothers, *Soga, Jûrô Sukenari* and *Soga, Gorô Tokimune* on *Kudô Suketsune,* who had murdered their father in 1177 in the mountains of Hakone, is one of the episodes of the civil wars between the Taira and Minamoto in the 12th c. The two brothers waited until they were adult, finally attacked their father's murderer in 1193 in a hunters' camp, and killed him. For this deed they were put to death by Minamoto, Yoritomo, commander-in-chief of the army and victor in the civil war.[4]
The history of this vendetta (*Soga-kyôdai*) is one of Kabuki's best-loved themes, and has provided the material for innumerable dramas.[5] Danjûrô II had already played *Gorô* in 1708 at the age of twenty, but he first created the interpretation shown here in 1729. Entitled *Ya-no-ne* (Arrow Head), his performance was originally only one scene in the drama *Koizume Sumida-gawa* (Love Trade at the Sumida River). *Ya-no-ne* is today an independent play; one of the eighteen famous plays by the Ichikawa family, performed as early as the 18th c. to open the second half of the season at the beginning of the year. It is not so much the dramatic story, but rather the choreography in exaggerated *aragoto* style, which nowadays still provokes theatre enthusiasts to rounds of ecstatic applause.[6] The print shows the opening moment. *Soga, Gorô* is sharpening an enormous arrow on a whetstone in a cask filled with water. He is preparing himself for the destruction of his mortal enemy. Behind him there is a stand containing large arrows held upright. Above him there is a blossoming plum branch indicating the season, and a mighty sword in a stand. This is the sword with which he will later slay *Kudô, Suketsune,* after awakening the sleeping enemy with the cry: "The Soga Brothers have come to take their revenge."
Danjûrô II is dressed in full armour. Over this he has put on a robe, the upper part of which bears stylized clouds, while the lower part – almost completely hidden under the folds – is decorated with crayfish (*ebi*).
Danjûrô II had passed his name on to his adopted son in 1735 and called himself Ebizô, as can be read on the inscription "Ichikawa Ebizô."[8] The butterfly (also half hidden) and tea blossoms under a roof on the black upper robe are the crests of the Soga.[9] A long apron bears the crest of the Ichikawa: rice measures, one inside the other. This crest is repeated as the hilt (*tsuba*) of the sword (*tachi*) hung overhead. The billowing sleeves demonstrate the actor's energetic movements.
In addition to the woodblock print reproduced here, Kiyonobu II also painted a votive picture (*ema*) of Danjûrô II in this role for the Saidai-ji temple in Nara.

[1] Kurth, (1921) and (1922), see Bibl. Kiyonobu II also created another woodblock print of this scene; the actor's dress exhibits *ebi* and butterflies (no plum blossoms or sword). But the print is not artistically convincing. (Sakai Coll., [1968], B. no. 2).
[2] See Link in: *Ukiyo-e Art*, 1968, vol.19 and *Ukiyo-e geijutsu,* (1972), no. 34.
[3] See also p. 92.
[4] KHT, I, p. 325.
[5] Halford, (1956), p. 352.
[6] Barth, (1972), p. 300; Halford, (1956), p. 252. "*zume*" – the term refers to objects which are packed in a box.
[7] It is considered cowardly to murder a sleeping enemy. But the cry rouses the whole camp. The brothers are captured.
[8] In 1735 Danjûrô adopted Mimasuya, Masugorô (born 1722), but he died in 1753; see p. 100.
[9] Waterhouse, (1975), p. 52; Schmidt, (1971), p. 77.

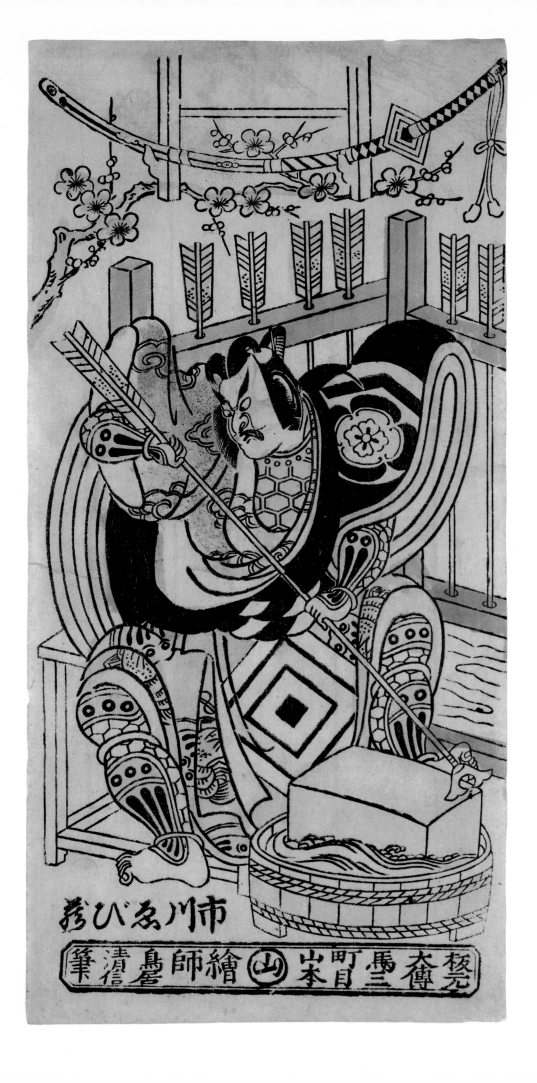

TORII, KIYONOBU II
(active ca. 1720 – ca. 1760)

THE ACTOR SEGAWA, KIKUNOJÔ I AS THE FOX SPIRIT
KUZU-NO-HA

Signature: Torii, Kiyonobu hitsu

Publisher: Sakai-machi Nakajima-ya

Hoso-e, 32.1 x 15.2 cm

Urushi-e

Date: 1737

In the third month of the year 1737, the play *Ô-uchi kagami Shinodazuma* ("Palace Mirror of the Wife from Shinoda") was performed at the Nakamura-za.[1] The leading role of the female fox spirit *Kuzu-no-ha* (arrowroot leaf) was played by Segawa, Kikunojô I (1691–1749).[2]
This actor was one of the most important *onnagata* performers of his time. Originally he came from the stage of the Dôtombori district in Ôsaka. From 1712 he played female figures, but did not receive any special attention until his thirtieth year. He even turned his back on the stage for a while, and adopted a middle-class profession. But in 1720 he returned to the theatre. For ten years he played as a *zamoto* at various Kamigata theatres.[3] In 1730 he came to Tôkyô (Edo); from 1737–1741 he played outside the capital. Kikunojô also lived as a woman in his private life. In a work fundamental to the school of Kabuki, he wrote down his thoughts on playing women. It bears the title *onnagata hiden* ("The secrets of *onnagata*"). This work also contains his thoughts on the stage dance (*shosagoto*), giving guidelines for dance musicals such as *Muken-no-kane*[4] or *Shakkyô Dôjôji*, on the basis of which a form was adopted that is still valid today.
Our sheet was produced on the occasion of his farewell performance on leaving Edo. He was then over forty-five years old. The dance known as the Shinoda Dance must have received special acclaim from his contemporaries, for Kiyonobu II created at least three different versions at three different publishing houses.[5]
The woodblock print published here is the only case where Kikunojô's *uchikake* bears leaves of the *kuzu* plant. The robe is decorated with *aoi* leaves and plum blossoms in tortoise-shell pattern outlines. Both motifs, the *aoi* leaves and plums, also adorn Kikunojô's robes in other prints.[6] They seem to be connected more with his person than with the role depicted here.
Kuzu-no-ha (arrowroot leaf)[7] is one of the best known legends of the ancient fox superstitions in East Asia, originating in China. Pu Songling has recorded many of these beliefs in his work "Strange Stories from the Studio of a Chinese Scholar" (12th c.).[8] In Japan this kind of belief in foxes seems to have been imported in the 10th c. There, a kind of fox belief is to be found in which the fox is also associated with rice cultivation.[9]
The legend of *Kuzu-no-ha* is as follows: the courtier *Abe-no-Yasuna* (10th c.) was going for a walk one day in the park of the Inari shrine and was reciting poetry, when a vixen sought his protection from the hunters who were chasing her. He hid the fox under his robe and thus saved her life.
Shortly afterwards, he met a beautiful young woman and married her. She bore him a son, but suddenly, after three years, she disappeared, leaving behind a poem on the house wall:

Koishikuba	If you love me
Tazunekite miyo	come and look for me
Izumi naru	in the Forest of Shinoda in Izumi
Shinoda no mori no	and you will find
Urami Kuzu no ha.	an arrowroot leaf.

In a dream she appears to her husband and reveals to him that she is really the vixen whose life he saved. The son which she bore to *Abe-no-Yasuna, Abe-no-Seimei* (died 1005), became a gifted astrologer with magical powers at the court of the Emperor Toba.

Provenance: M. Haviland Collection;
Vignier et Inada, (1909), no. 56.

[1] The theme of the *Kuzo-no-ha* legend was used in a *jôruri* play (for the puppet theatre) in Kyôto by the playwright Tosa-no-jô in the 1680s. Ki-no-Kaion (1663–1742) took up the theme again in his puppet play *Shinoda-no-mori-onna-urakata*. This was used by the house playwright Takeda, Izumo II (1691–1756) for his play *Ashiya dôman ôuchi kagami* at the puppet theatre Takemoto-za in Kyôto. It seems that the story was soon adapted for Kabuki (see also Yoshida, [1972], I, p. 323). Okumura, Masanobu depicted Segawa, Kikunojô in the role of *Kuzu-no-ha* on a woodblock print as early as 1736. The play has the same title as the last play mentioned above by Takeda, Izumo II (previously Saitô Coll., *Ukiyo-e zenshû*, I [1957], fig. 50). Kikunojô will have taken the great success of this play into account when selecting this piece for his farewell performance.

[2] The syllable *jô* at the end of a name also applies to puppet players. Originally this was a title of the provincial governors in the Heian period, and from the Kamakura and Muromachi periods onwards was also conferred on craftsmen (sword-smiths, also puppet-makers, *Nô* musicians, etc.); Barth, p. 188, footnote 541. The literal translation of the name Kikunojô is *"jô* of the chrysanthemum." Kikunojô's biographical data are also given differently: born 1693 and died 1750.

[3] It is only in Edo (Tôkyô) that *zamoto* means "theatre director." In the Kamigata (Kyôto–Ôsaka) *zamoto* refers to the actor of highest rank, while the theatre director is called *nadai*; Barth, (1972), p. 219.

[4] The *uki-e* by Okumura, Masanobu discussed on p. 72 also deals with this theme. It can likewise be dated to the 1740s.

[5] Publishers of the other sheets: the sheet from the Michener Coll. was publ. by Murata-ya (Link, [1980], Kiyonobu II, no. 4), while the sheet of the Winzinger Coll. was published by Mikawa-ya Rihei (Winzinger, [1975], p. 32, no. 4).

[6] *Aoi* (bot. Paulownia imperialis), symbol of integrity of character, appears in both versions by Kiyonobu II cited above. On the aforementioned sheet by Masanobu (see footnote 1), Kikunojô also wears *aoi* leaf and chrysanthemum decorations. A further woodblock by Kiyomasu II, on which Kikunojô appears as *Matsukaze*, presents the actor with *aoi* and plum blossoms on his robe (*Ukiyo-e taikei* [1974], vol. 3, fig. 128). Finally, Kikunojô as the actress Okuni in a woodblock print by Nishimura, Shigenaga bears plum blossoms on his robe; (TNM, I, no. 328).
Chrysanthemums, which also appear on the woodblock prints in the Michener and Winzinger Collections, are reminders of the belief that a fox spirit transformed into a woman reveals her true nature when she sleeps under chrysanthemums (Joly, [1983³], p. 148).

[7] *Kuzu* (bot. Pueraria Thunbergiana) was used in early times to produce a material resembling hemp. The legend is cited according to Joly (1983³), p. 53, cit.; see also KHT, I, p. 474, I, p. 19.

[8] Joly, op. cit. pp. 144, 143; H.A. Giles, *Strange Stories from a Chinese Studio*, reprint, Taipei, (1971).

[9] Joly, ibid. Inari shrines are dedicated to the fox.

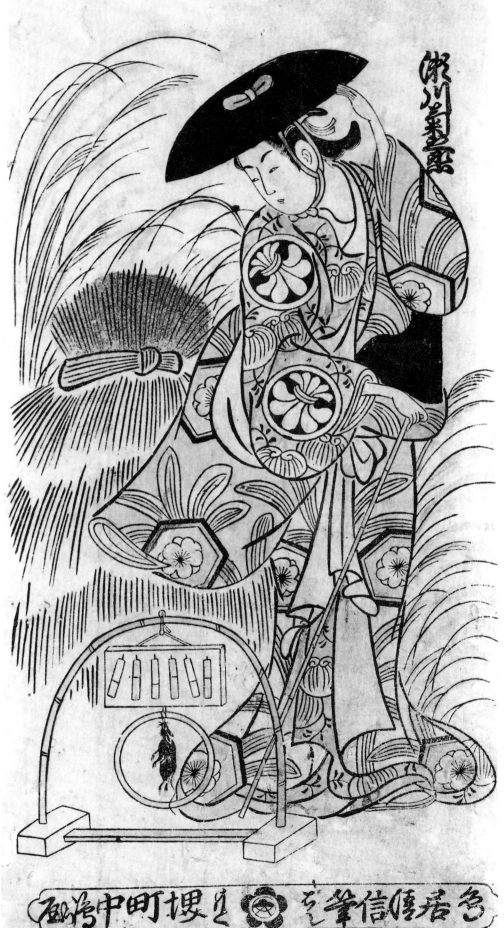

TORII, KIYONOBU II
(1702–1752?)

THE ACTOR ICHIKAWA EBIZÔ AS *HATA ROKUEIMON*

Signature: Torii Kiyonobu fude

Publisher: Hammoto Murota-ya

Urushi-e

Hoso-e, 32 x 15 cm

The scene is part of the second act of the historical drama *Mitsugifune Taiheiki,* which was performed at the Ichimura-za theatre in Edo in the eleventh month of 1738 at the beginning of the season (*kaomise).*

Ichikawa Danjûrô II (1688–1758), who had been using the name Ebizô since 1735, poses here in front of a house in the role of *Hata Rokueimon.* This is the tense moment when *Rokueimon,* who is just washing his hands, discovers a pool of blood on the rim of the clay water container. Supporting his arm on the lid of the vessel, his sword held high in his right hand, he stares horror-struck at the blood, the moment before he lifts the lid and discover the severed head of *Yômeinosuke*. The finely articulated ornamental drawing of details – the bamboo, the patterns on the basin and robes – is characteristic of the Torii masters' woodblock prints during these years. The painstaking illustration of the set in no way diminishes the power of the image; on the contrary, it brings the freezing of the face and the dramatic gesture of the raised sword to full expression.
Provenance: Scheiwe Collection.
R. Hempel

Rose Hempel, 1959, *Kat. Coll. Scheiwe,* No. 10, Pl. 1
Rose Hempel, Stuttgart 1963, No. 10 p. 43
Rose Hempel, *Kat. Essen* 1972, No. 15

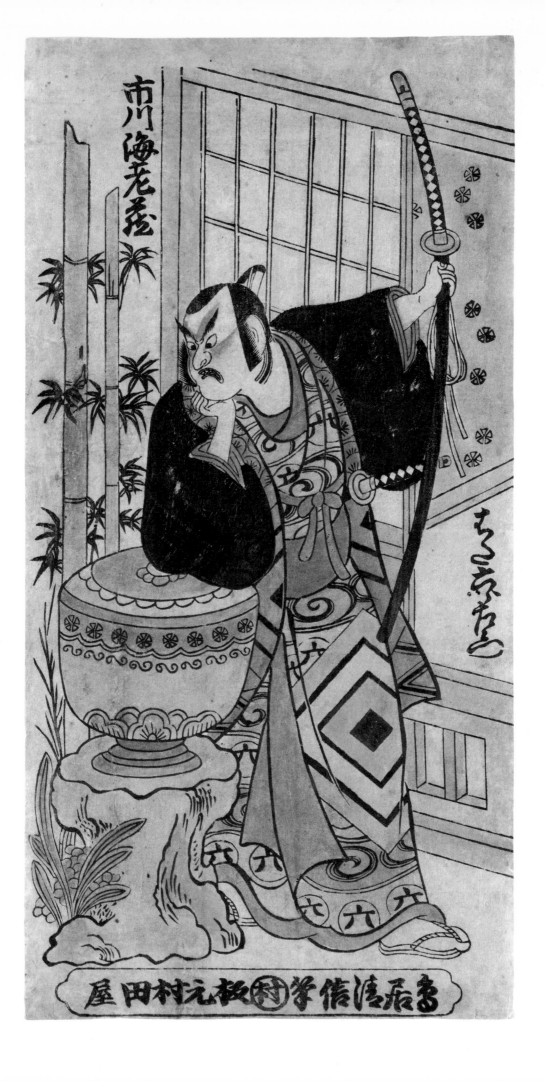

TORII, KIYONOBU II
(active 1720 – ca. 1760)

THE ACTORS SEGAWA, KIKUNOJÔ II (KICHIJI)
AND SEGAWA, KUKUJIRÔ

Signature: Torii, Kiyonobu hitsu

Publisher: hammato and the three triangles of Urokogata-ya (publisher)

Hoso-e, 30.5 x 13.6 cm

Benizuri-e (two-colour print in pink-green)

Date: Hôreki Era (1751–1764), probably 1753

A youth acted by Segawa, Kikunojô II (here described as Kichiji) plays the flute to a girl acted by Segawa, Kikujirô under a blossoming plum tree. The actor impersonating the girl holds a little table in his hand. His kimono is decorated with large stylized iris flowers, while his *uchikake* (cloak) bears *chidori* birds. On his sleeves is the *mon* (crest) of the Segawa family. The youth, also bearing the *mon* of the Segawa family, wears a cloak with blossoms or fruits (Tachibana?) over a kimono decorated with cherry blossoms.
Segawa, Kikunojô II (1741–1773) was the adopted son of Segawa, Kikunojô I (see p. 104). The former was also known as Hamamura-ya Rokô or Ôji-no-Rokô and first bore the name Tokuji, then Kichiji as in this sheet, and later, after 1756, called himself Kikunojô after his adoptive father. He is regarded as his father's worthy successor in *onnagata* roles. But here he plays a *wakashûgoto* (youth) role.[1] Segawa, Kikujirô, also known as Hamamura-ya Sengyo, was a younger brother of Kikunojô I. He lived from 1715–1756. He also appeared as an *onnagata* actor (female impersonator).[2]
The two actors are depicted here on a sheet which is difficult to identify according to theatre history. The only play which comes into consideration is the "*Shida-no-Kotarô yotsugi kagami*" ("Mirror of the inheritor Kotarô of Shida"), which was performed at the Nakamura-za in the seventh month of 1753. But plays with these features are usually performed at the *kaomise*[3] ("To show one's face," eleventh month) and the *shôgatsu*[4] at the New Year. From the hairstyles it is possible to date the print to the first years of the Hôreki Era.
The print shows all the characteristics of the *benizuri-e*. The composition is simpler than that of the contemporary *urushi-e* leaves. The robe patterns seem crude and lacking in structure. This phenomenon may well be due to technical difficulties at the beginning of multi-coloured printing. It was apparently only possible to achieve a clear print at this time by simplifying the drawing.
Provenance: Otto Jaekel Collection.

[1] Barth, (1972), p. 310; Rumpf, (1924), p. 139.
[2] Rumpf, pp. 138f., Barth, p. 247, footnote 653.
[3] The actors presented themselves to the public with only a little make-up and in their normal clothes.
[4] *Shôgatsu* (Performance at the New Year). Portheim, (1975), I, 3.

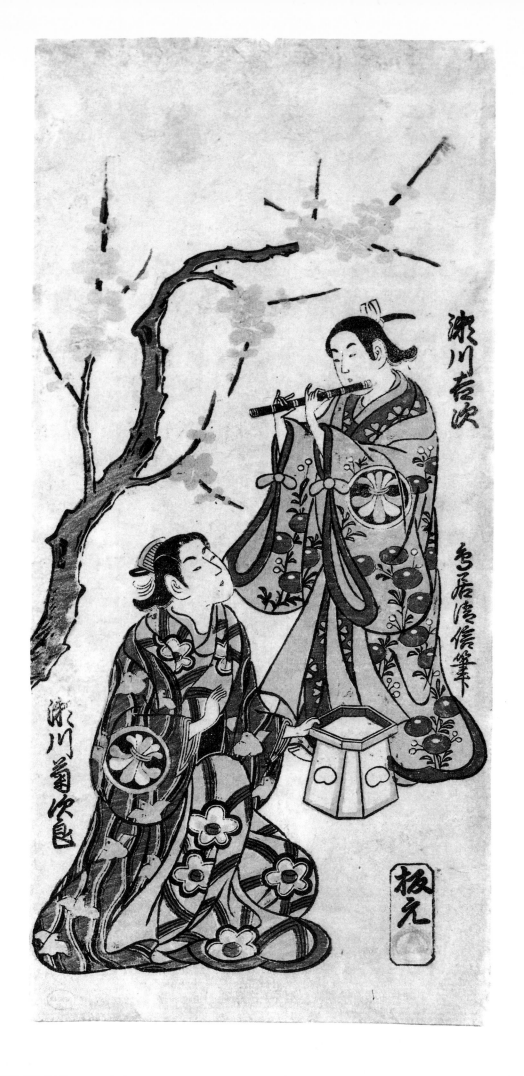

UNSIGNED
TORII, KIYOMASU II

THE TWO ACTORS ICHIKAWA, DANZÔ I AND ÔTANI, RYÛZAEMON

Publisher: beni-e kongen hammoto (original publisher)/Okakuba san-chôme (3rd chôme)

Urokogata-ya, Publisher's seal: Urokogata-ya

Hoso-e, 32.5 x 15.2 cm

Urushi-e

Date: 1735

The two actors are depicted in a *mie* pose.[1] Ichikawa, Danzô appears above, identified by his crest and his name written beside him. Underneath Ôtani, Ryûzaemon kneels, also identified by family crest and inscription. The actors play two heroes in the *aragoto* style.

Ichikawa, Danzô,[2] the founder of this subsidiary branch of the Ichikawa family, was one of the less important actors of his time. He was born in 1662 and was a pupil of Danjûrô I. In 1731 he removed a cross-bar from the Ichikawa family crest which he had inserted in 1716. His family are counted as Kamigata actors, since they often appeared in West Japan. He died in 1740. Little is known about Ôtani, Ryûzaemon. He played from 1716 in minor roles, retired from the stage in 1745, and died in 1747.
The style of the leaf and the altered crest of Ichikawa, Danzô indicate a dating to the fourth decade of the 18th c. The roles cannot be identified more closely, in our view.[3]

[1] Reading of the actor's name E.K. On the *mie* pose see Barth, (1972), p. 292.
[2] Barth, (1972), pp. 223, 243; footnote 649.
[3] Eiko Kondo suggests that Danzô is shown here as *Kamakura Gongorô Kagemasa* and Ryûzaemon as *Abe-no-Munetô* in the play *Kotobuki kôyô Kagemasa* (Kagemasa congratulated on his official duties), which was performed at the Kawarazaki-za in the 9th month of 1738.

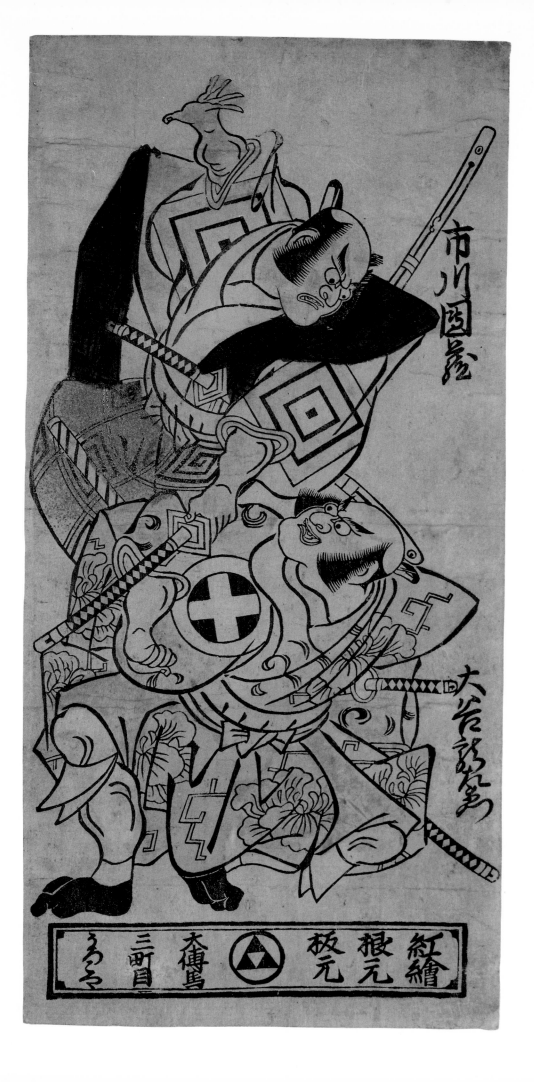

NISHIMURA, MAGOSABURÔ
(NISHIMURA, SHIGENOBU)
(active ca. 1730 – after 1740)

There has been some confusion surrounding this artist, because various scholars believed it possible to prove that Shigenobu was an earlier name of Ishikawa, Toyonobu. In the meantime, this problem seems to excite less interest, or has at least been deferred, so that for the present we can regard Shigenobu as an independent artist in his own right. What we really know about him is little enough. His style

follows that of his teacher Nishimura, Shigenaga, without adopting the latter's pictorial innovations; indeed one could perhaps identify a return to the stylistic means of a somewhat earlier time.

Nishimura's name as an artist was Magosaburô from 1731, and Shigenobu from 1737/38 to about 1740.

J.G.G.

112 THE ACTORS MATSUMOTO, KOCHIRÔ II
(DANJÛRÔ IV) AND ICHIMURA, MANZÔ (UZAEMON IX)

Signature: eshi Nishimura, Magosaburô hitsu
(left side of the cartouche)

Publisher: Moto-ya, Ôdemma, San-chôme, Maru-ya
(right side of the cartouche)

Hoso-e, 31 x 14.8 cm

Beni-e

Date: 1744, 7th month (ca. 1738)

This leaf is an altered version of a woodblock by Shigenobu, which shows the two actors Sanjô, Kantarô (see p. 78) as *Nagoya, Sanza* and Ogino, Izaburô[1] as *Fuwa, Banzaemon* in a theatre play dealing with the fate of the former. This original version will be discussed first. It is to be found in the Ainsworth Collection, Oberlin, Ohio.[2] Two men are having a fierce argument in front of a garden fence. *Fuwa, Banzaemon* (in the foreground) insults *Nagoya, Sanza* who seems to have been stopped in his tracks, as if stricken by a bolt of lightening. He clenches his left fist in a gesture of suppressed anger. His opponent *Fuwa, Banzaemon* almost steps on a lantern lying on the ground which bears the inscription "Nagoya."[3] The sandal which he is holding in his aggressively raised hand belongs to a third person, not shown in the print, *Sanza's* fiancée *Koshimoto Iwahashi*. The patterns on *Izaburô (Banzaemon)'s* kimono represent shafts of lightening (*ikazuchi*).[4] On his black *haori* only his *mon* is left blank. Kantarô's kimono is decorated with folded umbrellas, which are actually motifs from the Sukeroku play (see below).[5] His checked *haori* displays his butterfly crest. This dramatic print was used by Shigenobu a second time for the woodblock print discussed here by the same publisher. But here the youthful head of Kantarô has been removed and replaced with the head of a horrible, white-haired, white-bearded old man. The crests on the robes of the two figures have been exchanged. The crest of Ogino, Izaburô has been replaced by the orange blossoms of Ichimura, Manzô (Uzaemon IX),[6] while the crest of Sanjô, Kantarô has been replaced by the crest of Matsumoto, Kôshirô II.[7] But trouble was not even taken to alter the ornamentation of the robes or the name on the paper lantern. Thus the woodblock print suddenly comes to depict a new theatrical performance which it is even possible to identify. Ichimura, Uzaemon IX appears as the *sumô* wrestler with the name *Ikazuchi, Tsurunosuke*. Thus the robe patterning "*ikazuchi*" becomes his family name. Danjûrô IV plays the *Yamana, Sôzen*. The title of the play, which was performed in the eight month of 1744 at the Ichimura-za, namely *Kaibyaku Imagawa-jô*,[8] can be connected with one of the earliest Kabuki plays. The *jôruri* play *Imagawa-monogatari* was reworked as a play in two acts for Kabuki. The performance of this drama in 1664 heralded the beginning of Kabuki plays having several acts.

The play shows the deeds of the hero *Imagawa, Toshihide*, who after being rescued from the most desperate need, takes revenge on those responsible for his ruin. A version performed in 1699 is analysed in depth by Barth.[9] The new, substituted head also introduces other associations.

A similar hairstyle as the one for *Yamana, Sôzen* is worn, for example, by the *Tengu King*, ruler of the winged, long-nosed wood spirits. This description fits that of the adversary of the *Sukeroku* in the famous version of the Soga Vendetta created by Danjûrô II (1713–1749).[10] Torii, Kiyomitsu on a *benizuri-e* from the period around 1760, shows the actor Sakata, Hangorô in the role of *Satsushima, Hyôgo*, as an old man with long white hair and a white beard.[11] Such alterations to the woodblock and the ensuing changes in identification are known elsewhere in *Ukiyo-e*. The example discussed illustrates this procedure particularly clearly.

1 On Ogino, Izaburô see p. 96. The *mon* reproduced here seems to have been the actor's personal crest. The wisteria crest belonged to the Ogino family, who adopted the actor. The personal crest seems to have been used exclusively by Izaburô from 1733 (repr. Gunsaulus, [1955], p. 96. Woodcut by Torii, Kiyomasu II). In the Victoria and Albert Museum, London, there is a woodblock print by Torii, Kiyonobu II dated about 1725, on which Izaburô is already shown with his personal crest (Crighton, [1973], I, 36). He appears on a woodblock print by Masanobu as the courtesan from Kyôto in a version of the "Courtesans of the Three Cities," from the period around 1730 with both *mon* on his robe (see Takahashi, [1973²], p. 24, III, no. 18).

2 Keyes, (1984), p. 136, cat. no. 56.

3 Contents: Halford, (1956), p. 345. The play carries the title *Ukiyo-zaka Hiyoku no Inazuma*, usually called *Nagoya, Sanza*. It is the story of a stolen picture scroll, with which *Sanza* had been entrusted by his master and of which he was robbed by the villain *Fuwa, Banzaemon*. This scoundrel molests the fiancée of *Sanza, Koshimoto* (chamber-maid) *Iwahashi*. She flees and loses her sandal in the softened earth around the Hase-Kannon temple in Kamakura. The rogue put this sandal into the box in place of the valuable scroll. The scene occurs in the first act.

4 This robe pattern is associated with the role of *Fuwa Banzaemon*.

5 Ill. of Danjûrô II as *Sukeroku*, woodcut by Masanobu (ca. 1749). The umbrella is called *shigure gasa*. Gunsaulus, (1955), p. 171, no. 113, woodcut by Masanobu; Link, (1980), p. 117.

6 On this actor, (see p. 131). He used the name Manzô from 1731 to 1745. He was theatre director of the Ichimura-za.

7 Matsumoto, Kôshirô II (1711–1778): the name of Danjûrô IV, who was considered to be the illegitimate son of Danjûrô II. He grew up in the house of the actor Matsumoto, Kôshirô I (see p. 58), and married a niece of this actor. From 1735–1754 and again from 1770–1772 (see p. 100), he called himself Matsumoto, Kôshirô.

8 Names, roles and play identified by E.K.

9 Barth, (1972), p. 215, pp. 219–220. Title of the play: *Keisei Hotoke no hara*, but the name *Imagawa* is used by the main heroine, a courtesan. The hero is called *Umenaga, Gyôbu*.

10 Halford, p. 321. It is not impossible that this type of old man uses a European as a model. On wood spirits, KHT, II, p. 385. On the *Soga* Vendetta, see p. 102.

11 Sakai Coll., *Three Hundred Years of Ukiyo-e*, (1968), sect. B., no. 9.

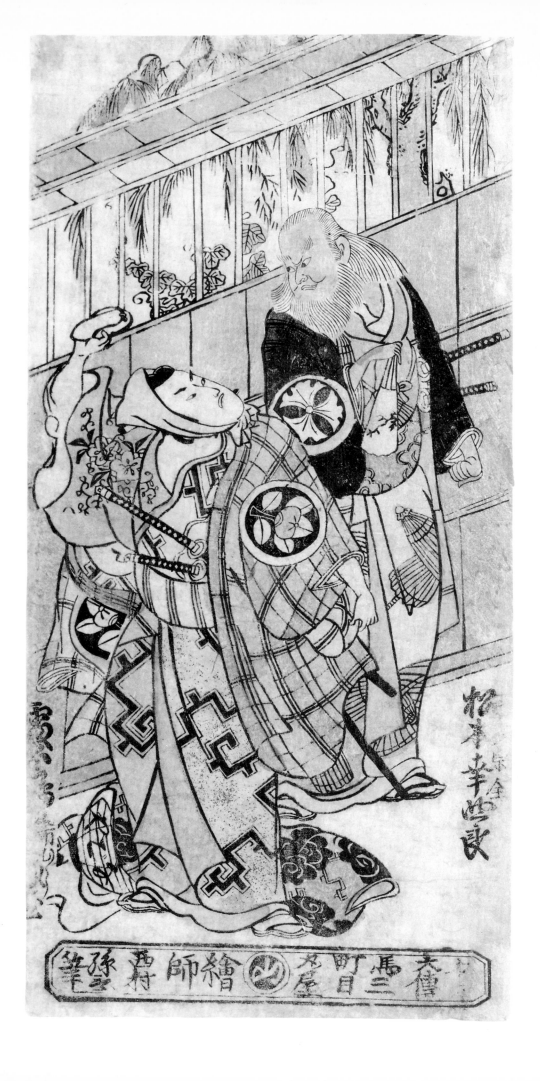

NISHIMURA, SHIGENOBU
(NISHIMURA, MAGOSABURÔ)
(1711–1785)

THE ACTORS ICHIKAWA, DANJÛRÔ II (EBIZÔ I)
AS *SHINOZUKA IGA-NO-KAMI* AND ICHIKAWA, DANZÔ I
AS *WATARI, SHINZAEMON*

Signature: Nishimura, Shigenobu hitsu

Publisher: Hira, Ningyô-chô, Hirano-ya
(Aikindô, Hirano-ya Kichibei)

Hoso-e, tan-e, 31.2 x 15.4 cm

Beni-e

114

Date: end of 1736, beginning of 1737

The two actors appear in a scene from the play *Jumpû Taiheiki* ("Favourable wind – Taiheiki"),[1] which was performed in the eleventh month of the first Gembun year (1736) at the Kawarazaki-za theatre.[2] Ichikawa, Danjûrô II (1688–1758), who had been using the name Ebizô since 1735 – as in our print here – played the positive hero *Shinozuka Iga-no-Kami*. His courtly robe is decorated with tortoise-shell patterns, *ebi* (crayfish), and the Ichikawa *mon*. Kneeling, he appears to be holding his opponent back with outstretched arms. His sword in his raised left hand is embellished with a *tsuba* bearing the Ichikawa *mon*. He carries a *samurai-eboshi*, the headwear of a knight.
Ichikawa, Danzô (1684–1740) (see p. 110) played *Watari, Shinzaemon*, who as *Daitô* ("he who wishes to mount the throne") wants to be emperor.

His courtly dress with peony patterns is complemented by a *kammuri* headdress, as befits an emperor or an imperial prince. Two marks on his forehead are reminiscent of the fashion of court nobility; the ladies and gentlemen shaved their eyebrows and replaced them with black marks on the forehead. On his breast and sleeves can be seen the crest (*mon*) appropriate to his role, a circular target (*mato*). In his right hand he holds a sword with a cockerel's head, in his left hand raised above his head – a ceremonial rod (*shaku*).

Although identification of the action and the actors seems so easy at first sight, on closer inspection confusion arises. The title of the play, *Jumpû Taiheiki*, points to a theme from the civil wars of the 14th c. *Shinozuka Iga-no-Kami*[3] was a vassal of *Nitta, Yoshisada* (1301–1338),[4] who fought for the cause of the Emperor Go-Daigo[5] (reigned 1319–1338). His opponent was Ashikaga, Takauji (1305–1358).[6] Takauji took Kyôto, dethroned Go-Daigo-tennô, first nominated an imperial prince as Kogon-tennô (reigned 1331–1336) and then nominated another as Kômyô-tennô (reigned 1336–1338). Finally he made himself *shôgun*. These measures split the empire between northern and southern dynasties. The schism ended only in 1392.
It is claimed of *Shinozuka Iga-no-Kami* that the power of his breath alone was sufficient to blow the enemy far away.
Watari Shinzaemon is at first sight impossible to identify. But his identity can be determined by the characteristic costume, his *mon* and his mask.

On a woodblock print of the Torii School – dateable to 1714 (Ostasiatisches Museum, Berlin)[7] – he is depicted in a similar manner and identified by his name *Ôtomo-no-Matori*; his opponent bears the name *Sukune-no-Kaneya (Kanamura)*. In the Michener Collection, Honolulu, there is another woodblock by Torii, Kiyotsune created in 1771.[8] There his name is given as *Ôtomo-no-Yamanushi*, while his partner is called *Hannya-gorô*. According to the legend, *Ôtomo-no-matori-no-Sukune* usurped the imperial throne in the fifth

century. The rightful heir, the later *Buretsu-tennô* (reigned 449–506), fought and defeated him.[9] In our opinion the *mon* "*mato*" and the characteristic dress allow *Watari, Shinzaemon* to be regarded as the same person as *Ôtomo-no-Matori* ("*mato*" *ri*). The phonetic similarity between *Matori* and *Watari* is also clear. (In the Ashikaga wars several members of the Ôtomo-Daimyô made an appearance, including Sadamune, who took Kyôto for Ashikaga, Takauji in 1336.)[10]
The theatre play *Jumpû Taiheiki* was thus a mixture of different "worlds" (*kakikae*), a well-known Kabuki technique. The real name *Heguri* of *Matori* allows an association with the *Taiheiki*.[11] It is still an open question how far it is admissible to regard *Ôtomo, Matori* as being identical with Ashikaga, Takauji, who presumed to dethrone the emperor, replaced him at will, and then raised himself to the highest position of government. *Shinozuka Iga-no-Kami* was in contrast the faithful vassal of the emperor. The play could have been intended as a hidden critique of the political situation.[12]
The leaf strongly resembles in style and composition the print discussed on p. 110, in which Ichikawa, Danzô is also depicted.

[1] On the *Taiheiki* see p. 70.
[2] Identification of the play and names of the roles, E.K.
[3] KHT, II, p. 291; Joly, (1968[3]), no. 844 (*Iga-no-Kami*).
[4] Ibid., no. 656 (*Nitta, Yoshisada*).
[5] Ibid., no. 249.
[6] Ibid., no. 940; KHT, II, p. 513.
[7] Schmidt, (1971), p. 48, no. 86.
[8] Link, (1977), p. 65, no. 86.
[9] KHT, II, p. 31; I, p. 74.
[10] Papinot, (1972), p. 500.
[11] *Hei* (peace) appears in both words.
[12] The Tokugawa shôgunate watched distrustfully over the theatres, which in its eyes were the breeding ground of moral decline and also politically unsound. Strict censorship was imposed on theatres.

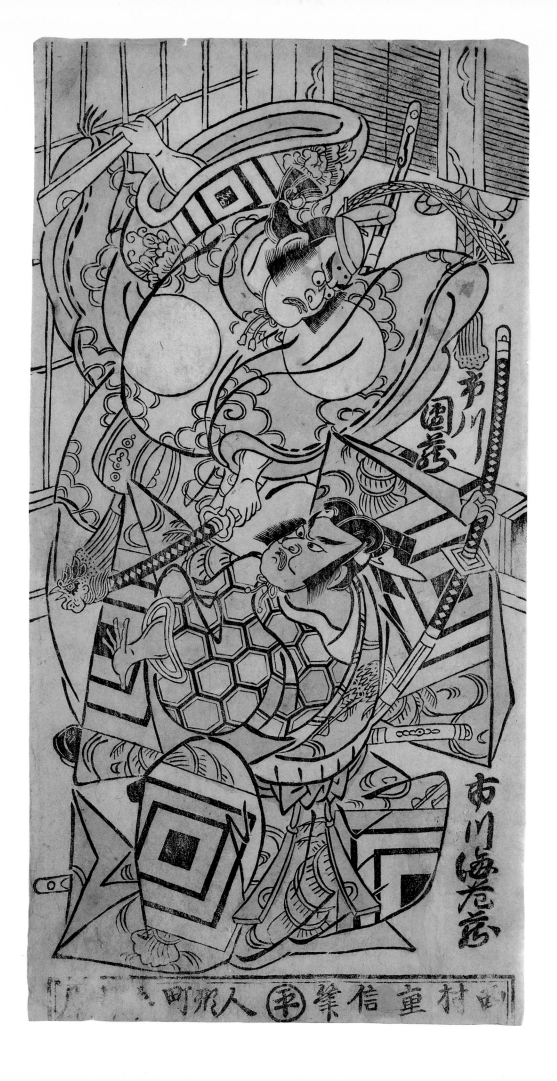

NISHIMURA, SHIGENAGA
(ca. 1697–1756)

Shigenaga followed his models Sukenobu, Kiyonobu and Masanobu as a self-taught artist, according to the historical records. This may account for his sometimes rather unwieldy compositions; but he completely makes up for such alleged deficiencies through his incomparably rich ability to invent new themes and to master them artistically by applying appropriate technical means of expression.

Thus, he developed from the Chinese model the *ichizuri-e* (white lines on a black background), the *mizu-e* (printing with blue pigment), and even the form of the triptych is attributable to him. His most important contribution to early *Ukiyo-e* art is perhaps landscape representations with small, often squat figures, as an independent artistic genre, in which he took over the principles of the Tosa style.
He successfully transmitted his artistic concepts to his pupils Shigenobu, Toyonobu and Harunobu, who were to become the leading masters of future decades.
J.G.G.

MII-NO-BANSHÔ ("EVENING CHIMES OF THE MII-DERA," No. 2)

A leaf from the series of *Ômi Hakkei*
("Eight Views of Ômi on Lake Biwa")

Signature: eshi Nishimura Shigenaga/Seal: Shigenaga

Publisher: Shiba Shimmei-mae yoko-chô Edo-ya hammoto/Publisher's seal: *e*

Hoso-e, 30.1 x 1.5 cm, trimmed above and at the sides

Black-and-white (*sumizuri-e*), hand-coloured, colours faded

Date: ca. 1725

The leaf belongs to a series which Shigenaga produced for the publishing house Edo-ya. The combination of beautiful landscape scenery goes back to a Chinese model, "The Eight Views of the Rivers *Xiao* and *Xiang*."[1] In the illustrations of early landscapes other combinations were produced in emulation of *Ômi Hakkei*, as for example, the "Eight Views of Kanazawa," which Shigenaga also illustrated. The upper and lower parts of the print are hidden in the traditional manner of *Yamato-e* behind wide bands of clouds. In the upper part, the title is given in a rectangular, longitudinal cartouche: "*Mii-no-banshô*," with the supplementary transcription in *hiragana* syllabic script. The series number "2," upper right, is now almost illegible. The poem reads:

Omou sono	I wait –
akatsuki chigiru	then I hear
hajime zoto	the evening chimes of the Mii temple
matsu kiku Mii no	as if to promise
iriai no kane	the arrival of the longed-for
	dawn.

Here, the famous bell is struck with powerful blows by a monk. Two pilgrims reverently worship in front of a little temple. In the foreground two priests stride out of the clouds. The roof of a larger temple projects behind a tree to the left. Here, too, the figures are drawn too large in relation to the buildings. The buildings are arranged in a sharp angle from left to right and then again to the left (as far as the belfry), while the figures are arranged one above the other in a diagonal row from below, right to upper left.
Provenance: Otto Jaekel Collection.

[1] Gabbert Avitabile, (1983), pp. 65 ff. Portheim, Heidelberg, (1975), III, no. 16.

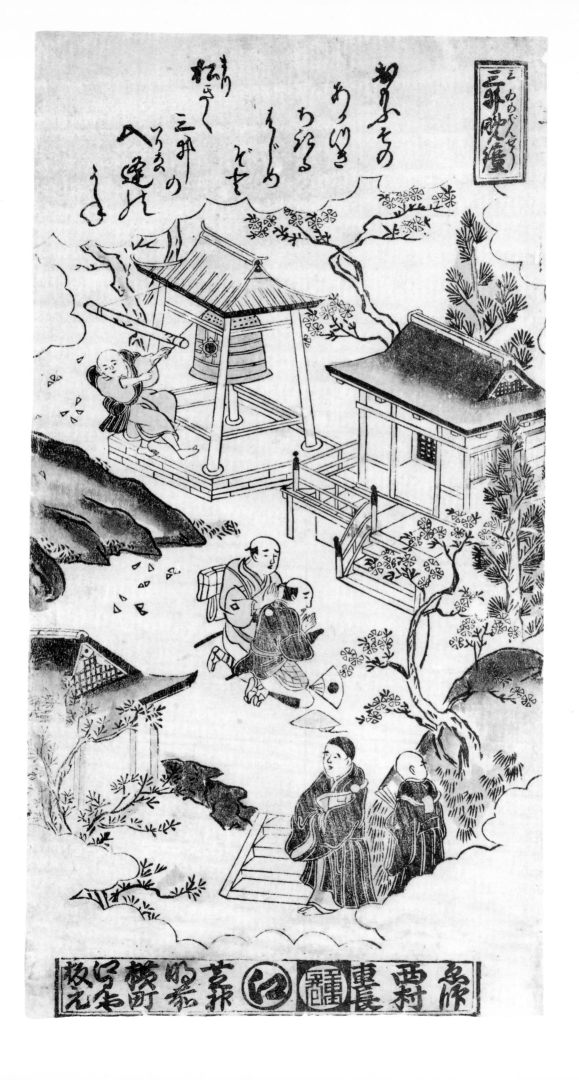

118 NISHIMURA, SHIGENAGA
(1697?–1756)

TWO FIGURES FROM A PUPPET PLAY
(NINYGÔ-JÔRURI)

Signature: gakô Nishimura, Sigenaga hitsu

Publisher: Kinoshita Jin'emon

Hoso-e, 30.3 x 15.2 cm

Urushi-e

Date: 1725–1730

The notable characteristic of this woodblock print is the cartouche in the form of a script copy (*nukihon*)[1] in the upper right-hand corner; this is a script for the third act of the theatre play *Hakata Tsuyuzaemon iro denju* (*Hakata Tsuyuzaemon* – "Initiation into the Secrets of Love") for the puppet stage. The protagonist – here shown to the left and identified on his breast by the character *tsuyu* (rope) from his name – appears in this scene as the seller of *goraigô*.[2] This was the name given to a kind of toy which enjoyed great popularity during the Genroku Period (1688–1704), which was offered for sale by street-traders. A little image of Buddha made of paper, wood or clay was stuck on a bamboo cane; when the rod was pulled down – as can be seen in this print – a halo made of paper opened up to display the image in front. The clothing of *Hakata Tsuyuzaemon*, who here appears equipped with a rich assortment of wares, shows the "Seven Chinese Wise Men in a Bamboo Grove," designed as details on a folding screen. The woman at his side, in a kimono patterned with chrysanthemum blossoms and stylized hand drums, wears a sash-belt fastened at the front in the manner of courtesans.

The aforementioned cartouche also provides us with the information that this scene is from a puppet stage play composed and presented by *Tosa-no-shôjô*[3] Tachibana-no-Masakatsu (II,?–1741/11); in addition the publisher's seal, possibly *seiri*, can be read. The narrator represented the school of *tosabushi*, a refined stylistic trend of the *ningyô* (puppet) *jôruri*,[4] the Japanese puppet theatre in Edo, now Tôkyô, which was popular there from about 1670. Unfortunately, little source material is available about the puppet theatre in Edo, so it is not possible to determine when and on which stage the performance was given.

The puppet theatre, which started in about 1600 in Kyôto, was made up of a combination of the three elements: puppet theatre, chanting, and *shamisen*[5] (lute) accompaniment, which were all performed simultaneously; their precise integration created the puppet theatre ensemble. The narrator, called the *tayû*, is the leading figure in the performance, whom the puppet players follow. He functions not only as the narrator of the text, describing and commenting on the action, but he also delivers the whole dialogue. With his script on a black lacquered pulpit in front of him, he usually sits together with the *shamisen* players on a raised platform to the right of the stage. The puppets were at first manipulated by one player, but from 1700 puppets manipulated by three players became the norm. This represented a synthesis of hand puppets and marionettes, whose strings and attachments for manipulation were moved to the inside of the puppet figures. The second player guided the left arm, while the third was responsible for moving the feet. During the play, the upper part of the puppet players' bodies could be seen above a balustrade at half height. The woodblock was published by Kinoshita, Jin'emon, who is known as a publisher of puppet theatre scripts (seal in lower right-hand corner); three further prints by him are known, identified by the cartouche in the form of a *nukihon* script and illustrating protagonists from puppet theatre scenes narrated by *Tosa-no-shôjô* Tachibana-no-Masakatsu. These were also created by Nishimura Shigenaga. It can be assumed that the publisher of the *nukihon* script in which *Hakata Tsuyuzaemon* appears, published this woodblock print at the same time and used it for advertising purposes. Possibly Shigenaga also illustrated the *shôhon* script[6] for this stage play.

M. Schönbein

1 *Nuhikon* is the name for a script for the *jôruri*, the Japanese puppet theatre. This script contained only a part of the play – a famous scene, for example.

2 The term *goraigô* comes from the religious field and refers to the appearance of Buddha at the death-bed of believers, in order to lead them to Paradise – the Buddhist Pure Land.

3 The title *Shôjô*, indicating lower nobility, was bestowed on narrators as a public distinction, usually in combination with the name of a province – here Tosa (today Kôchi on Shikoku).

4 The term *jôruri* (pure lapis lazuli) goes back to the legendary story of the princess of that name. The story enjoyed such popularity that one came to use the term as synonymous for chanting. The word combination *ningyô* (puppets)-*jôruri* was common from about 1615.

5 This musical instrument reached Japan from China in the second half of the 16th c. and supplanted the Japanese lute (*biwa*), which had previously been used to accompany recitations, especially war and hero ballads. Since the *shamisen* was lighter and easier to play than the *biwa*, it promoted a superior, more fluent manner of playing. The body of this three-stringed instrument, which is struck with a large plectrum, is covered with cat skin.

6 One speaks of a *shôhon* when the script contains the complete *jôruri*.

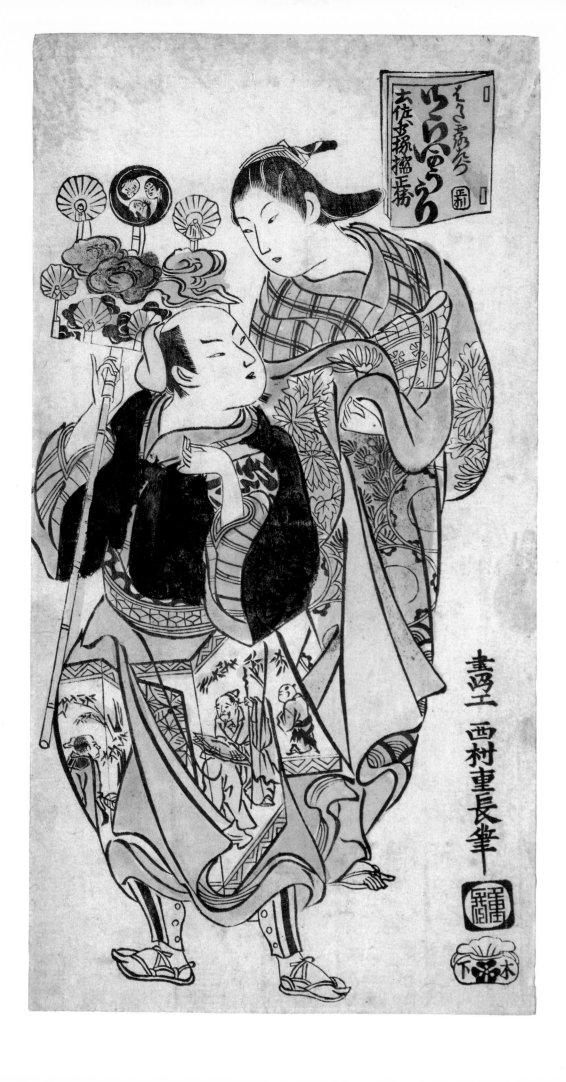

NISHIMURA, SHIGENAGA
(ca. 1697–1756)

THREE LEAVES FROM A SET OF EIGHT *ÔMI HAKKEI*
EIGHT VIEWS OF LAKE BIWA IN THE ÔMI PROVINCE

No signature

No publisher's mark

Hoso-e, 34.3 x 16 cm

Black-and-white (*sumizuri-e*), hand-coloured, colours faded

Date: ca. 1725

The latest studies suggest that four series of *Ômi-hakkei* by Shigenaga were published. The three leaves shown here are closely based on an earlier set, which was produced by the publisher Masu-ya in about 1725. But in contrast to these, they are neither signed nor bear a publisher's mark. The wood blocks were recarved. The model for these eight views of Lake Biwa in the Ômi Province are Chinese illustrations for the eight poems about the natural beauties of the rivers Xiao and Xiang in Hunan Province on Lake Dongting, which are known from the Song Period (960–1279). The early landscape illustrations of *Ukiyo-e* closely followed the painting traditions of the Tosa style of the traditional Yamato, and hardly allow one to anticipate the later landscapes, with their spatial and atmospheric pictorial effects, which we have come to know from Hokusai and Hiroshige. Rather, they point to the illustrated travel guides produced by hand by unknown skilled illustrators to serve a new travel fever, which arose in the first half of the 17th c. as a result of massive social change, in a broad section of the population.
Although the leaves published here are dated in the literature on *Ukiyo-e* to later than the woodblock prints of *Ômi hakkei* by Masanobu (p. 68), the set discussed here appears to us to have retained more "archaic" features: the additive arrangement of landscape elements, figures and buildings, and the exaggeration of human physical proportions relative to their surroundings.

Leaf 1: *YABASE-NO-KIHAN*

(SAILING BOATS RETURNING TO *YABASE*)

The boats are returning home across the wide waters. Some have already anchored at the shore and in the bay, and have reefed their sails. The boatmen unload their ships. A warrior goes determinedly on his way, a monk waves good-bye.
Poem:

Maho hikite	With filled sails
Yabase ni kaeru fune wa ima	the boats return home to *Yabase*
Uchide no hama no	in the gentle breeze
saki no oikaze	back to the shores of *Uchide*.

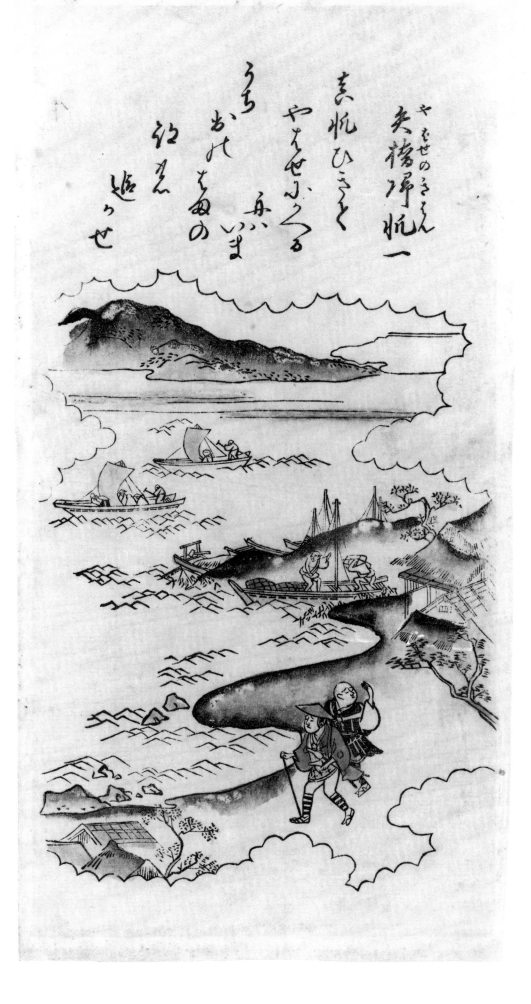

Leaf 2: *AWAZU-NO-SEIRAN*

(FRESHENING WIND OVER AWAZU)

Awazu is a tiny place very near to Otsu, situated at the southern end of Lake Biwa. From there, the view of the lake under clear skies and with a fresh breeze was considered from the earliest times to be one of the most moving experiences of nature. About 1500 the feudal Lord Konoe is supposed to have designated this place, following Chinese tradition, as one of the eight most beautiful views of Lake Biwa.

The fortified castle of Zeze, near the city of Ôtsu, – founded around 1600 – towers over the shore of the lake. Boats, waves, ducks, mountains, and trees are distributed like patterns on the page. Three busy travellers and a horse loaded with bundles of brushwood acquire increased significance through their exaggerated proportions; they pay hardly any attention to the famous landscape.

Kumo harafu	Clouds are dispersed by the same wind
arashi ni tsurete	that sends one hundred boats,
hyaku fune mo	one thousand boats,
chifune mo	home –
nami mo	through the breaking waves
Awazu ni so yoru.	that surround Awazu.

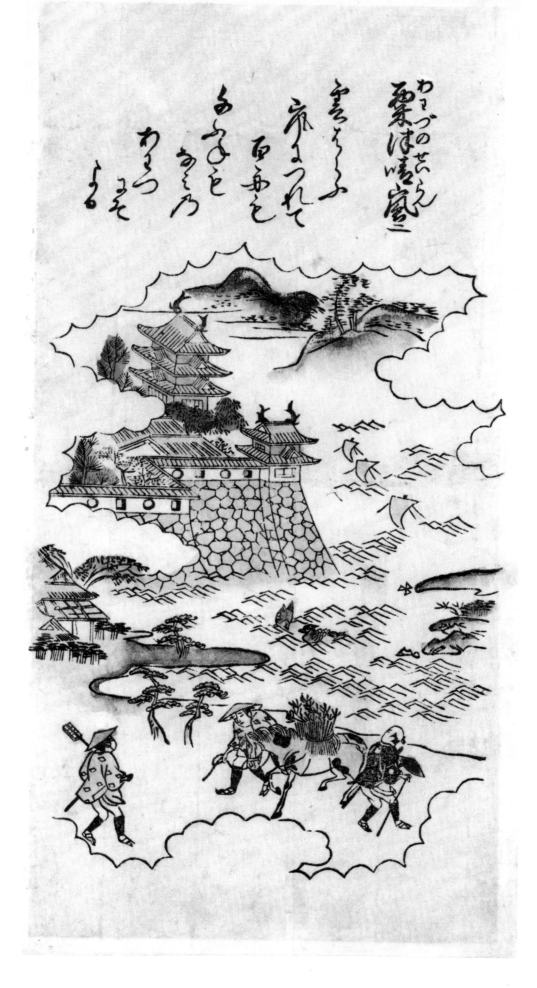

Leaf 3: *SETA-NO–SEKISHÔ*

(EVENING SUN OVER SETA)

A priest walks lost in thought on the bridge over the Ujigawa, which was famous for its beauty. A fisherman draws in his net. Two travellers with walking-sticks are about to cross the bridge. In spite of the overall activity, the persons illustrated seem entirely preoccupied with themselves. An idyllic tranquillity emanates from this picture. Trees and huts on the little island between the two bridges make up the central focus of the picture.

Poem:

Tsuyu shigure miru yama	Leaving far behind us in the rain
tôku sugi ki tsutsu	the hill, wet with dew,
yûhi ni wataru Seta	we cross the big bridge of Seta
no nagahashi.	in the red of the setting sun.

Lit.: Link, (1980), pp. 155–158.
Hempel, (1967), nos. 10, 11, (pp. 43, 44).
Gunsaulus, (1955), vol. 1, nos. 2–6 (pp. 187, 188).
Japanese Woodcuts in Museum Rietberg Catalogue, (1977), no. 24.

せきの

粉田夕照三

よのしくれ

りろ山こゑく

夕くにけるせつれ

をし

こ味

川

そと

125

TORII, KIYOMITSU
(1735-1785)

Kiyomitsu is an artist of transition. But this does not reduce his importance. He was a determining influence in the period of two-and three-colour printing. His father, Torii, Kiyomasu II, was one of the chief masters of the second Torii generation, while his pupil Harunobu was to become his teacher's competitor in his later years. Since Kiyonobu II's son died young, Kiyomitsu became the third head of the Torii family.

His influential, elegant style represents an intermediate position between the powerful works of the first and second Torii schools and the refinement of full-colour printing (nishiki-e). Kiyomitsu played a decisive role in the development of nishiki-e, through his experiments and his handling of different colour plates.

J.G.G.

THE ACTORS SEGAWA, KIKUNOJÔ II AND BANDÔ, HIKASOBURÔ II

Signature: Torii, Kiyomitsu ga

Publisher: Uma-naki-chô (Hishimura) itchôme hammoto (Nishimura-ya Yohachi Eiju-dô)

Hose-e, 31.5 x 13.8 cm

Three-colour print (benizuri-e) in red, yellow and blue. Partly superimposed to create a fourth colour.

Date: 1767

The woodblock print shows Segawa, Kikunojô II as onna-Narihira ("female-Narihira") and Bandô, Hikasoburô II as Oyamada-tarô.[1] Both can be identified since their names, their roles and their mon (crests) are given. Kikunojô rides on a little black steed dressed in shirabyôshi costume with an eboshi (hat).[2] He swings his sleeve over his head in a graceful dancing movement. His robe is decorated with large pumpkin blossoms, kiri leaves and blossoms, and trellis-work. Hikasoburô dressed in courtly attire holds the horse by the reins. He carries one sword over his shoulder and another fastened in his belt. His robe is adorned with hand drums,[3] his haori with blossoming twigs. The ground is suggested by a few lines; otherwise the background is empty.

Both actors performed in 1767 in a play presented at the Nakamura-za theatre with the title Taiheiki Shizume Furisode (The Long-sleeved Kimono of a Woman of Low Rank in the Taiheiki).[4] Kitao, Shigemasa (1739-1820), who in the following decades came to the fore as a master of coloured woodblock prints, also created two prints on these same characters.[5]

Neither Oyamada-tarô nor his sister Itsuki is known. However it is possible from Itsuki's clothes to identify her as a shirabyôshi dancer.[6] These female dancers, who were commoners, already performed in the 12th c. at courtly events. They wore usual male attire, a court hat and a sword. They accompanied their dances and songs on a hand drum. A few of them enjoyed the favour of high nobility, such as Shizuka-gozen, the mistress of Yoshitsune (12th c.), or three shirabyôshi dancers known to have been mistresses of Taira-no-Kiyomori.

Of particular interest is the use of the term onna-Narihira for the figure Itsuki. Ariwara-no-Narihira (825-880) was the grandchild of Emperor Kammu (reigned 782-815), the founder of Kyôto.[7] He was given the family name Ariwara by the Emperor and was therefore struck off the list of imperial family, as was customary in order to prevent this from growing too large. Little is known about Narihira's life. We

know only that when he was fifty-two he was named Lieutenant-General of the Imperial Guard of the Right. Many poems are to be found in the various anthologies from the Middle Ages of Japan. The Ise-monogatari ("Tales of Ise") is attributed to him; it describes in seventy-five chapters (dan) the events and love affairs of this epitome of the classical, sensitive, courtly lover.[8] Its sprinkling of poems and metaphors is familiar to every educated Japanese. Thus the Ise-monogatari was one of the first illustrated books to be printed for popular consumption (1608).[9]
In fine arts and literature, reference is often made to the Ise-monogatari.

Narihira was regarded at the beginning of the 17th c. as the handsome man par excellence (mame-otoko). He was considered to embody the feminine and the masculine ideal of beauty in one person.[10] The great haiku poet Matsuo, Bashô (1644-1694) described this sexual ambivalence in the person of Narihira as the combination of the plum blossom, symbol of severe masculine beauty, and the pliant willow twig, a symbol of feminine beauty. Already in the early decades of the 17th c. actress-prostitutes appeared dressed as men. Boys and youths organized into dance troops worked also as prostitutes. They performed, for example, dances known as Narihira-odori in those years.[11] This ambiguity is also to be found in later Kabuki (following the bans on women and youth in Kabuki in 1629 and 1652 respectively). The person of Itsuki, who is here impersonated by a man as is customary in Kabuki, is lent such an ambivalent meaning by the use of the term "onna-Narihira" (female-Narihira). The scene shown on our leaf is recorded as Narihira Azuma-kudari mitate ("Travesty of the Journey to the East of the Cavalier Narihira"). This theme is based on dan IX, in which Narihira composes his famous poem about the snow-covered Mount Fuji.[12]
Segawa, Kikunojô II, the adopted son of Segawa, Kikunojô I (see pp. 104, 108) is supposed to have been a descendant of a prince from Musashi. He was already performing as a child actor in 1750, and from 1756 he was a female impersonator. He died in 1773 at the age of thirty-three. He was practically predestined to play such ambivalent roles.[13]
Bandô, Hikasoburô II, son of Hikosaburô 1 (see p. 86) born 1741, switched from youth roles to male roles in 1765. He was the special favourite of all theatre goers. But he died at the age of twenty-eight in 1768, a year after this print was published.[14]

1 On the role descriptions see below; Link, (1980), p. 269, reads Koyamada-tarô.
2 On the shirabyôshi see below, footnote 6.
3 The hand drum (ko-tsuzumi) was sometimes also called the hip drum. (Barth, [1972], p. 119). It is the instrument of the shirabyôshi.
4 Identified by E.K.; see also both following leaves of the Michener and Vever Colls.
5 Vever Coll., (1974), vol. 1, no. 93; Link, (1980), p. 260 (Shigemasa no. 3)
6 Barth, (1972), pp. 55ff. The dancers wore the white hemp garments of the common people. They were employed at court festivals as early as the 12th c. The term shirabyôshi is thought to have been originally a musical term. Later it came to refer to the white colour of the clothing. (Barth, [1972], pp. 50ff.) They sang and danced. In the Muromachi Period they lost their high rank and became wandering dancers who also practised prostitution.
7 Hisamatsu, (1976), p. 54.
8 Transl. H.J. Harris, The Tales of Ise, Rutland, Vermont/Tôkyô, 1972.
9 Schmidt, (1971), p. 14.
10 Barth, (1972), pp. 199, 205. He cites the Keichô-kemmonshû (1596-1615). In this, the performance of a courtesan as a female dancer in male clothing is described. "Doesn't this remind one of Narihira, the god of the feminine and masculine?"
11 Ibid., p. 205.
12 Harris, (1972), pp. 45ff.
13 Kikunojô still calls himself Kichiji on the leaf discussed on p. 108. There he is twelve years old, on the print discussed here he is twenty two. Yoshida, II, p. 134 (biography).
14 Yoshida, III, p. 64.

128 TORII, KIYOMITSU
(1735–1785)

THE ACTORS ÔTANI, HIROJI AND ONOE, MATSUSUKE

Signature: Torii, Kiyomitsu ga

Publisher: Nishimura, Eiju-dô Konya

Hoso-e, 31 x 13.5 cm (proof sheet of a line plate)

Date: 1765

The leaf is a proof sheet for a woodblock by Kiyomitsu I, of which a finished print in *benizuri-e* (two-colour print) is to be found in the Michener Collection, Honolulu.[1]
Above and below, the printer has added impressions of the heads of the two protagonists.
Ôtani, Hiroji plays *Sakata-no-Kintoki,* who is dressed as a *Sambasô* dancer. Onoe, Matsusuke plays a female dancer by the name of *Bijo Gozen.* We see the two actors in a dance scene from the play *Furitsumuhana Nidai Genji,* which was performed in the eleventh month of the year 1765 at the Ichimura-za theatre.[2]
A *Sambasô* dance number was usually performed at the opening of a new season – mostly by the *zamoto* (theatre director) and his son – as an expression of wishes for good luck and blessings from the beginning. The *kaomise,*[3] in which the actors showed themselves to their public with little make-up, as well as the first day of the New Year, were opened with such a *Sambasô* dance performance.[4] *Sambasô* was already known in the late Heian Period (early 12th c.).[5] The performer, dressed like an old man, danced with two other old men in the *shiki-samba,* the three "good luck-bringing dances." These had their origins in dances associated with Buddhist monasteries. *Chichi-no-ha* (the aged father) was already regarded at that time as a personification of Buddha himself; *Okina*[6] symbolized the Bodhisattva of Wisdom and *Sambasô* (the third old man), the Buddha of the Future.

The role crystallized out of these original meanings and retained its character of promising an auspicious future into the Kabuki period. From the end of the Kamakura Period (1148–1333), the *Sambasô* was danced by a *Kyôgen* actor at the beginning of a *Nô* performance.[7]
In Kabuki the dance was integrated into a theatre play. In the scene shown here, the actor Ôtani, Hiroji plays *Sakata-no-Kintoki* one of the faithful companions of *Raikô, Minamoto-no-Yorimitsu,* who conquered and slew the *Shûten-dôji,* a man-eating monster.[8] *Kintoki* is dressed here as a *Sambasô* dancer. *Bijo Gozen,* a *shirabyôshi* dancer, assists him.[9]
Hiroji is dressed only in an apron, over which hang ropes on which little bells are sewn. He has hung a cloak, decorated with cranes as symbols of a long life, over his shoulders. On his head he wears the characteristic tall black headwear with

white lines. In his right hand he swings a little bell-tree, in his left he holds a lacquered box for storing masks.[10]
Matsusuke's kimono as *Bijo Gozen* displays cherry blossoms, while his *uchikake* is identical to that of the *Sambasô* dancer; his head is adorned with a *samurai* cap. He beats on a little hour-glass drum. On this trial print, a background decoration of a pine tree has been preserved which was replaced in the leaf in the Michener Collection by architectural detail.
Onoe, Matsusuke (1744–1815)[11] started playing female roles in Ôsaka from 1755. He played male roles from 1771. In 1809 he changed his name to Shôroku. He died at the age of 71. Since the sons of Onoe, Kikugorô had died young, Matsusuke took their place as his pupil after their death. After his change from female impersonator to actor of male roles he became one of the most impressive actors of his time. He was particularly gifted in depicting ghosts. He invented many stage tricks. For example, in one play he acted three roles simultaneously on the stage.
Ôtani, Hiroji I belonged to the *shi-tennô,* the "Four Greatest Actors of this Time" (see p. 86). The son of a Kabuki actor, he began his acting career at the age of four. As an adult, he was famous for his interpretation of positive heroes (*tachi-yaku*) like *Asahino, Saburô.* Rapid costume change on stage (*hiki-nuki*), made possible by loosely sewing costumes so that they could be instantly ripped apart, was his innovation. He also invented the trapdoor on stage, first used when he appeared with Danjurô II at the Ichimura-za in 1727.[12]

[1] Link, (1980), p. 230, Kiyomitsu I, no. 16. The publisher is Kichi Uemura.
[2] Identified by Link, who gives no translation. The title could not be reconstructed in Japanese characters.
[3] *Kaomise,* see Barth, (1972), p. 275.
[4] Barth, op. cit.
[5] Ibid., pp. 61 f.
[6] Ibid., KHT, II, p. 21. The mask of the *Okina* shows on old man with a light-coloured face. As in the mask of the *Bugaku* the face is designed to be moveable. The lower jaw is separate and both parts are tied together with strings formed into pompons. Such pompons are also found on the forehead.
[7] The *Sambasô* mask is similar to the *Okina* mask except that it is black. Already in *Gigaku* in the 6th and 7th c. an old man (*Taikô-fu*) appeared in a kind of courtly refined *Okina* mask, as did the old man known as *Saisôrô* in *Bugaku* (Gabbert, [1972], pp. 233–243). *Kyôgen* are comic interludes in *Nô.* They are played by a special group of actors. Their function is similar to that of the comic interludes in the classic Greek comedies. On *Sambasô* at the start of the *Nô* performance: Barth, p. 63.
[8] KHT, II, p. 191.
[9] Link, (1980), p. 200, Kiyohiro I, published a woodcut with a male and female *Sambasô* dancer, but with other role identifications.
[10] See footnotes 6, 7. Although the mask box on the prints depicting *Sambasô* is almost always present, one never sees the *Kabuki* actor wearing the typical *Nô* mask.
[11] Barth, (1972), pp. 301, 317; Yoshida I, p. 205.
[12] Ibid., p. 292 and footnote 649.

TORII, KIYOHIRO

(active 1737–1766)

As with Kiyomitsu, Kiyohiro belongs exclusively to the period of the *benizuri-e*, and grace and refinement are the hallmarks of his work. Yet his works are distinguished from those of his contemporaries by the greater range of variation in his contours, which allows him to be identified as an absolutely independent talent. Since nothing about his life has been recorded, we can get to know him only through his works, which rank among the masterpieces of his time. J.G.G.

THE ACTORS NAKAMURA, KUMETARÔ II AND ICHIMURA, KAMEZÔ I (UZAEMON IX)

130 Signature: Torii, Kiyohiro hitsu

Publisher: Sakai-ya, (Seal) Sakai-ya

Hoso-e, 29.7 x 14.1 cm

Benizuri-e (green–pink)

Date: between 1750–1755

In front of a fence, behind which there is a pine tree, kneels the actor Ichimura, Kamezô I in the role of *Yorikaze*. His partner is the *onnagata* actor Nakamura, Kumetarô in the role of *Ominaeshi*. The female impersonator, his head declined, sits on the raised knee of Kamezô. With a melancholic gesture he holds up his right hand hidden under his sleeve. The player of *Yorikaze* looks up at him with his mouth turning down at the corners. On the green background of his kimono bell-flowers in *beni* red contrast with the sparrows on the black *uchikake* with green clouds. *Ominaeshi's* kimono is adorned with fans and maple leaves. The simplified style of the first two-colour prints can be seen in the ornamentation and in the folded fans on the kimono. *Ominaeshi's* robe cuts across the dark-coloured area of *Yorikaze's* clothing. This gives the coloured areas an abstract quality, so that at first glance one cannot decipher their real figurative nature. In the upper part of the leaf there is a *haiku* in big characters. The added phonetic reading of the words in *katakana* syllabic script is unusual.

Yume wo yabure	Interrupting the dream –
kane wa	the temple bells –
yogoto no	a storm over the meadow.
nowaki kana	

This Kabuki play must have been inspired by the *Nô* play *Ominaeshi*.[1] A couple have sworn to be true to each other forever. But the man abandons the girl and is unfaithful to her. She searches for him, and on finding him, throws herself into the river. He buries her. A wonderful flower grows out of her grave. But the more he tries to approach the flower, the more it retreats. At this, he also ends his life. The poetic content of the *Nô* was transposed to the world of Kabuki. Ominaeshi (bot. patrinia Scabiosaefolia) is one of the *aki-no-nana-kusa* ("Seven Autumn Grasses").[2] The characters used for its literal reading give to the Ominaeshi plant the additional meaning "Flower of the Courtesan" (*jorôhana*). The tragic content of the play, which certainly belonged to the group of *shinjû* ("double suicide out of love") plays, is also reflected in the added *haiku*.

The actor of *Yorikaze* is better known by the name Uzaemon IX.[3] He was the son of Ichimura, Uzaemon VIII (Takenojô) see p. 38) from the dynasty of the theatre directors of the Ichimura-za. Uzaemon IX (1724–1786) used the name Kamezô, as in this leaf, from 1745–1762. From 1755 he was the *zashu* (theatre director) of his family theatre. He is known as an experienced actor and dancer of male roles.

The female impersonator Nakamura, Kumetarô (1724–1777)[4] was the son of a well-known dancer, Arashi, Monjûrô, who in his turn was a pupil of Arashi ("Storm Wind"), San'emon I (1635–1690), the popular *aragoto* performer in the Genroku Period. From 1735 the *onnagata* of our print played under the name Nakamura, Kumetarô. On his arrival in Edo (Tôkyô) in 1748, he had already been accorded a high position in the actors' hierarchy by the theatre critics. In 1755 Kumetarô returned to Kyôto. In 1774 he took tonsure and died in 1777. Since the woodblock master Kiyohiro was first active in the 1750s, and Kumetarô left Edo in 1755, the print reproduced here must have been created in this period.

[1] Bohner, (1972), p. 385. According to Bohner, p. 313, *Yorikaze* is another name for the *Nô* play *Ominaeshi*.
[2] KHT, I, p. 24.
[3] Yoshida, I, p. 54.
[4] Yoshida, II, p. 294.

ISHIKAWA, TOYONOBU
(1711–1783)

THE ACTOR SANOKAWA, ICHIMATSU

Signature: Tanjôdô Ishikawa, Shuha Toyonobu zu

Hoso-e, 45.7 x 17.3 cm

Black-and-white (*sumizuri-e*), hand-coloured

Date: ca. 1743

Sanokawa, Ichimatsu[1] was born in 1722 into the actor family
Sanokawa in Kyôto in the Shijô destrict. He played in Ôsaka from 1733
as a child actor, then from 1738 as a *wakashû* (actor of youth roles); in
1741 he moved to Edo where he enjoyed great success due to his pretty
appearance at his premiere performance as *Kumenosuke* in the scene
Kôya-san shinjû ("The Suicide of the Lovers of Kôya-san") in the third
act of the play *Na-no-hana-Akebono Soga*, one of the many Soga
dramas. Kiyomasu II and Masanobu depict him in this role as a youth,
riding on an ox, and playing the flute. Then he wore a green and white
checked *hakama* (trousers).[2] Because of this pattern, known as
"market square and pine tree," he was called by the name Ichimatsu.
In 1744 he returned once more for a short time to Kyôto. He spent the
rest of his career in Edo. At first playing only youth roles, from 1751
he also impersonated women, and from 1760 concentrated
exclusively on female roles (*onnagata*). In 1763 he died at the age of
41. In addition to acting, he also ran a business trading in incense.
Toyonobu depicted this shop on a leaf from 1743 (now Buckingham
Collection, Chicago).[3] He always bears his characteristic *mon* (crest),
the character "unchangeable" (*dô, ona[ji]*).
The leaf reproduced here shows the actor with his feminine charm.
His figure is bent into a half-moon shape with his head inclined in
melancholy. On the left side he gracefully holds a flat straw hat. Over
the kimono with pine trees, ivy leaves and *chidori* birds, with a wide
obi, he wears a light, short coat (*haori*) with stylized sparrows and
curbis blossoms. These flowers, like the *kiri* blossoms, are some of the
ornamentation associated with this actor. He stands in front of a tea-
house; a curtain hanging over the door bears the character "*kyô*" for
Kyôto. In this leaf Ichimatsu probably plays a prostitute from the city
of Kyôto, his birth place, in an altered version of the theme
"Courtesans of the Three Cities," which had been a favourite since the
early years of the 18th c. (see p. 76). The other two leaves with the
courtesans of the cities of Edo (Tôkyô) and Ôsaka are not known.
Ichimatsu appears to have had an especially great influence on the
fashion of his times. Hardly any other actor is so often represented in
ever more varied, richly-decorated, elegant, flowing garments. In the
1740s he was illustrated by almost all the woodblock masters. Even in
representations of women his type is exemplary, especially for the
hoso-e.
A theatre illustration with Ichimatsu, created in 1743 on the occasion
of a Soga play at the Nakamura-za, resembles our leaf in the pose and
the folds of the robes. There Ichimatsu wears a checked *haori* over a
kimono with pumpkin curbis and sparrows.[4]
In 1750/51 Toyonobu used motifs from this leaf, now in Chicago, and
from our print, to create a two-colour print (*benizuri-e*) of four
beautiful actors. Ichimatsu wears a checked *haori* over a kimono with
plum blossoms and sparrows.[5] The characteristic of our leaf, the flat
straw hat, is held on the other side.

[1] Yoshida, I, p. 392.
[2] Link, (1980), p. 63 (Kiyomasu II). But Ichimatsu is not wearing his famous
checked *hakama* in this print; Gunsaulus, (1955), p. 159.
[3] Gunsaulus, (1955), p. 207, by Toyonobu, ca. 1743.
[4] Ibid., pp. 207, 208; Toyonobu shows Ichimatsu in a Soga drama which
played at the Nakamura-za in 1743.
[5] Ibid., p. 217.

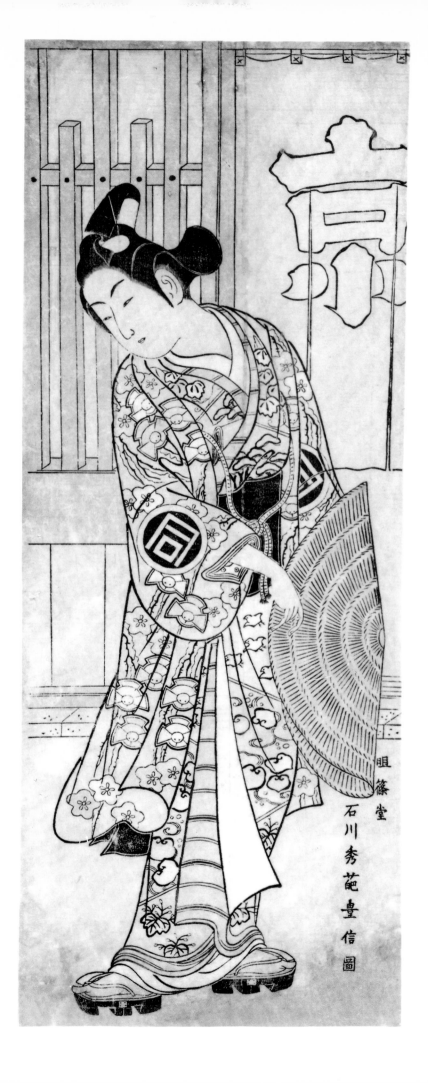

BIBLIOGRAPHY

In consideration of the fact that most friends and collectors of Japanese art in the West don't read a Far Eastern language, our bibliography largely contains literature in Western languages. In the catalog entries, the titles are quoted as follows: family name of the author, year of publication.

Avitabile, G. Die Frühen Meister, in: Artis, April 1988.
Vom Schatz der Drachen, Chinesisches Porzellan des 19. und 20. Jh. aus der Sammlung Weishaupt, engl./dtsch., London, 1987. s. Gabbert.
AIC Primitive Period s.Gunsaulus.
Barth, J. Kamakura, Die Geschichte einer Stadt und einer Epoche, Tôkyô, 1969.
Japans Schaukunst im Wandel der Zeiten, Wiesbaden, 1972.
Benl, O. Genji-Monogatari, Die Geschichte vom Prinzen Genji, 2 Bde., Zürich, 1966.
Bernabò Brea, L., Kondo, E. Ukiyo-e and Paintings from the Early *Masters* to Shunshô, Ed. Chiossone Museum of Oriental Art, Genova, 1980
Bernabò Brea, L./Frabetti, G./Kondo, E. Tradizione e rinnovamento nell'Arte di Itchô e di Sukenobu, 5a mostra didattica (Inverno/primavera 1974), Museo d'arte Orientale "E. Chiossone", Comune di Genova.
I Primi maestri Ukiyo-e, illustratori della grazia femminile, 6a mostra didattica (estate/autunno 1974). (s.o.).
Birch, C. Chin. Literature From Early Times to the Fourteenth Cent., New York, 1967.
Blau, H. Sarugaku und Shushi, Beiträge zur Ausbildung dramatischer Elemente im weltlichen und religiösen Volkstheater der Heian-Zeit. Stud. zur Japanologie, Bd. 6, Wiesbaden, 1966.
Bohner, H. Nô, Einführung, Tôkyô, 1959.
Brasch, H. Ukiyo-e und Holzschnitte Japans, Kiel, 1961.
Brower, R. Fujiwara Teika's Hundred Poems of the Shôji Era, 1200, Tôkyô, 1978.
Calza, G.C. Le Stampe del Mondo Fluttuante, Milano, 1977.
(Collection des Musées royaux d'Art et d'Histoire, Bruxelles) (ed. Kozyreff, C.) Estampes Japonaises, 1989.
Crighton, R.A. The Floating World, Jpn. Secular Prints, 1700–1900, Victoria and Albert Mus., London, 1973.
Eberhard, W. Lexikon chin. Symbole, Köln, 1983.
Evans, T. und M.N. Shunga, New York/London, Ontario, 1949.
o.A. Exh. of Masterpieces of the Sakai Coll., Tôkyô, 1968.
Fontain, J./Hempel R. China, Korea, Japan, Propyläen Kunstgesch., Bd. 17, Berlin, 1968.
Gabbert, G. (from 1986 Avitabile, G.) Die Masken des Bugaku, Profane japanische Tanzmasken der Heian- und Kamakura-Zeit, 2 Bde., Serie: Sinologica Coloniensia, Nr. 1, Wiesbaden, 1972.
(Avitabile) Japonica aus der Kunstsammlung des Herrn Wilhelm Peter Metzler (1818–1904), Mus. für Kunsthandwerk, Frankfurt, 1983 (Inrô, Tsuba, Keramik).
Gianadda/Gard/Tikotin/Kondo L'Art japonais dans les collection Suisses, Genève, 1982.
Giles, H.A. Strange Stories from a Chinese Studio, Taiwan/Taipei, Reprint 1971.
Gunsaulus, H. The Clarence Buckingham Coll. of Jpn. Prints, The Primitives, Art Inst. of Chicago, 1955.
Halford, A.S. The Kabuki Handbook, Tôkyô/Rutland Vermont, 1972.
Harris, J. The Tales of Ise, Tôkyô/Vermont, 1956.
R. Hempel Jpn. Holzschnitte, Slg. Theodor Scheiwe, Münster, 1957.
Holzschnitte Ukiyo-e Sammlung Prof. Dr. Otto Riese, Ingelheim, 1977
Jpn. Holzschnitte. Erwerbungsberichte im Jahrbuch der Hamburgischen Kunstsammlungen und im Jahrbuch des Museums für Kunst und Gewerbe, 1, 1982.

Japanische Holzschnitte, I, Hamburg, 1986.
Hickman, M.L. Views of the Floating World, in: Bull. of the Mus. of Fine Arts, Boston, vol. 76, 1978, p. 4–34.
Hillier, J. Sugimura, Jihei, in: Oriental Art, N.S., V. 1959.
Cat. of the Jpn. Paintings and Prints of the Coll. of Mr. and Mrs. Richard P. Gale, London, 1970.
Hillier, J./Smith, L. Jpn. Prints, 300 Years of Albums and Books, British Museum, London, 1980.
Hinagaki, H. A Dictionary of Jpn. Buddh. Terms, Kyôto, 1984.
Hisamatsu, S. Biographical Dict. of Jpn. Literature, Tôkyô, 1976.
Illing, R. Jpn. Prints from 1700–1900, Oxford, 1976.
JEBD, 1965 Jpn. English Buddh., Dictionary, publ. von Daitô Shuppansha, Tôkyô, 1965.
Jenkins, D. Ukiyo-e Prints and Paintings, The Primitive Period, 1680–1745, Art. Inst. of Chicago, 1971.
A Comparison of the Ryerson Shidare Yanagi and Kiyonobu's Keisei Ehon, in: Ukiyo-e Art, 1972, no. 36.
Joly, H.L. Legend in Jpn. Art, Tôkyô, 1977 (Repr.).
Keyes, R.S. Jpn. Woodblock Prints, A Cat. of the Mary A. Ainsworth, Coll., Oberlin/Ohio, 1984.
Kindermann, H. Fernöstliches Theater, Stuttgart, 1966.
Kleinschmidt, P., Die Masken des Gigaku, der ältesten Theaterform Japans, As. Forschungen, Bd. 21, Wiesbaden, 1967.
Kraft, Eva Illustrierte Handschriften und Drucke aus Japan, Wiesbaden, 1981.
Kurth, J. Die Primitiven des Japanholzschnittes, Dresden, 1922.
Lane, R. Masters of the Jpn. Print, New York, 1962.
Ukiyo-e Holzschnitte, Zürich, 1978.
Images from the Floating World, Oxford, 1978. *(German translation)*, München, 1982.
Lewin, B. Kleines Wörterbuch der Japanologie, Wiesbaden, 1968.
Link, H.A. The Torii Enigma. in: Ukiyo-e, vol. 19, 1968; Speculations on the Early Geneology of the Torii Masters, in: Ukiyo-e Geijutsu, No. 34, 1972, S. II-XIX.
The Theatrical Prints of the Torii Masters, Honolulu, 1977.
Primitive Ukiyo-e from the James A. Michener Coll. in the Honolulu Academy of Arts, Honolulu, 1980.
Kikuchi, S. A. Treasury of Jpn. Wood Block Prints Ukiyo-e, Transl., Don Kenny, New York, 1969.
Mass, J.P. The Development of Kamakura Rule, Stanford, 1979.
Meissner, K. Japanische farbige Holzschnitte mit versteckten Kalenderdaten, Hamburg, *no date*
Michener, A. Japanische Holzschnitte, München/Fribourg, 1961.
Miyake, S. The Kabuki Drama, Tôkyô, 1961.
Narazaki, M. Nikuhitsu Ukiyo-e I (Kambun to Hôreki). Tôkyô, 1987 *(Series:* Nihon-no-Bijutsu 1).
Netto, C. und Wagener G. Japanischer Humor, Leipzig, 1901.
Paine, R.T. The Masanobu Tradition of the Courtesan of the Three Cities, in: Ars Orientalis, vol.V. 1963, S. 273–281.
Jpn. Prints of Birds and Flowers by Masanobu and Shigenaga, in: Oriental Art, vol. IX, 1963, Nr. 1, p. 22–34.
Papinot, E. Historical and Geographical Dictionary of Japan, Tôkyô/ Rutland Vermont, 1972.
Perzynski, F. Japanische Masken, Nô and Kyôgen, 2 Bde., Leipzig, 1925.
(Pins Coll.) The Jácob Pins Coll., Jerusalem, 1983.
Portheim, J. und E. Stiftung Meisterwerke des japanischen Holzschnittes, Heidelberg, 1975, (Cit. Portheim-Stiftung or Portheim Heidelberg, [1975]).
Priest, A. Japanese Prints from the Henry L. Phillips Coll., New York, 1947.
Rickmeyer, J. Einf. in das klassische Japanisch anhand der Gedichtanthologie Hyakunin Isshu, Hamburg, 1985.
(Museum Rietberg) Japanische Holzschnitte im Museum Rietberg, Zürich, 1977.

(*Rijksprentenkabinet/Rijksmuseum Amsterdam*) (C. van Rappard-Boon, with the collab. of R.S. Keyes and K. Keyes-Mizushima)
The Age of Harunobu, Early Jpn. Prints ca. 1700–1780, 1977.
Roberts, L. A Dictionary of Jpn. Artists, New York, 1976.
Rumpf, F. Frühe japanische Holzschnitte in der Sammlung Toni Strauß-Negbaur, Berlin, no date
Meister des japanischen Farbenholzschnittes, Berlin und Leipzig 1924.
Beiträge zur Geschichte der drei Holzschnitt-zeichnerschulen Torii, Okumura und Nishimura, in: Ostasiatische Zeitschrift, N.F., 1930, p. 16–31.
Sawa, R. Butsuzô-zuten (Buddh. iconographical dict.), Tôkyô, 1951.
Schmidt, S. Katalog der Chinesischen und Japanischen Holzschnitte im Museum für Ostasiatische Kunst, Berlin, 1971.
Seckel, D. Buddhistische Prozessionsmasken (Gyôdô-men) in Japan, in: Nachrichten der Ostasiatischen Gesellschaft (NOAG), Bd. 76, 1954, p. 29–32.
Senzoku, Takayasu Kabuki, Das Theater des altjapanischen Bürgertums, Tôkyô, 1964.
Shibui, Kiyoshi Éstampes Érotiques Primitives du Japon, Bd. I, II, Tôkyô, 1926–28.
(*Hrg. Shimura*) Kojien, Tôkyô, 1972.
Stern, H.P. Masterpieces of Japan, New York, no date
Takahashi, S. Trad. Woodblock Prints of Japan, Tôkyô, 1972.

(*TNM: Tôkyô Nat. Museum*) III. Cat. of the Tôkyô Nat. Museum,
Ukiyo-e Prints, I, 1960, Tôkyô.
Ukiyo-e kenkyû, fasc. 23, series F–6, Tôkyô, 1929.
Ukiyo-e shûha, 10 Bde. Tôkyô, 1978 ff.
Ukiyo-e taikei, Tôkyô, 1974, used: Bd. 1, Moronobu (*Narazaki, M.*) Ukiyo-e Zenshû, I, 1957, Tôkyô Nat.Mus.).
Vergez, R. The Early Prints of Okumura, Masanobu, in: Ukiyo-e Art, no., 42, 1974.
(*Vever Coll.*) Cat. of Highly Important Jpn. Prints, Illustrated Books and Drawings from the Henri Vever Coll., Part I–II, 1974–1977, (Sotheby's).
Waterhouse, D. Images of Eighteenth Cent. of Jpn. Ukiyo-e Prints from the Edmund Walker Coll., Toronto, 1975.
(*ed. Watson, W.*) The Great Japan Exhibition, Art of the Edo Period 1600–1868, London, 1981.
Weber, V.F. Kojihôten, Paris/New York, 1965.
Weber-Schäfer, P. Vierundzwanzig Nô-Spiele, Frankfurt am Main, 1961.
Williams, C.A.S. Outlines of Chin. Symbolism and Art Motives, New York, 1976.
Winzinger, F. Meisterwerke des japanischen Farbenholzschnittes, Graz, 1975.
Yoshida, Teruji Ukiyo-e jiten, 3 Bde., Tôkyô, 1965.

The quoted literature is limited to the publications actually used.

136

GLOSSARY

ARAGOTO: A highly dramatic style of acting for male hero roles, Genroku Period (1688–1704); "rough play," invented by the actor Ichikawa, Danjûrô I.
BENI: Carmine red colour obtained from safflower (a kind of thistle, bot. Carthamus tinctoris)
BENI-E: "Pink-picture," an 18th c. hand-coloured woodblock print in which *beni* was used.
BENIZURI-E: "Pink woodblock print." The earliest prints using several woodblocks, especially those printed in *beni* and green (at first using only two blocks), from 1743. Overprinting of two colours also possible.
BIJIN: "Beautiful woman."
BIJIN-E (or BIJIN-GA): Painting or other picture of a beautiful woman.
BIWA: Stringed instrument, a kind of lute.
BUDÔ: Heroic warrior role (positive character).
BUGAKU: Court dance, from the 8th/9th c. to the present, performed mainly at the imperial court.
BUNRAKU: Puppet theatre.
BUTTERFLIES: Symbol of *Soga, Gorô.*
CHIDORI: A kind of plover. The birds are symbols of *Soga, Jûrô.*
CHÔ: Street.
E: Picture.
EDO: The old name for Tôkyô. The seat of the Tokugawa Shôgunate.
EHON (E–HON): Illustrated book.
ENGAWA: A kind of veranda around a Japanese house.
EMA: Votive picture on wood (*ema-e,* a painting or votive picture).
ENOSHIMA SCANDAL: In 1714, a court lady of the *Shôgun* visited the actor Ikushima, Shingorô in his theatre dressing room. This scandal resulted in the actor's being exiled until 1742, his theatre being demolished, and the theatrical productions being subjected to severe restrictions.
E-ZÔSHI: "Picture book."
FURISODE: Kimono with long sleeves, worn by young girls and at court.
FURISODE-KAJI: The great fire of Edo in the year 1657. The old *Yoshiwara* was destroyed, and the new *(shin) Yoshiwara* was built up.
FUSUMA: Sliding door in a Japanese house.
GA: Suffix, in conjunction with words: picture.
GEISHA: "Female artist," entertainer using dance, song, poetry; not a courtesan.
GEMPUKU: Male initiation ceremony for boys during which the hair on their foreheads was shaved.
GETA: Wooden sandals.
GIGA: Witty picture.
GO: Board game still played to this day.
GÔ: Artist's name, pseudonym, studio name.
GOSHO-GURUMA: Court wagon drawn by oxen.
HAGI: Bush clover.
HAKAMA: Trousers with long legs, trouser-skirt; worn by men als ceremonial costume and by princesses as classical court costumes.
HAMMOTO: Publisher.
HAN: Published.
HANA-GURUMA: Flower wagon.

HANAMICHI: Elevated passageway in Kabuki leading to the stage, enabling the actors to make an impressive entrance.
HANGA: "Printed picture," woodblock print.
HAORI: "Overgown", a shorter kimono worn by men over ceremonial costume.
HARUGOMA: "Little Spring Horse," New Year's dance of child actors.
HASHIRA-E: Pillar pictures (67.5x12.5 cm).
HITSU: Literally "brush"; painted.
HORI: Carved by; also *chô,* relating to the wood carver.
HORIKÔ: Wood carver.
HOSO-E: Elongated format, ca. 30x15 cm.
HYAKUNIN ISSHU: "One Hundred Poems by One Hundred Poets." A poetry anthology of classical poets, each represented by one poem, compiled by Fujiwara, Teika around 1235.
IKEBANA: "To bring flowers to life." The traditional art of flower arrangement.
INRÔ: Small bag or box fastened with a button (*netsuke*) above the belt, for medicines, amulets, etc. Often wonderful examples of miniature art, mainly in lacquer.
IRO: "Colour," "love."
JITSUGOTO: "Positive hero," male role speciality (*tachiyaku*).
JORÔ: Courtesan.
JÔRURI: Sung recitation with musical accompaniment for puppet theatre as well as Kabuki.
KABUKI: "Song-dance-art," popular theatre, founded in 1586 in Kyôto by Okuni, female dancer from a *Shintô* shrine. Female Kabuki was banned in 1629. Youth Kabuki was banned in 1652. Thereafter acted only by men.
KABUKI-E: Theatre picture; depiction of an actor.
KADOMATSU: Two pines at the entrance of a house at the New Year Festival.
KAKEMONO-E: Woodblock in unusually large format (usually 75.7x45.4 cm).
KAKIKAE: "Transposition to another world." Scenes and persona from different periods, legends, and fields are recombined to create a new whole, a new play.
KAKIHAN: Running hand signature, often following the real signature or seal.
KAMIGATA: The area between Osaka and Kyôto.
KAMMURI: Court gentleman's cap, in various shapes for various ranks and functions.
KAMURO: A small maid serving a courtesan who was later to become a courtesan herself.
KANA: Japanese syllabic script having two types: *hiragana* and *katakana,* with approximately fifty-two characters in addition to those adopted from China; e.g., the syllabic script used, too, as pronunciation marks.
KANA-ZÔSHI: "*Kana* reading book," popular illustrated booklet printed in *kana* script, from the first half of the 17th c.
KAOMISE: Theatre performance in the 11th month, at the beginning of the theatre year. "To show one's face." The actors presented themselves to the public wearing only a little makeup.
KATAKI-YAKU: "Enemy" role, rogue; male role speciality.
KEISEI: "Castle conquerors," courtesan.

KENTÔ: "Pass mark"; identifying mark for different printing blocks, invented in 1742.

KIMONO: "Thing to wear." A belted gown resembling a coat, for men and women.

KOMUSÔ: A wandering priest who often hid his face under a broad straw hat.

KÔRÔ: Incense burner.

KOSHÔ: young page.

KOTO: A Japanese harp.

KUGE-AKU: Court rogue, role speciality.

KUSAZURI-BIKI: "Tugging at the armour," a scene from the *Soga-monogatari* involving *Soga, Gorô* and *Asahina-no-Saburô*.

KYÔGEN: Humorous theatre play, farce, originally an interlude in a *Nô* perfomance.

KYÔKA: "Witty verse," thirty-syllable humorous poem.

MAKURA-E: "Pillow picture," erotic depiction.

MICHYUKI: "Wandering paths." Kabuki love scenes. To run away with a kidnapped lover.

MIE: Tableau at the Kabuki performance.

MIMASU: Three rice measures. Three such measures inserted into each other are the crest *(mon)* of the actor family Ichikawa.

MITATE: Travesty of a theme used in Japanese woodblock prints.

MON: Crest. Symbol of an individual actor or actor's family by which the actor can be identified; also for courtesans and their houses, for craftsmen, and the crests of nobility.

MONOGATARI: "Narrative."

NARA-EHON: Illustrated, handwritten manuscript of popular stories, produced in series. Regarded as the precursors of the earliest printed books.

NISHIKI-E: "Brocade picture"; multi-coloured prints after 1765.

NO: Genetive particle, also "by"; can be omitted from names.

NÔ MASK DRAMA: Old Japanese chivalrous dance and song play developed in the 14th/15th c., and imbued with Buddhist spirit.

NUREGOTO: Love scene from a Kabuki play.

ÔBAN: "large format," format of a woodblock print: 38.5x25.5 cm.

OBI: Kimono belt; if courtesan, tied at the front.

OHAGURO: Tooth-blackening powder.

OIRAN: Courtesan.

OKUNI-KABUKI: Kabuki with women actresses, the original form of Kabuki dates from about 1600. Banned 1629.

ÔMI HAKKEI: The "Eight Views of Ômi on Lake Biwa." Eight especially beautiful landscapes around Lake Biwa.

ONNA-GATA: Actors who played women's roles following the banning of appearances by women in Kabuki in 1629 and 1652.

OTOKODATE: Popular hero, in contrast to the warrior heroes of the middle classes.

OYAMA-E: Pictures of beautiful women.

RÔNIN: "Wandering man," lordless *samurai*.

SAKE: Rice wine.

SAMBASÔ: Old auspicious New Year's dance. Danced at the New Year and at the opening of the season of the theatre in the 11th month.

SHAMISEN: Stringed instrument with three strings, played by courtesans and geisha, the musical instrument of *Jôruri* and Kabuki.

SAMURAI: Member of the hereditary military nobility.

SEMIMARU: Blind prince and poet of the Heian Period.

SENRYÔ: Satirical form of poetry.

SHAKUHACHI: A kind of oboe or shawm.

SHIBARAKU: "Wait a Minute." Title of a scene from a Kabuki play; its appearance has the function of a "Deus ex machina" to solve a hopeless situation. Created by the actor Danjûrô I; first used in 1697.

SHICHI-FUKU-JIN: The seven gods of good fortune.

SHIKORO-BIKI: "To tug at the helmet," an episode involving the warriors *Kagekiyo* and *Kunitoshi*.

SHIRABYOSHI: Wandering women dancers and singers who appeared wearing men's clothing.

SHÔ: Mouth organ. East-Asian musical instrument with pipes combined in one mouthpiece.

SHÔGUN: Military ruler of Japan after the emperor was deprived of his power in the 12th c. The Tokugawa bore the title of "Imperial Administrator" from 1603.

SHÔJI: Sliding-doors or windows covered with paper in a Japanese house.

SHUNGA: "Spring pictures." Erotic Japanese woodblock prints, mostly albums. Created by all the great *Ukiyo-e* masters, sometimes using a pseudonym: see *makura-e*.

SOGA-DRAMA: Theatre plays about the revenge of the Soga Brothers in the 12th c.

SUGOROKU: A game similar to backgammon.

SUMI: Ink from lamp or pine soot. Traditional East-Asian ink.

SUMIZURI-E: Black-and-white print ("ink-print-picture").

TACHIYAKU: Actor of male roles: see *jitsugoto, budô, katakiyaku, kuge-aku.*.

TAN-E: "Orange-picture." Early prints painted with *tan* orange (obtained from lead oxide) and yellow pigment obtained from a plant. Earliest type of illumination.

TANZAKU: Strips of paper of a special shape for a poem, especially for woodblock prints (36x11–18 cm).

TAYÛ: Courtesan of the highest rank.

TÔKAIDÔ: "East Sea Street." The main connecting artery between the *kamigata* (see above) and Edo.

TOKONOMA: Picture niche in a Japanese house where a flower arrangement, a picture scroll, or some other decoration was placed.

TOKUGAWA: The name of the *Shôgun* family which held power from 1600. The epoch was named after them: Tokugawa Period (1603–1868).

TORII: The entrance to a *Shintô* shrine, a holy place of the indigenous nature religion.

TORII MASTER: School of woodblock print artists. Active from shortly before 1700, first as poster painters. Many famous artists specializing in theatre illustrations.

UCHIKAKE: Overgown, coat. Worn by court ladies and also by courtesans.

UCHIWA-E: Fan pictures. (*uchiwa*: leaf or round fan).

UJI BRIDGE: Historically important bridge in Kyôto.

UKI-E: Perspective picture. Woodblock print in which architecture is depicted according to the European rules of central perspective.

UKIYO: "Floating world," see Introduction.

UKIYO-E: "Pictures of the floating world." The main term for Japanese woodblock prints which were usually produced in the world of the merchant class. Fashionable genre painting and woodblock prints of the Tokugawa Period (1603–1868).

URUSHI-E: Woodblock prints in which a glossy effect resembling black lacquer is achieved using ink mixed with glue.

WAGOTO: Gentle, rather feminine lover in Kabuki.

WAKA: Classical form of poetry with 30 syllables.

WAKA SANJIN: The three gods of Japanese literature.

WAKASHÛ: Youth.

YA: Suffix meaning "house".

YAKUSHA-E: Picture of an actor.

YAMATO: Old name for Japan.

YAMATO-E: Painting in the traditional Japanese style.

YAMATO-ESHI: Painter in the Japanese style.

YOSHIWARA: Pleasure district in the Japanese capital Edo. (Tôkyô) after the fire of Edo; *Shin-Yoshiwara:* see *furisode-kaji*.

YOKO-E: Horizontal format, "horizontal picture."

YÛJO: Courtesan.

ZA: Suffix meaning "theatre."

ZAPPAI: Form of poetry.

CALCULATION OF TIME: In East Asia, time is calculated in a cycle of sixty years resulting from a combination of Chinese animal signs with elements such as wood, fire, water, etc. In addition, there are special names pertaining to groups of years; e.g., the "Genroku Era," which lasted from 1688 to 1704.

JAPAN'S HISTORICAL EPOCHS:

Jômon	10,500 to 300 B.C.
Yayoi	ca. 300 B.C. – ca. 300 A.D.
Kofun (Tumulus)	ca. 258–646
Asuka	552–710
Nara	710–794
Heian	794–1185
Kamakura	1185–1333
Muromachi	1336–1568
Momoyama	1573–1615
Edo (Tokugawa)	1603–1868

MODERN PERIODS:

Meiji	1868–1912
Taishô	1912–1926
Shôwa	1926–1989
Heisei	1989–

NAMES OF ERAS OF THE 17TH AND 18TH C. *(NENGO)* THAT APPEAR IN THE CATALOGUE:

Kan'ei	1624–1644
Meireki	1655–1658
Kambun	1661–1673
Jôkyô	1684–1688
Genroku	1688–1704
Hôei	1704–1711
Shôtoku	1711–1716
Kyôho	1716–1736
Kampo	1741–1744
Enkyô	1744–1748
Kan'en	1748–1751
Hôreki	1751–1764
Meiwa	1764–1772

CONTENTS

OFFICERS OF JAPAN SOCIETY

The Honorable Cyrus R. Vance, *Chairman*
William H. Gleysteen, Jr., *President*
John Wheeler, *Vice President*
Carl E. Schellhorn, *Vice President*
 Finance and Administration
Richard L. Huber, *Treasurer*
Alice Young, *Secretary*
Iris Harris, *Assistant Secretary*

JAPAN SOCIETY
BOARD OF DIRECTORS

Mr. Teiken Akizuki
Mr. Robert E. Allen
The Honorable W. Hodding Carter III
The Honorable Kenneth W. Dam
Mr. George M.C. Fisher
Mr. Taketo Furuhata
Mr. William H. Gleysteen, Jr.
Prof. Carol Gluck
Mr. Koretsugu Kodama
Mr. Isamu Koike
Mr. Sadahei Kusumoto
Mr. Richard S. Lanier
Mr. Minoru Makihara
Mr. Masaaki Morita
Mr. Jiro Murase
Mr. Paul H. O'Neill
Prof. Hugh Patrick
The Honorable Peter G. Peterson
Mr. Anupam P. Puri
Mr. Burnell R. Roberts
Mr. James D. Robinson III
Mr. William A. Schreyer
Mr. Kunio Shimazu

ADVISORY COMMITTEE ON ARTS

Porter A. McCray, *Chairman*
Dr. Jan Fontein
Martin Friedman
Dr. Sherman E. Lee
William S. Lieberman
Dr. Howard A. Link
Dr. Miyeko Murase
Dr. John M. Rosenfield
Dr. Emily J. Sano
Dr. Yoshiaki Shimizu
Henry Trubner

FRIENDS OF
JAPAN SOCIETY GALLERY

Morton H. Meyerson, Chairman
Mr. and Mrs. Peter A. Aron
Lily Auchincloss
Mr. and Mrs. Armand P. Bartos
Phillip C. Broughton
Mary Griggs Burke
Mr. and Mrs. Willard G. Clark
Dr. Carmel and Babette Cohen
Mr. and Mrs. Lewis B. Cullman
Mr. and Mrs. C. Douglas Dillon
Mr. and Mrs. Peter F. Drucker
Mrs. Frederick L. Ehrman
Mr. and Mrs. Myron S. Falk, Jr.
Dr. and Mrs. Robert Feinberg
Mr. and Mrs. Hart Fessenden
Dr. and Mrs. Roger Gerry
Mr. and Mrs. Charles A. Greenfield
Louis W. Hill, Jr.
Liza Hyde
Mr. and Mrs. Sebastian Izzard
Mr. and Mrs. James J. Lally
Mr. and Mrs. E.J. Landrigan, Jr.
Lucia Woods Lindley
Mrs. Jean Chisholm Lindsey
Mrs. Richard D. Lombard
Mr. and Mrs. Leighton R. Longhi
Stanley J. Love
Mort and Marlene Meyerson
Klaus F. Naumann
Halsey and Alice North
Mr. Houn Ohara
Mr. and Mrs. Joe D. Price
Mrs. John D. Rockefeller III
Mr. Etsuya Sasazu
Mr. and Mrs. Soshitsu Sen
Mr. and Mrs. Alan J. Strassman
Mr. and Mrs. Donald B. Straus
Hiroshi Sugimoto
Miss Alice Tully
Henry P. van Ameringen
Mr. and Mrs. Guy A. Weill
Mr. and Mrs. Roger L. Weston
D.E. Wilder
Barry and Susan Wine

ADVISORY COMMITTEE
ON CARE AND HANDLING
Mitsuhiro Abe
Yasuhiro Iguchi
Takemitsu Oba